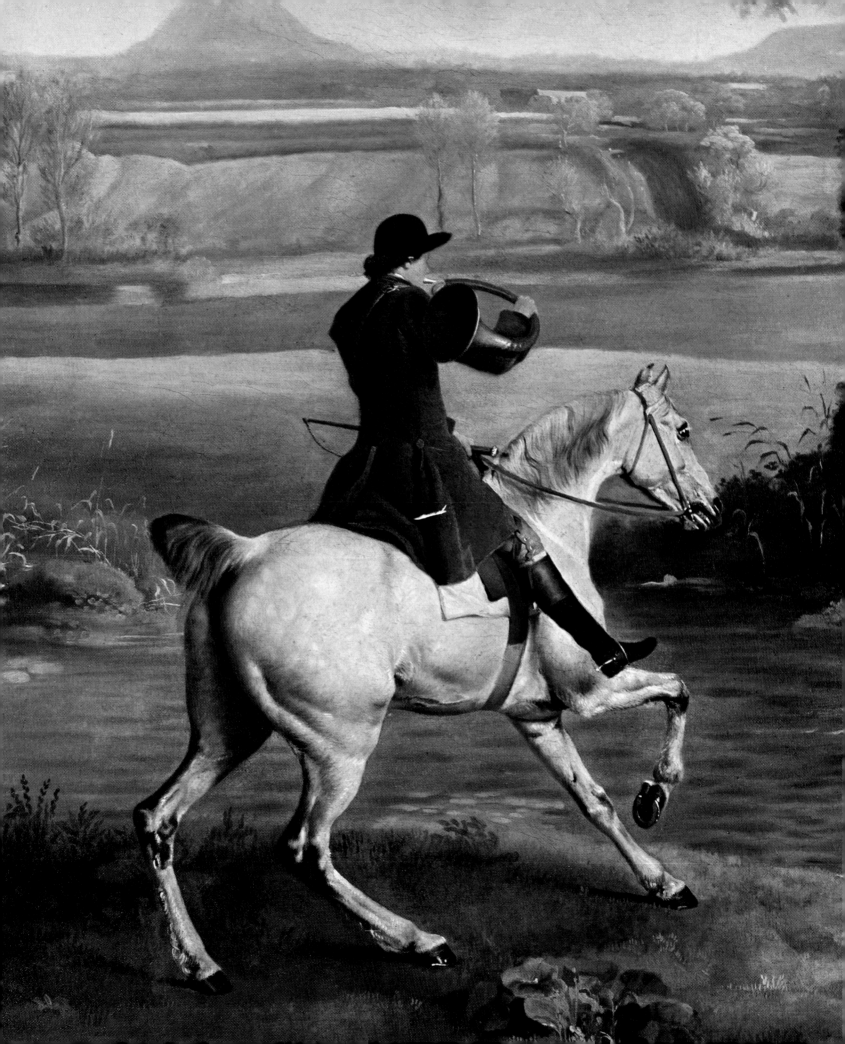

THE GREAT CENTURY OF BRITISH PAINTING:

HOGARTH TO TURNER

William Gaunt

THE GREAT CENTURY OF BRITISH PAINTING:

PHAIDON

HOGARTH TO TURNER

PHAIDON PRESS LIMITED, 5 Cromwell Place, London SW7

Published in the United States of America by Phaidon Publishers, Inc.
& distributed by Praeger Publishers, Inc., 111 Fourth Avenue, New York, NY 10003

First published 1971 © 1971 by Phaidon Press Limited All rights reserved

ISBN 0 7148 1452 0 Library of Congress Catalog Card Number: 70–117415

Printed in Great Britain at The Curwen Press Limited, London

Contents

THE EIGHTEENTH CENTURY may justly be regarded as the great period of art in Great Britain. This was mainly due to the number of gifted individuals who chanced to be active at about the same time, the distinct character British painting attained, and the richness and variety of the genres that reflected national traits and tastes. British art had at last come into its own after the long reign of settlers from abroad.

There was William Hogarth (1697–1764) in the first half of the century, who gave his unique portrayal of social life in the capital. The portrait painters established a new criterion in their combination of informality and elegance. Richard Wilson (1714–82) and Thomas Gainsborough (1727–88) set landscape on the course that was to lead to the triumphs of John Constable (1776–1837) and J. M. W. Turner (1775–1851). The painters of rural life and sport included such an outstanding artist as George Stubbs (1724–1806).

The century's remarkable development followed an inauspicious beginning, tartly described by Horace Walpole. In his *Anecdotes of Painting*, after briefly dismissing the reign of Queen Anne, he remarks of George I's: 'We are now arrived at the period in which the arts were sunk to the lowest ebb in Britain.' This was an exaggeration, partly owing to Walpole's dislike of the monumental baroque style of Sir John Vanbrugh (1664–1726) in his role as architect of Blenheim Palace and Castle Howard, and partly to a contempt for Sir Godfrey Kneller (1646–1723) and the inferior examples of his portraiture.

Born in Lübeck, Gottfried Kniller, his name made plausibly English by the slight alteration to Kneller, was granted a baronetcy by George I in 1715. He was the last in the line of immigrant-artist celebrities, but may be viewed as a distinguished figure of the new century at its outset. In the thousands of canvases he and the assistants in his studio produced, there were as many examples of portraits turned out to mechanical recipe as in the output of his predecessor, Peter Lely (1618–80). Walpole's criticism that where Kneller 'offered one picture to fame he sacrificed twenty to lucre' was not merely an expression of prejudice. Yet the saving picture was produced on occasion. When he took the trouble he could paint with a directness of style and sense of character that were not only admirable in themselves but had a favourable influence. He also gave an orientation to the century by promoting in 1711 the first English academy for the study and practice of art, in premises at Great Queen Street, near his London house. It was a first step towards the Royal Academy, to which nearly all the eminent artists of the time—George Romney (1734–1802) being a remarkable exception—were later to belong.

It is true that conspicuous evidence of a new vigour in English painting did not appear until George II's reign, and that on the whole the second half of the century was

richer in production than the first. But a number of great artists were born while George I was on the throne, or even somewhat earlier: Hogarth in 1697, Allan Ramsay in 1713, Richard Wilson in 1714, Reynolds in 1723, Gainsborough in 1727. They grew up in an atmosphere that was in many ways more propitious to native talent than that prevailing in pre-Hanoverian times. There was increasing prosperity, the result of settled and peaceful conditions and the growth of trade. Resolutely holding to the doctrine that 'the most pernicious circumstances in which this country can be are those of war', Sir Robert Walpole did well for England in keeping the peace for some twenty years. When Walpole resigned in 1742, exports had practically doubled since the beginning of the century. Wealth flowed in from the colonial trade. As well as the capital, Manchester and Birmingham shot up surprisingly in size and population; Bristol flourished; and Liverpool developed from a small township into the third largest port. The property of landowners gained a new value. The needs of the London markets stimulated improved methods of farming and food production, and as the areas of cultivation were extended, prosperity was diffused through the home counties.

The growing wealth encouraged people to spend more money on works of art, although this increased patronage had several directions and limitations. With the accession of George I, a German who spoke no English and cared little for his adopted land, it could be said that the revolutionary work of the seventeenth century was finally completed. Not only was the royal influence in politics diminished, but the court ceased to be the centre of cultural life and the supporter—as in monarchical Europe—of arts that reflected either the stern authority or the hedonistic indifference of ruler and courtiers.

The baroque style, which had been the propagandist weapon of despotism abroad, had no such function in England. Nor was the rococo idiom the mirror of a luxurious court life as it was in contemporary France. Simply in terms of style, these international movements had a certain influence on English painters, more especially in the earlier part of the century, but the essential motives were altered in transit across the Channel.

In the vast mural decoration by Sir James Thornhill (1675–1734) in the Painted Hall at Greenwich, completed in 1727, it is possible to discern the influence of such Italian baroque masters of wall and ceiling painting as Pietro da Cortona and Andrea Pozzo, whose science of rendering space Thornhill studied through the medium of engravings. But his *Triumph of Peace and Liberty* manifestly retains no trace of the militant Counter Reformation. His 'protestant baroque' was soon to become demoded in an age of scepticism, reason and freedom of thought that eschewed grandiose assertion and the exaggerations of enthusiasm. Nor was the world of the Whig squirearchs and a growing middle class any closer in spirit to that of Louis xv and Madame de Pompadour, given up to the playful illusions of French rococo.

Again a distinction can be drawn between the technical influences to which English artists were responsive and their insular ideas and sentiments. Hogarth, in his own phrase the painter of 'modern moral subjects', is to this extent the opposite of François Boucher (1703–70), the inventor of voluptuous mythologies. The satirical fun of *The Roast Beef of Old England* (Plates 16 and 18) is far from the soft enchantment of Boucher's *Birth of Venus*. Yet it can hardly be doubted that his first visit to Paris in 1743 gave Hogarth those impressions of clear colour and the graceful flow of brushwork and composition that served him well in the *Marriage à la Mode* series painted soon after his return to London. His *Analysis of Beauty* was a theoretic exposition at a later date of the value of essentially rococo systems of curvature.

It would be an error to suppose that the rise of English painting in the eighteenth century implied a seclusion from all foreign contact. The French painters and engravers who worked for a while in England or settled there inevitably brought with them an infiltration of style. Philippe Mercier (1689–1760), who came from an emigrant Huguenot family, contributed to the development of the English conversation piece with compositions that had their origin in the *fêtes galantes* of Jean-Antoine Watteau (1684–1721) and his followers. The accomplishment of French engravers, then without rival, gave them a privileged place in the production of English illustrated books and prints. Hogarth had recourse to the French masters of the burin—Scotin, Baron and Ravenet—for the engravings of the *Marriage à la Mode* series, to which they added their own touch of the rococo style.

Of particular importance was the influence of Hubert François Bourguignon, called Gravelot (1699–1773), the pupil of Boucher. Gravelot worked in England for thirteen years, from 1732 to 1745, as book illustrator and ornamental designer, and taught a whole generation at the academy in St Martin's Lane in London, the offshoot of Kneller's and Thornhill's foundation. He imparted a French refinement to his illustrations for Richardson's *Pamela* and Gay's *Fables*. Francis Hayman (1708–76), his fellow teacher in St Martin's Lane and collaborator in illustration and in decorative panels for the pleasure gardens of Vauxhall, benefited from the association. It seems likely that Gainsborough in his early period of study in London—before he was nineteen—found some inspiration from the work of both. There is a delicate suggestion of the French pastoral in certain of his landscapes and open-air groups of the 1750s (Plates IX and 14).

To judge simply by the number of foreign artists who were active in England in the eighteenth century, it might be thought dubious to describe Kneller as the end of an immigrant line. For a few great houses the impressiveness of baroque decoration still seemed appropriate. Thornhill had his rivals not only in William Kent (about 1686–1748), whom Hogarth described as 'a contemptible dauber', but also in such Italians as

Sebastiano (1660–1734) and Marco Ricci (1676–1729), Gianantonio Pellegrini (1675–1741) and Jacopo Amigoni (1682?–1752).

During his stay in England from 1746 to 1756, Canaletto (1697–1768) was as much sought after by the connoisseurs for views of London and other English sites as he had been in Venice for paintings of the Grand Canal. No doubt his example influenced such English topographers as Samuel Scott (about 1702–72), whose close-up paintings of Westminster Bridge in particular followed the Venetian master's treatment of the same subject (Plate 29).

Yet a general view of the first half of the century would show that the English painter was ceasing to be a diffident imitator; he had gained a new confidence and independence of outlook, and could accept foreign influences without subservience. Rejection of artificiality, a corresponding regard for truth, and realistic observation were salient features in which painting showed a trend parallel with that of literature. There is an affinity between Hogarth and Henry Fielding as social observers; and the author of *Tom Jones* showed himself to be well aware of this in his admiring references to the painter's art. In so far as John Gay's *Beggar's Opera* (1728) was intended to ridicule the pomposity of foreign grand opera and especially the Italianesque operas of Handel, it was entirely in accord with Hogarth's attitude to foreign aesthetic imports.

The fact—allowing for certain exceptions—that painters were largely concerned with the realities of their own time was in some measure the result of the type of patrons and their requirements and tastes. It is significant that many of them were landowners and country squires whose interests and affections were centred on their rural estates. The Whigs were to some extent tied to the House of Commons in their long run of political power, but there was little to choose between Whig and Tory in active concern with estate management and pleasure in country diversions (Plates XVIII and 8). Charles Townshend (1674–1738), after he left political life, could devote himself to the improvement and rotation of crops with an energy that earned him the name of 'Turnip Townshend'. He is an early example of the rural innovators who continued throughout the century to seek better methods of agricultural production and improved breeds of sheep, cattle and horses.

The mode of life and the efforts that were a part of it made their demands on artists and added to their scope. Portraits were required as much as they had ever been since the Reformation, but the splendour of aspect and the air of metropolitan fashion were not such insistent conditions as they had been in the court portrait of the past (Plates 10, 11 and 17). Informality gained delightful expression in such a characteristic product of the century as the conversation piece (Plates 5, 40 and 48).

Pride of ownership called for portraiture in another form: the picture of the stately

country house in its setting of parkland. Farmland, newly productive in response to understanding treatment, needed the landscape painter to record its fertile aspect. As in seventeenth-century Holland, the variety of contemporary interests brought a number of specialized genres into being. The importance of the sea to Britain, in commerce, exploration and defence (which entailed naval operations in many different parts of the world), gave rise to a new type of marine painting, based to begin with on Dutch models but quickly becoming distinctive (Plate 24).

Sporting and animal genres developed with the country gentry's interest in organized hunting and the breeding of racehorses (Plates XVIII, XIX, 8, 36, 37 and 62). The hunting picture had a great patron in Frederick, Prince of Wales (1707–51), son of George II (and first of the Hanoverians to appreciate pictures of any kind), who employed John Wootton (about 1682–1764), the virtual founder of the school that reached its zenith in the second half of the century (Plates 8 and 9). Racing had long been an organized sport, but it was not until the middle of the century that pictures of racing and racehorses obtained their vogue. A stimulus to their production was given about that time by the foundation of the Jockey Club and the effort of such a pioneer in the breeding of blood-stock as William Augustus, Duke of Cumberland and the third son of George II. After crushing the last hopes of the Young Pretender and the Scots for a change of dynasty in the 1745 attempt at rebellion, the Duke, in the pacific role of Ranger of Windsor Forest and Great Park, bred the horses that Paul Sandby (1725–1809) drew for him and Sawrey Gilpin (1733–1807) painted.

In the varied specializations that broadened out during the century, and answering to the requirements of patrons for a pictorial record of a local and domestic kind, English artists found employment that fostered their talents but left a measure of dissatisfaction or feeling of frustration. The connoisseur and patron often displayed two levels of taste, and from what in his estimation was the higher level, the native artist was likely to be excluded. All the reasons that drew the cultured and wealthy to Florence, Venice and Rome as the splendid climax of the Grand Tour were operative. The amateurs of the Society of Dilettanti, founded in 1732, pursued the study of antique sculpture in Italy, and also in Greece. The third Earl of Burlington (Plate XI) returned from Italy a devotee of the classical style of Palladio's architecture. Collectors doted equally on the seventeenth-century 'classical landscapes' of Nicolas Poussin, Claude Lorrain and Salvator Rosa, and the Venetian views of Canaletto and his assistants. The young English milord in Rome with his tutor would sit to Pompeo Batoni (1708–87) or Anton Raphael Mengs (1728–79) for a portrait that usually included a glimpse of Rome and its classical ruins in the background to serve as a reminder of his visit. This pattern implied a cultural prestige to which English art could not aspire. Little encouragement was

offered the painter to indulge in imaginative composition. History painting (that is, of classical or Biblical subjects) was assumed beyond his capacity, or when he attempted it, it was regarded tepidly as an imitation of what was done better in other countries and, moreover, in earlier periods. Hogarth's fulminations against the collectors who imported 'shiploads of dead Christs, Madonnas and Holy Families' added an extra malice to the criticisms with which his own excursions into the field of history painting were received.

Those who plumed themselves on their appreciation of Claude or Poussin had less favour for Richard Wilson. His landscapes, said Sir Joshua Reynolds, 'were too near common nature to admit supernatural objects'—that is, the figures of classical myth. To introduce gods and goddesses in Sir Joshua's view required a mind 'as it were naturalized in antiquity, like that of Nicolo [*sic*] Poussin'. The connoisseurs who established a special relationship between antiquity and an eighteenth-century work of scholarly equilibrium were not so fond of 'common nature', and though Wilson had his admirers, he had few commissions. (Plate 53 shows one of his rare attempts at the kind of historical landscape approved by connoisseurs.)

An outlet for the imaginative faculty was to be found in the second half of the century, when painters took subjects from Shakespeare (Plates 123 and 130) and Milton, rather as the Renaissance masters had drawn upon Homer and Ovid. But it would be obtuse to deny the word 'imaginative' to the pictorial survey of the whole social order that was Hogarth's marvellous achievement; this was history painting in a contemporary sense such as had never been known before.

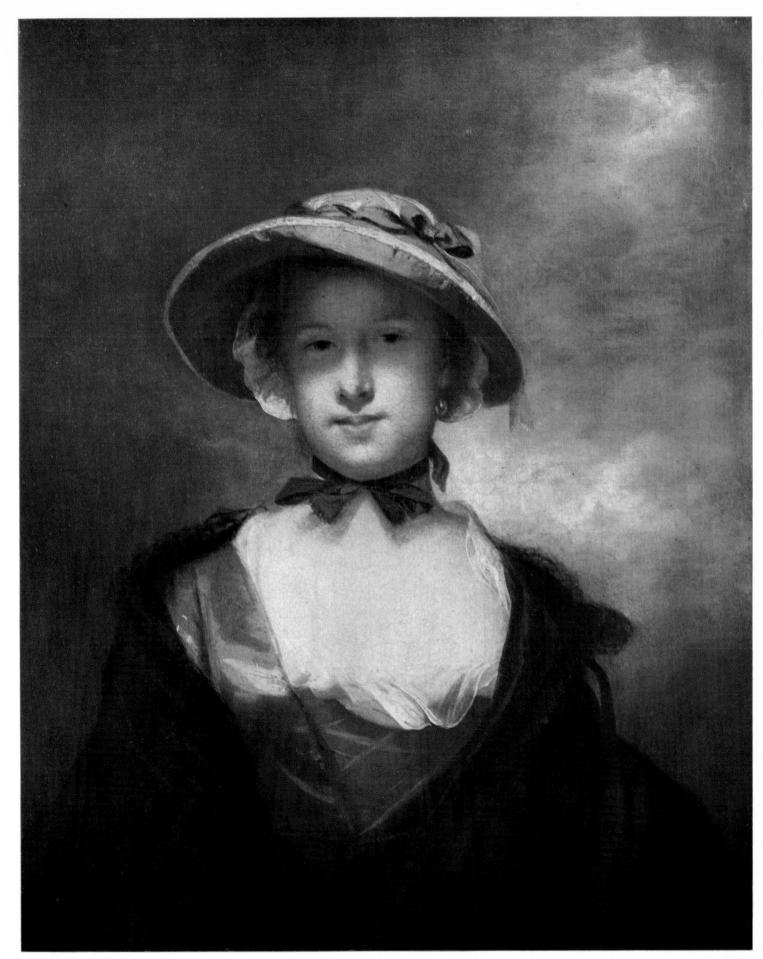

II SIR JOSHUA REYNOLDS (1723–92): *Lady Chambers*. 1752. Canvas, $27\frac{1}{2}\times22\frac{1}{2}$in. London, Kenwood

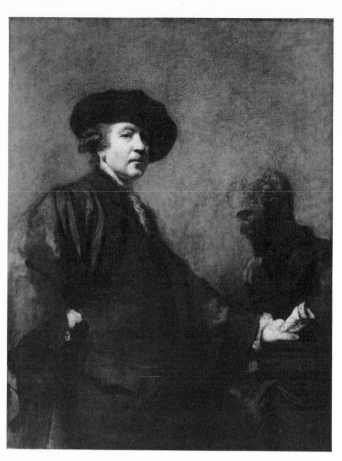

III SIR JOSHUA REYNOLDS: *Self-portrait*. 1773.
Panel, 50 ×40in. London, Royal Academy

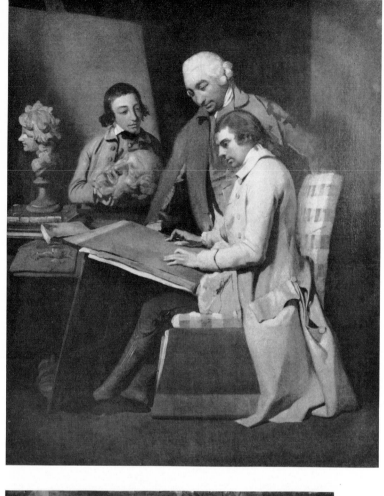

IV JOHN
HAMILTON
MORTIMER
(1741–79)
*The Artist,
Joseph
Wilton, and
a Student.*
About 1760
Canvas,
29 ×24in.
London,
Royal
Academy

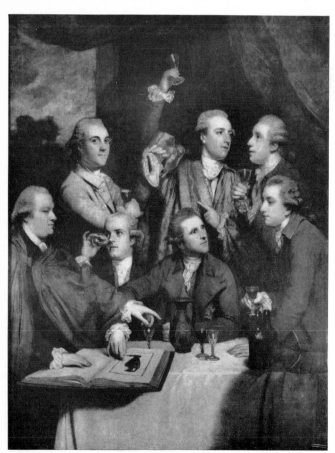

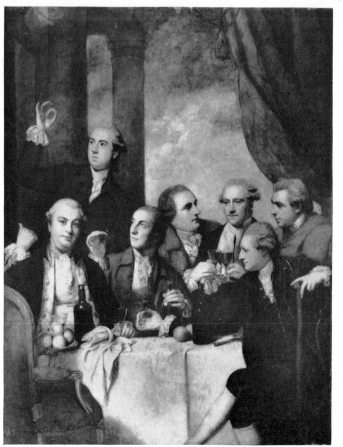

V & VI
SIR JOSHUA
REYNOLDS: *The
Society of
Dilettanti*. London
Society of
Dilettanti. These
companion
canvases (each
78 ×59in.) were
painted between
1777 and 1779

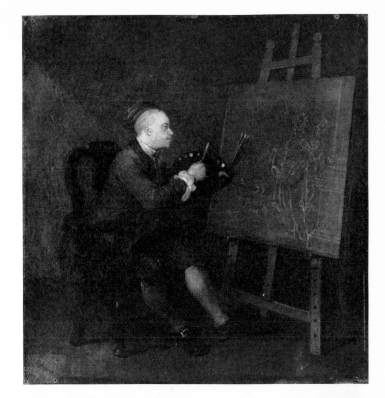

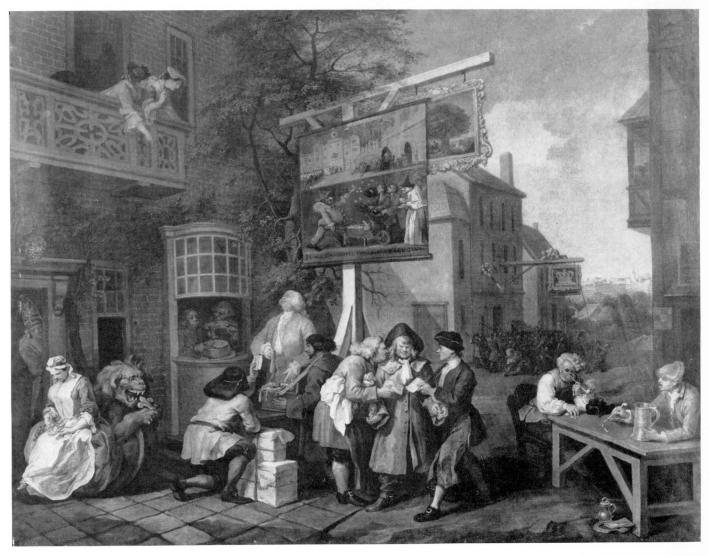

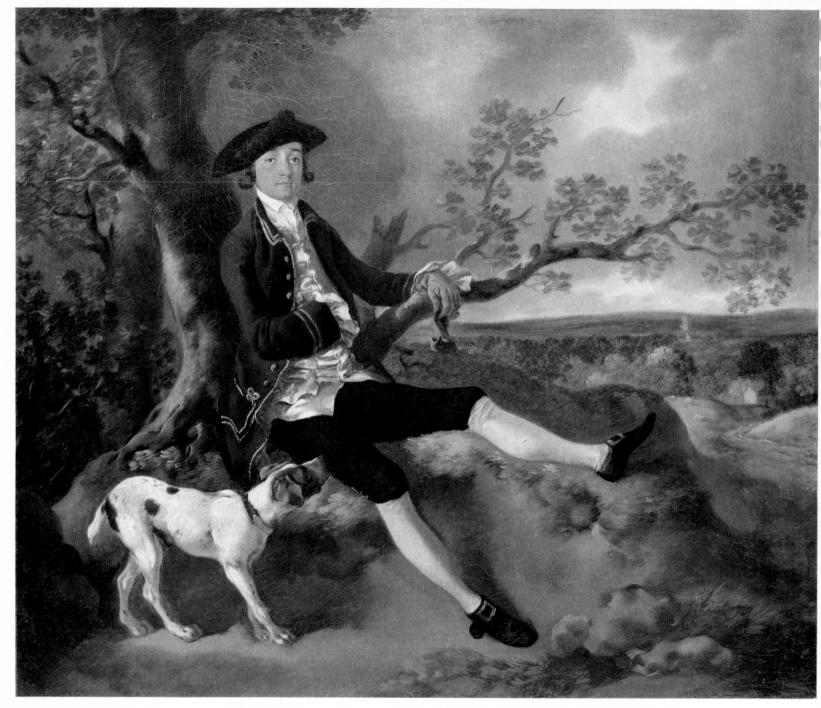

IX THOMAS GAINSBOROUGH (1727–88): *John Plampin*. About 1755. Canvas, $19\frac{3}{4} \times 23\frac{3}{4}$in. London, National Gallery

2 The conversation piece and portraiture

HOGARTH'S ENLARGEMENT OF PAINTING'S SCOPE was based on the conversation piece, which was to prove one of the most flexible and adaptable of genres. The idea of an informal group was not in itself new, nor the invention of Hogarth alone. The small-scale picture of family or friends in their habitual routines or diversions that became popular early in George II's reign had seventeenth-century Flemish and Dutch proto-types, to which were added the influence of pastorals and scenes from Italian Comedy and their groups of actors by Antoine Watteau.

Marcellus Laroon (1679–1774), eighteen years older than Hogarth, had been one of Kneller's embryonic academicians. After a period as a singer at Drury Lane and a soldier under Marlborough, he returned to art, depicting open-air occasions and fashionable gatherings. An amalgam of impressions from the eighteenth-century Dutch painters Cornelis Troost and Peter Horemans, from Watteau, and from his young friend, Hogarth, were combined in a curious style of Laroon's own, giving the effect of near-monochrome with highlights touched with white.

Philippe Mercier brought the fanciful pastoral of Watteau to a stage of realistic evolution in his portrait groups. Yet it was the genius of Hogarth that made the conversation piece entirely English. His dislike of formal portraiture and what he contemptuously termed 'phizmongering', the stubborn middle-class consciousness that set him against the aristocratic patron, may account for the fact that his best individual portraits on a scale approximating life-size are of the common man and woman. He translated the baroque state portrait with its accessories of grandeur into the decent plainness of his portrait of Captain Coram (Plates 11 and 13). His sense of character was most intensely displayed in the studies of his servants (Plate 30) and of a Cockney shrimp-seller (Plate 45). The small conversation piece was another escape from the drudgery of portraiture. Among the finest are *The Woollaston Family* (1730; on loan to Leicester Art Gallery) and *The Indian Emperor* (1731–2; London, Earl of Ilchester). The 'puppets' (for so the persons portrayed might be considered) could be arranged in a composition to his liking, and such agreeable side activities were involved as the still life of objects in an interior or the painting of a landscape backcloth for an open-air group. Taking advantage of the growing vogue for such small works in the 1720s, and under the necessity of earning more money than the craft of engraving could provide, after his runaway marriage to Sir James Thornhill's daughter in 1729, Hogarth quickly became the leading exponent of the genre, outshining such rival contemporaries as Gawen Hamilton (1698–1737), Bartholomew Dandridge (about 1690–1754), George Knapton (1698–1778) and Charles Philips (1708–47).

Viewing the portrait group as a miniature stage, Hogarth was so much the better equipped to paint an actual stage and its performers in his first resounding success, the

scene from *The Beggar's Opera*, of which he made several versions between 1728 and 1731. It was the first of a long series of theatrical conversation pieces, with portraits of actors and actresses 'in character', a genre that really came into its own in the second half of the century. Johann Zoffany (1733/4–1810), encouraged by the great actor David Garrick (1717–79), was the leading exponent (Plate 58) and had an able follower in Samuel de Wilde (1748–1832; Plate 149). For Hogarth a sequence of thought seems inevitably to have led from the satirical comedy of Gay's opera to what might be made of the human comedy on the grander scale of real life. He thought of the dramatic stories that could be unfolded in a series of scenes, as in a play. But a play needed as large an audience as possible. To paint replicas of an oil painting was a toil that did not bring it before many eyes—nor bring in much money; engravings, on the other hand, could be multiplied without difficulty. The nation in this way was to be his audience, or at least that solid middle-class part of it from whom applause for the illustration of themes with conspicuous moral overtones could be confidently expected.

With the success of the first series, *A Harlot's Progress*, in the six engravings of 1732 from the paintings later destroyed by fire (at Fonthill in 1745), Hogarth circumvented the system of patronage he so disliked; he was able to pursue an independent course in the great series that were to follow, bringing Hanoverian London vividly before the eyes in a tumult of action. In the breadth of his social vision, evident in the four series, *A Rake's Progress*, *Marriage à la Mode*, *An Election* (Plate VIII) and *The Four Times of Day*, as well as in a number of single works, he had no rival and, in spite of many imitators, no successor.

The history of the conversation piece, however, branches out in other ways. One direction is given by Joseph Highmore (1692–1780), who was born before Hogarth but long outlived him. So little scholarly attention was at one time given to early eighteenth-century style, and so far was the period regarded as Hogarth's exclusive property, that some of Highmore's best work was attributed to Hogarth. The portrait group *Mr Oldham and his Guests* (Plate XXI) is an instance. In this painting Highmore's delicacy of style is recognizable, though he also displays a sense of rough masculine good humour in his sitters. His series masterpiece, the twelve paintings illustrating Richardson's *Pamela* (Plate 6), was a new adaptation of the conversation piece as a means of representing the characters and incidents of a novel within a stage-like area. The paintings differentiate him from Hogarth, not only in being illustrations to a book but in having a rococo refinement of their own.

In the mid-century the conversation piece gained a provincial and rural currency. Arthur Devis (1711–87) of Preston, with something of a Puritanic simplicity that has its sharp relish, painted families stiffly posed in the grounds of their country houses or

interiors that excluded any flamboyance of decoration (Plates 48 and 49). The realistic placing of figures in landscape, as distinct from setting them against a stagey landscape backcloth, was an advance in which Francis Hayman was also an innovator.

Hayman, friend of Hogarth, whom he accompanied on his visit to France, is a link between the first and second phases of the eighteenth century. A versatile if not a great artist, he painted a number of portraits; decorations for Vauxhall, much esteemed in his own day; history pictures, few of which are now known; theatrical scenes for David Garrick; and conversation pieces, which were original in their informal treatment of figure and landscape and had their influence on the young Gainsborough.

The superb marriage picture by Gainsborough of young Mr and Mrs Andrews (Plate 14) surveying their rural domain that sets them so perfectly in East Anglian country—a masterpiece in its own right—indicates also a nicety of transition in its reminiscence of Hayman, whom he knew in his student days in London when he studied under Gravelot. The small full-length figures of Gainsborough's 'Suffolk style', like the amiable John Plampin lounging beneath a tree with his dog at his side (Plate IX), have their ancestry in Hayman's paintings of the gentry 'seated at their ease in a landscape' —to quote the descriptive titling of his picture of David Garrick and Garrick's friend, William Windham, on a country jaunt. The influence of Gravelot is more perceptible in the larger commissioned works of the Suffolk period, when Gainsborough seems deliberately to have aimed at producing idyllic English pastorals according to French recipe.

Though Johann Zoffany extended the life of the conversation piece in the second half of the century by recalling the genre to the purpose of conveying royal and aristocratic magnificence as well as informality, the demand for the large three-quarter-length or full-length portrait was insistent. The heyday of portraiture was still to come after the halfway mark of the century had been passed. A significant date in Gainsborough's career is 1759, when he moved to Bath to become a fashionable portrait painter.

Bath, no less than London, was a centre of fashion. Esteemed since Roman times for its medicinal waters, it had flourished anew under the autocracy of the foppish Beau Nash. The century's taste for the classical in architecture had magnificent expression in the replanning carried out by John Wood (1705–54) and his son (died 1782), who designed the incomparable Crescent and Circus. In this resort for the wealthy, Gainsborough was quickly inundated with commissions. The beautiful sensation of a fresh and intimate accord with nature, as represented not only by the Suffolk landscape but also by such portrait studies as he made of his young daughters (Plate 34), was enhanced by a style of painting that translated light and shade into simplified areas of clear colour. The rural freshness and the method of its expression disappeared from his

work in the years spent at Bath. He himself was apt to lament being confined to portrait commissions and diverted from the landscape he loved, but in fact he was maturing rather than submitting to a routine.

Gainsborough came under a new influence at Bath, that of Anthony van Dyck, whose portraits he was able to admire in the great houses of the region, such as Wilton. He set himself to emulate van Dyck in a style of courtly elegance enhanced by new delicacies of tone and brushwork (Plates 74 and 75). The portrait background now became an artificial or idealized landscape. The disappearance of real country from his work was not merely the result of departure from his native Sudbury but is symptomatic of the desire for experiment, in which he remained consistently active and original.

In landscape painting, which Gainsborough pursued for his own pleasure (his studio-home, Schomberg House in Pall Mall, was full of unsold landscapes when he died), he became immersed in general principles of composition (Plate 56). In his landscape drawings he showed how variously different graphic media might be effectively combined. Less obvious to the eye of the present day than to Reynolds in Gainsborough's later portraits are the 'odd scratches and marks' which baffled the president of the Royal Academy by magically assuming form when seen at a certain distance. This liveliness of technique gives vivacity to the elegance of such a masterpiece as *The Morning Walk* (Plate 122) and to a painting like the *Diana and Actaeon* (Plate 112), whose shimmering lightness of touch brings to mind the oil sketches of a Boucher or Fragonard.

Comparable with Gainsborough in exquisite quality, though without his variety and flourishing somewhat earlier, was the Scottish painter Allan Ramsay (1713–84). Born in Edinburgh, the eldest son of the poet, Allan Ramsay, he was exceptional in assimilating features of style and profiting by the example of contemporaries in Italy and France. As a young man he worked in Naples and Rome, and he found much that was both stimulating and instructive in the work of the decorative painter Francesco Solimena (1657–1747) and the portraits of Batoni, who knew so well how to invest his sitters with an air of well-bred nonchalance. The skill and confidence gained abroad brought Ramsay into prominence in London on his return from Italy in 1738; and he was able gleefully to record that he had driven from the field the French portrait painter, Jean-Baptiste Van Loo (1684–1745), who worked for some years in England and painted Sir Robert Walpole.

Ramsay's portrait of his first wife, Anne Bayne, is one of the small masterpieces of the first half of the century, combining a dignified grace of style with sensitive perception of character. He excelled in female portraiture, and the refinement and pastel-like colour of his portraits in his best years (the 1750s) suggest strongly that he had studied the French portraitists, Jean-Marc Nattier (1685–1766), Jean-Baptiste Perronneau

(1715–83) and Maurice-Quentin de La Tour (1704–88), and that his taste had veered towards French rococo in preference to late Italian baroque. The portrait of his second wife, Margaret Lindsay, was probably painted about 1755–7 and is a beautiful example of this second phase of his art (Plate 41). Ramsay was a talented draughtsman as well as a charming colourist but there is a want of variety in his work that distinguishes him from both Gainsborough and Reynolds. After the 1760s he virtually gave up painting, though he lived until 1784. His studio assistants remained busy turning out replicas of his royal portraits, while he adopted the role of man of letters and wrote essays on politics. Yet such portraits as that of the celebrated bluestocking, Mrs Montagu, and of Lady Mary Coke, standing with theorbo, both painted in 1762, show what an original and sensitive contribution he made to the great age at the peak of his achievement.

Sir Joshua Reynolds (1723–92), knighted at the age of 46 in 1769, the year after he became the first president of the Royal Academy, remains the dominant figure in portraiture, with an aim differently directed from that of Hogarth, Gainsborough or Ramsay. He sought to raise the standards of English painting within the European tradition as represented mainly by the masters of the Italian Renaissance, though not excluding the profit that might be derived from the study of Rembrandt, Rubens and Van Dyck. If Gainsborough was the greater artist, and Ramsay the better painter of women, Reynolds by dint of much close study in Rome and Venice and by reason of his own philosophic habit of thought, achieved if not the 'grand style' of his *Discourses*, a dignity of style and richness of colour all his own.

The variety that Gainsborough admired in Reynolds was achieved within the boundaries of portraiture, and lay chiefly in the understanding fashion in which he adapted pose and composition to the character of his sitter. The process also involved an extensive use of pictorial 'quotations' from approved art of the past, adaptations that could give a learned touch to his work, as in the *Self-portrait* with the bust of Michelangelo (Plate III), in which he neatly combined homage to the Florentine with a stylistic souvenir of Rembrandt's *Aristotle contemplating the Bust of Homer*. An even clearer example is the famous portrait of *Sarah Siddons as the Tragic Muse* (Plate 101), an image designed not only to honour the greatest tragic actress of her day, but also to bring again to the spectator's mind the work of Michelangelo, the artist whom Reynolds revered above all others. The pose of Mrs Siddons is based on the figure of Isaiah on the Sistine ceiling.

It would be a great mistake, however, to assume that Reynolds was always so pictorially ambitious, or so relentlessly high-minded. There was often an ease and naturalness in his portraits that links him with Gainsborough and which made him superior to

his talented rival, George Romney, 'the man in Cavendish Square' as Reynolds disdainfully called him. Reynolds's famous portrait of Nelly O'Brien (Plate 44) is a masterpiece of gentle informality. So too—in a slightly different vein—are his pictures of young motherhood (Plate 35). He also had, to a high degree, that sympathy with and liking for children in which the English painters of the century excelled (Plate 95). In the sense of character that enabled him to give so splendid a record of his gifted contemporaries—Johnson, Goldsmith, Boswell, Burke, Sheridan, Fox, Gibbon, Garrick, Mrs Siddons—there was a substratum of the humour that had first shown itself in Italy in caricature portraits after the manner of Thomas Patch (about 1725–82). His influence was strong enough on others—James Northcote (1746–1831), Sir William Beechey (1753–1839), John Hoppner (1758?–1810), Sir Henry Raeburn (1756–1823)— to found a tradition.

3 The rise of landscape

THROUGHOUT THE EIGHTEENTH CENTURY the process that may be called the 'discovery of Britain' was continuous and expansive. It is marked by a profusion of county and town histories, illustrated accounts of antiquities, finely engraved and coloured maps, and records of travel in various regions, giving much illustrative employment to the topographical draughtsman and watercolourist. The changed, man-made landscape incited record. Change was brought about by the enclosures of common land that became more frequent with the growing value of land and farm development, and by the type of landscape gardening that contrived picturesque compositions of trees, water and parkland, imitating in three dimensions the painted landscape of Claude (Plate XVI).

The oil painter, like the watercolourist, might be employed to make a 'country-house portrait' with the setting prompted by the aesthetic tastes of the owner; or depict for the landed proprietor's satisfaction, the bounteous harvests so frequent in the latter half of the century, such as appear in George Stubbs's beautiful paintings of reapers in the cornfield (Plate 78). The earlier Georgian painters still depended on Claude and Gaspard Dughet (Poussin) for conventions of style in painting trees and stretches of country. John Wootton gives examples in the backgrounds of his hunting scenes—and was later to be chided by Constable because 'he painted country gentlemen in their wigs and jockey caps . . . and placed them in Italian landscapes resembling Gaspar Poussin, except in truth and force' (Plate 8). Constable was no less scathing about Wootton's follower, George Lambert (about 1700–65), who, he said, 'is now remembered only as the founder of the Beef Steak Club'.

Yet Lambert, for whose landscapes his friend Hogarth sometimes painted incidental figures, deserves better than Constable's summing-up as a pioneer, if still hesitant between an imitative 'classical landscape' and the reality of English country (Plate 23). In certain works he seems to burst through imitation to give a fine open vista in original fashion, the largeness of view perhaps owing sometimes to his experience in scene painting at Covent Garden for the actor-manager, John Rich. He was most active in the 1730s and 1740s and had pupils of some interest, chief among them John Inigo Richards (died 1810) who, like Lambert, combined landscape with scene painting at Covent Garden.

It was after the mid-point of the century had been reached that Richard Wilson, the first great master of landscape, emerged. It is surprising to recall, in view of his fame in landscape, that until the age of thirty-five, he was a portrait painter and by no means unsuccessful. Some six years in Italy between 1750 and 1756 and the encouragement of Francesco Zuccarelli (1702–88), the Italian painter of rococo pastoral, and Claude-Joseph Vernet (1714–89), the French 'latter-day Salvator Rosa', led him to devote

himself to landscape. There is no doubt that he was influenced by Claude and Gaspard, perhaps also to some extent by Canaletto, as well as by the glowing skies of Aelbert Cuyp, the 'Dutch Claude' as he was sometimes termed. But the light of Italy, the space of the Roman Campagna, the structure of the hills and volcanic lakes contributed to form a style independent of the work of others. Wilson was also capable of interpreting nature with the aid of the universal key represented by the words 'light' and 'structure', independently of region.

His achievement is well defined by the great nature-worshipper, John Ruskin (in handsome recompense for earlier misunderstanding). With Wilson, said Ruskin in *Art in England*, 'the history of sincere landscape art founded on a meditative love of nature begins in England'. The love of nature and the ability to give it masterly expression survived all the vicissitudes of his career. His first attempts to introduce mythology according to the recipe of classical landscape (Plate 53) did not go down well, though his drawings of Rome and its environs had attracted many aristocratic English buyers on the Grand Tour during his stay in Italy. The disbelief in the capacity of English artists to work in the classical spirit, which has already been remarked on, came into play.

A hard economic struggle caused Wilson to produce some inferior versions of his Italian views after his return to England, but the three phases into which his art can be divided all had their masterpieces. These include the best and most spontaneous of his paintings of mountains and lakes in southern Italy; sunlit vistas along the Thames (Plate 27) and on the estates of the country gentry; and lastly the pictures of Snowdonia, which he painted after he had retired to Wales with a small legacy, pictures in which his feeling for the grandeur of mountain scenery found memorable expression (Plate 55).

Wilson had an immediate following of pupils and admirers who displayed considerable talents: William Hodges (1744–97; see Plates 66 and 67), who began as his studio assistant and remained a lifelong friend; William Marlow (1740–1813; Plate 26), a pupil also of Samuel Scott; Thomas Jones (1743–1803; Plates 86 and 87), devoted disciple who produced some original Italian views; and Joseph Farington (1747–1821), the topographical painter and diarist. Imitation was a form of rivalry in George Barret (1728–84), the Irish painter who worked in London, resorted to Wilson's manner, and perhaps had a larger contemporary reputation. Wilson, however, can be viewed in a broader perspective, and his work seen as one of a great series of landmarks in the history of English landscape art.

The succession was perceptively outlined by John Constable in one of his lectures describing the reemergence of landscape after a period of decline. 'It is delightful to say that landscape painting revived in our own country in all its purity, simplicity and

grandeur in the works of Wilson, Gainsborough, Cozens and Girtin.' This was an appraisal of genius irrespective of medium, as John Robert Cozens (1752–97) and Thomas Girtin (1775–1802)—to both of whom Constable ascribed 'genius of the highest order'—worked exclusively in watercolour. Yet in their feeling for landscape (which Constable signalized by the word 'poetry') they could be considered equal with those who worked in the weightier medium, distinct in personal expression as they were.

Wilson was poetic in the breadth and simplicity of style that was to have its echo in John Crome (1768–1821), and in both Turner and Constable. Cozens imparted a romantic sensation of height and distance in his austerely toned watercolours that gave Turner his first idea of the fascination of Alpine scenery. Girtin was inspiring to Constable in freshness and the impression of truth to natural effect he could so convincingly create. Constable found the memory of Gainsborough 'in every hedge and ditch' of their native Suffolk, though the eulogy in his lecture, 'The Decline and Revival of Landscape', dwells on the later products of Gainsborough's imaginative vision: 'the lonely haunts of the solitary shepherd—the return of the rustic with his bill and bundle of wood—the darksome lane or dell—the sweet little cottage girl at the spring with her pitcher . . .' (see Plate 116).

Though Constable and Turner belong to the romantic era of the early nineteenth century, it is clear they owed much to the great age that had gone before. They found poetry of a congenial kind not only in its painters, but in such a treasury of landscape description as James Thomson's *The Seasons*, from which both artists made admiring quotation. Both painting and literature show the growth of affection for the beauties of nature in its wilder aspect from the middle of the eighteenth century onwards. The work of the painters who 'discovered' Scotland, Wales and the Lake District—Paul Sandby, Julius Caesar Ibbetson (1759–1817) and Philip James de Loutherbourg (1740–1812)—has a parallel, for example, in the letters and journals of Thomas Gray (1716–71), a literary pioneer in the 1760s in Scotland, Wales and, together with his old Etonian friend Horace Walpole, in Cumberland and Westmorland.

4 The rural scene

ALLIED TO LANDSCAPE, but distinct as a genre dealing with human activity, was the type of painting that mirrored rural life and recreation. The sporting picture was an English invention in the peaceful era of Sir Robert Walpole. It answered to the demand of the country gentry for representations of the traditional stag hunt and the fox hunt that was coming into vogue, and also of the racehorses and the races themselves.

The first practitioner of note was John Wootton. He was the pupil of Jan Wyck (1652–1700), a Dutch painter influenced by Wouvermans, who specialized in battle pieces but also made illustrations of hunting and hawking. Horace Walpole speaks of a greyhound's head by him in the family collection at Houghton 'of admirable nature'. Wyck settled in England, was married there, and lived at Mortlake.

Wootton applied Wyck's style of composition to hunting scenes. He was first distinguished, says Walpole, by frequenting Newmarket and drawing racehorses. His later treatment of landscape in hunting scenes was not unkindly regarded by Walpole, who said he 'approached towards Gaspar Poussin and sometimes imitated happily the glow of Claude Lorrain'. But he was later exposed to cruel jibe by Constable, who said Wootton 'without manual dexterity left [landscape] in unredeemed poverty and coarseness'. More credit, without overpraise, may nowadays be given to the 'primitive' of a school, whose *Members of the Beaufort Hunt* (Plates 8 and 9) reveals a degree of realism breaking through the shell of artificial conventions.

The work of Pieter Tillemans (1684–1734), a Flemish painter who came to England as a young man in 1708, is an early example of the sporting conversation piece, the portraits of individuals on horseback, with the hounds and personalities of the hunt around them. James Seymour (1700–52) painted horses in a more natively English style than Wootton or Tillemans. John Nott Sartorius (1755–1828) retained something of the naïve quality in his horse paintings, but in the second half of the century the realism of the genre developed quickly with the encouragement of owners and such addicts of the racecourse as the young Prince of Wales (later George IV).

Sawrey Gilpin, brother of the apostle of the picturesque, the Reverend William Gilpin (1724–1804), was assigned a studio in the Great Lodge at Windsor by the Duke of Cumberland and portrayed the stars of the Duke's stable. In his accomplished paintings of animals and landscape he benefited by the example of George Stubbs, who came south in 1759 and was quickly in demand with aristocratic patrons, giving a new significance to a limited specialization by virtue of his individual genius.

It was the strength of Stubbs, as of other great masters, not to specialize. His famous *Anatomy of the Horse* might initially suggest a confinement of interests; actually, it was only one product of a desire for knowledge and mastery of form, recalling the great Renaissance men. Stubbs's spirit of intellectual inquiry makes it quite out of place to

call him a 'sporting painter', a label which would fit his younger contemporary, Benjamin Marshall (1767–1835). Nor is 'animal painter' entirely appropriate, although he displayed a boundless curiosity about animal life, portraying the first kangaroo brought to Europe and, in his several versions on the theme of the lion frightening or attacking a horse (Plates 81 and 82), showing early signs of the romantic obsession with the savagery of nature.

Stubbs was a master equally of the human figure, character and expression, and of landscape and composition, as of the equine anatomy he studied so thoroughly (Plates 36, 51, 133 and 134). His variations on the theme of 'mares and foals' have a timeless beauty (Plate 37). The experimental spirit that so often accompanies greatness appears in his paintings with enamel colours on wedgwood plaques, and in the superb engravings of mixed methods made after his own pictures. His open-air conversation pieces and farming pictures, added to the hunting and shooting themes, convey the essence of rural life in Georgian England.

For George Morland (1763–1804) the rural scene was a peasant idyll. Whatever hardships may have resulted at this level from the enclosures, which in the reign of George III were bringing more and more land under the control of the magnates, they have no reflection in his paintings. There is a strange contrast between what is known of his harassed and dissipated life, and the smiling pastoral that he depicted in succession to and influenced by Gainsborough. *Seashore—Fishermen hauling in a Boat* (Plate 152) is an unusually spirited example of his work, both in handling and subject matter.

Morland had the same suspicion of patrons, the same fierce desire for freedom with no strings attached, as Hogarth and Wilson. But all is amiable and tranquil in his pictures of besmocked rustics quaffing ale from their pewter mugs, the cottagers and their wives at the doorways of their delightful-looking, thatched-roofed habitations, the rustic scene which might then be found as near to London as Paddington and Kilburn, where at times he lived. With no great depth of social perception, Morland conveys much of what was happy in the eighteenth century.

Morland's fresh and fluent style of painting was the result of a well-disciplined apprenticeship with his father, Henry Robert Morland (1716–97), himself a painter of talent. Henry Morland also restored pictures and set his son to help him and make copies of Dutch paintings that passed through his hands. Like Wilson and Gainsborough, George Morland acquired a formula for painting foliage, and especially the foliage of the oak, from seventeenth-century Holland. But the characters in his pictures, the ostlers, post-boys, farmhands, fishermen and gipsies, were drawn from the types who were his friends in real life (and thought him, in the words of one of them, 'as queer a file as any in England'). In spite of their roughness or lowly status, his style touched

them with something of eighteenth-century elegance. The children he painted had the special charm that artists of the time were so well able to convey (Plates 131, 137, 115 and 96).

The country offered a refuge from town creditors as well as a repertoire of subjects. One of Morland's escapes was to Leicestershire, where he went snipe and duck shooting and studied animals in the farmyards and stables. Another hiding place was the Isle of Wight, where he made paintings of shore and fisher folk in the last year of the century— though it was in London he died, sad to say, in a sponging-house in Cold Bath Fields.

A parallel life with his was that of Julius Caesar Ibbetson. Born at Farnley Moor, the son of a clothier in Leeds (Julius was a family name but 'Caesar' refers to the operation that attended his birth), he was apprenticed as a boy to a marine painter at Hull, applying paint to the exterior and interior of ships instead of making pictures of them. At the age of seventeen he ran away to London and gained the rudiments of art in working for picture restorers and fakers. The similarity of this early experience with Morland's is close, and it produced for a while a likeness of manner. They met and became close friends. In rural Kilburn and the surrounding area on the edge of London, Ibbetson composed pictures of rustic life not unlike Morland's. For example, in his *Anglers at the Alehouse* (private collection), the place can be identified as Mrs Reid's alehouse at Stonebridge Park, Willesden, the scene of Morland's *Alehouse Kitchen*. But Ibbetson's career was of wider geographical range than that of his friends. If the death of the Hon. Charles Cathcart had not put an end to his embassy to China, Ibbetson, the appointed draughtsman of the expedition, might have had a career in the East. As it was, he returned to make the picturesque tour of Wales as the artist-companion of Robert Fulke Greville. Although he spent difficult years in London in the period of the Napoleonic Wars, he contrived a Wordsworthian retreat to Ambleside in the early years of the nineteenth century, ending his days at the small manufacturing town of Masham in the North Riding of Yorkshire near Ripon.

The difference of ground also produced some difference of manner, which has its point to make on the evolution of ideas. According to the system of aesthetic appraisal devised by the Reverend William Gilpin, the 'picturesque' was essentially a diversity of form. This had two aspects: either the domestic—that is, the homely irregularity of domestic architecture and scene in southern England—or the sublime, as expressed in the exciting prospects of the Grand Tour, or the wilder prospects of Britain. The sublime aspect of the picturesque is conspicuously absent from the work of Morland, who favoured the flat and more placid counties, but it belongs to the subjects Ibbetson painted in Wales and the Lake District—Conway Castle by moonlight, for example, or the rushing waters of North Esk.

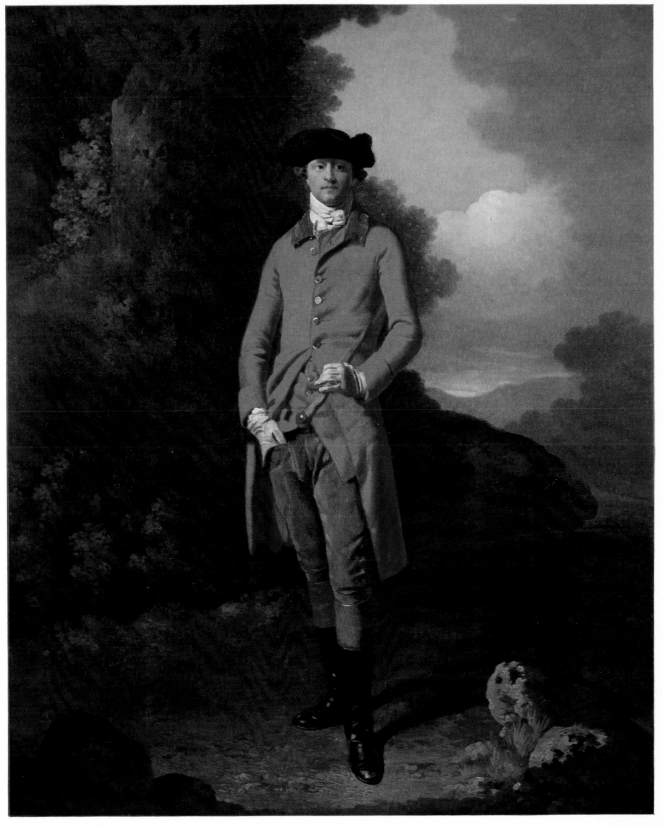

X FRANCIS WHEATLEY (1747–1801): *Lord Spencer Hamilton*. About 1778. Canvas, $30\frac{1}{8} \times 25$in. Windsor Castle. Reproduced by gracious permission of Her Majesty The Queen

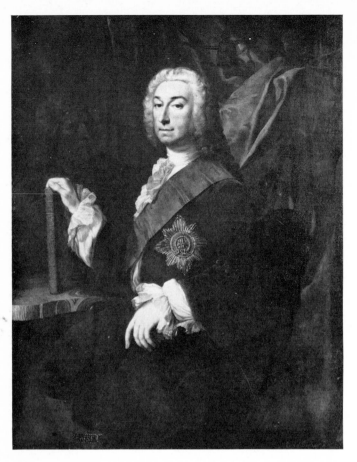

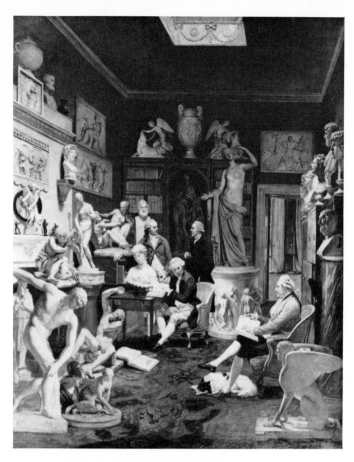

XI GEORGE KNAPTON (1698–1778): *The Third Earl of Burlington*. 1743. Derbyshire, Chatsworth

XII JOHANN ZOFFANY (1733/4–1810): *Charles Towneley*. 1790. Burnley, Towneley Hall

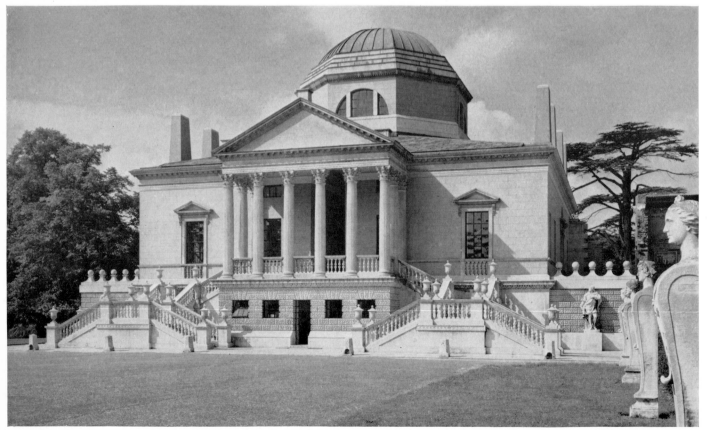

XIII
Chiswick Ho
London.
Designed by
Lord Burling
(1695–1753)
William Ke
(1685–1748)
about 1725

There is a transition to be seen at the end of the century towards the heightened form of emotional expression by which the 'romantic' may be distinguished from the 'picturesque'. Ibbetson gives an example in his *Phaeton in a Storm* (Leeds, City Art Gallery), the scene, of which he was an eye-witness, being made as dramatic as possible by the strange rock formations of the mountain road, the tense atmosphere of the thunderstorm, the excitement of the carriage horses and the hurried movements of the travellers to restore control. The picture is exceptional for him in its romantic interest.

James Ward (1769–1859), George Morland's brother-in-law, represents more vividly the growth of the romantic spirit—and something of the torture that was self-inflicted by those it possessed. The account of his disappointed and tormented career belongs substantially to the nineteenth century; yet it was in the Morland circle that he started out. As a boy, he had lessons in engraving from the celebrated mezzotint engraver, John Raphael Smith (1752–1812), the friend of Morland and Ibbetson. From 1783 he worked as engraver with his elder brother, William Ward, and then, with considerable success, took to painting farmyard animals in Morland's style. Ward developed a great contempt for his brother-in-law's art and a disapproval of his mode of life. The cottage idyll was beneath the notice of one with ambitions to paint vast allegories in the manner of Rubens. To convey violence, force and grandeur became his ruling purpose, but a monumental design to commemorate the battle of Waterloo was not the success he hoped, and he was condemned, as he put it, 'to be a mere Morland'. Even so, the temperamental difference appears: Ward illustrates the change from one period into another of altered complexion.

Painters who resembled Morland in the charm with which they were able to invest popular life were Henry Walton (1746–1813) and Francis Wheatley (1747–1801)—both in rural and metropolitan scenes (Plates 72, 73, 114 and 132). A market girl painted by Walton with her basket of eggs, or a group of milkmaids by Wheatley, still belongs to the rural utopia of the eighteenth-century artist. In the work of Walton especially it is possible to discern the beginnings of the picture with a simple story, which was to entertain the middle class of the following age.

5 The metropolitan scene

TWO MEN OF GENIUS working in London at the same time have left magnificent pictorial descriptions of the appearance and character of London towards the middle of the eighteenth century: Canaletto and Hogarth. Canaletto was essentially the visiting celebrity, well known to, and confident of, welcome and commissions from English patrons, and ready to paint the mansions of the nobility and the most distinguished aspects of the city. Not a hint of squalor, no taint of the smoke ascending from countless coal fires, disturbs the crystalline clarity of air or the dignity of architecture in his London views. From the surviving palaces along the Strand, with their spatial luxury of terraces and gardens, he could trace the great curve of the river towards St Paul's and the skyline, itself a work of art, of Wren's City churches beyond (Plate 25). He painted the fashionable milieu of Westminster, Whitehall and St James's Park. The Thames, then as much a traffic highway as the Grand Canal of his own Venice, was obviously his subject, and if the darting wherries were not as decorative as the gondola, they made up for this lack in numbers and movement, while an occasional gilded barge offered a passable substitute for the Venetian *bucentaur*. The calm objectivity with which Canaletto lauded London in a series of beautiful works extended to the elegant beings with whom he peopled his views in impeccable calligraphy of the brush.

This polite, ambassadorial approach was modified by William James (active in the middle of the century), who may have been an assistant to Canaletto and painted in a cruder version of his style, and Samuel Scott, who turned from marine painting to London views in the mid-1730s (Plates 28 and 29). Though he specialized in the same views of the Thames in the region of Westminster as Canaletto, Scott gave a more homely and intimate touch to his topography. But the contrast between the visiting and the native painter is most dramatically seen in a comparison with Hogarth.

London was Hogarth's universe, as satisfying to him and in as little need of being re-placed by more exotic sources of inspiration, as it was to Dr Johnson. Hogarth saw it completely, in grandeur and supposed grandeur, and in its miseries and brutalities. That he was at home in any part of it may be concluded from the variety of scenes to be found in his great series of pictorial dramas. He takes us from Tyburn Tree to St Mary Axe, from Southwark to Mary-le-Bone, from the fashionable West End to the rookeries of St Giles. The House of Commons and the halls of the City companies claimed no more of his attention than the dreadful interior of 'Bedlam', with its pathetically de-mented inmates, and the horrors of the Fleet prison. A garret in Long Acre was de-picted as carefully as the *salon* in Arlington Street, which is said to have provided the luxurious background of the second episode of *Marriage à la Mode*.

Unlike the foreign artist, who chose his locale with an eye to what was most pleasing and likely to please, Hogarth could depict such a scene of metropolitan ruin as that of

his *Gin Lane*, with the steeple of Hawksmoor's St George's, Bloomsbury, overlooking architectural and human decay. He made use of that freedom of expression which a refugee from Continental censorship, such as Voltaire, was so amazed to discover in England. If George II was angered, as is alleged, by the pointed absence of martial discipline in Hogarth's *March of the Guards towards Scotland in the Year 1745* (Plates 19 and 20), he could neither consign the painter to a dungeon nor inflict dire penalties for the pique that led Hogarth to dedicate the engraving of the picture to the King of Prussia!

Perhaps too much has been made of Hogarth's didactic intentions. His morality, contained in the simple propositions that virtue is likely to be rewarded and vice punished, that the industrious succeed and the idle come to a bad end, was certainly firmly on the side of what was proper and prudent; but it can also be seen as a simple dramatic convention that enabled him to reflect the fullness of London life. As other artists have done (Dickens is a later example in literature), Hogarth painted with especial gusto the very scenes that he must have meant to be particularly deplorable, such as the folly of the rake in his cups among the hussies at the Rose Tavern in Drury Lane, or the explosive alliance of orgiastic indulgence, bribery and corruption, with concomitant violence and fury, that marks the *Election* series (Plate VIII). These canvases are so full of tumult as to create, in the spectator's mind, the sensation of a burst of sound in the monastic silence of the Sir John Soane's Museum where they now hang.

Poverty, brutality (as much characteristic of the law as of the lawless), ignorance and crime grew apace in a city unprepared for the population explosion that was under way. But by the mid-century, the number of reforms and improvements launched by energetic and philanthropic individuals would have dispelled any contention that the disorders and shortcomings of society were generally viewed with a cynical indifference. There was John Howard, whose agitation for prison reform secured the abolition of the system whereby gaolers extorted payment from the prisoners, and compelled other changes for the better, especially in sanitation (Plate 141). General Oglethorpe offered the ruined debtor hope of a new life in Georgia; John Wesley and George Whitefield launched their religious revivals (Plate 83). Popular education had a fresh start with the charity schools, and hospitals and dispensaries began their care for public health. It might even be said that the cult of sentiment and the ennoblement of the simple life—so characteristic of thought in the second half of the eighteenth century, as the Age of Reason merged into the romantic era—made charity not only morally satisfying but also aesthetically and socially fashionable. Bigg's *Charitable Lady* (Plate 113) is a minor example of a trend that finds comparable expression in the sentimentalized rusticity of Opie's *Peasant's Family* (Plate 115) or Gainsborough's *Cottage Girl with Dog and Pitcher* (Plate 116).

Hogarth was as active a participant in this new philanthropy as a painter could be. Elected a governor of St Bartholomew's Hospital in 1734, he decorated the great staircase with religious scenes, perhaps in the hope of encouraging a school of history painting. Five years later he attended the meeting that brought the Foundling Hospital into being and became the close friend and loyal supporter of Captain Thomas Coram (Plates 11 and 13), the mariner and shipwright who initiated this plan for taking care of unwanted children.

The process by which the philanthropic foundation became an art centre, also in a quite modern sense of the term, was an extraordinary and influential development. Hogarth's great portrait of Coram was an early (1740) gift to the Hospital. The winning ticket among the unsold tickets for his lottery, which Hogarth presented to the Hospital, secured his masterpiece *The March of the Guards* (Plate 19). In 1746 he added one of the most successful of his ventures into history painting: *Moses brought before Pharaoh's Daughter*.

Hogarth's example was promptly followed by the portrait painter Thomas Hudson (1701–79), with a portrait of Theodore Jacobson, architect of the Hospital; Joseph Highmore, doing his best with an unwonted Biblical subject, *Hagar and Ishmael*; Richard Wilson, with views of St George's Hospital and the Foundling Hospital; and Francis Hayman, with *The Finding of the Infant Moses in the Bulrushes*. Gainsborough in 1748 contributed his delightful roundel of the Charterhouse, while Allan Ramsay provided his portrait of the famous Dr Mead, George 11's physician and a governor of the Hospital (whom Watteau came to London to consult). Sir Joshua Reynolds painted his portrait of the Earl of Dartmouth, vice president, and Charles Brooking (1723–59) is said to have painted his largest sea piece at the Hospital in eighteen days.

In the space of some twenty years the cream of the nation's talent in painting was represented in the building in Lamb's Conduit Fields. The home for foundlings became the resort of fashionable society, which flocked to see the assembled works of art. Music had its place also in the impromptu art centre. Handel presented the organ in the chapel and annually gave performances of his oratorios in aid of the Hospital. This unique example of artists cooperating in a good cause was not without its influence in purely aesthetic terms. After the Foundling Hospital experiment, it became easier, because it was self-evidently reasonable, to expand the conception of an academy as a training-ground, so as to include an annual exhibition of artists' work. The Society of Artists, which acted as an exhibiting group from 1760 to 1768, was followed and superseded by the Royal Academy, of which three founding members, Reynolds, Wilson and Hayman, were governors of the Foundling Hospital. For the rest of the eighteenth century, indeed until the 1860s, the Academy exhibitions were to comprise practically

all that was important in British painting in the sense of the 'considered' work intended for public showing.

Hogarth, consistent in his sturdy individualism, even though he had played a part in the embryonic teaching academy in St Martin's Lane, had been against forming an official body of artists; nor would he have been likely to concur in the canons of appreciation and criticism that Reynolds, as first president of the Royal Academy, set out in his *Discourses*, especially in his strictures on works 'which depend for their existence on particular customs and habits'. It was Hogarth's individual view of such customs and habits that made his picture of society unique.

He had 'no school', said John Constable of Hogarth, 'nor has he ever been imitated with any tolerable success'. The remark, however, requires qualifying: Hogarth was virtually the founder of the school of conversation-piece painters; and although no oil painter could emulate his panorama of the metropolitan scene, the independent outlook and the determination to be free and outspoken were to be found in others. Thomas Rowlandson (1756–1827) and James Gillray (1756–1815) come immediately to mind. They differ from Hogarth in the medium they used and in traits of character, but in all three there was the spirit of the independent Briton.

With a lighter, more humorous touch than Hogarth, and without the least evidence of a moralistic purpose, Rowlandson had an even wider social range. With a delicacy of line and colour that rebuts the accusation that he was merely a coarse caricaturist, he depicted the countryside and its inhabitants, the village green, the market town and its inns, the river and seashore, the rural sports and diversions. Yet he was essentially a metropolitan character, and the fashionable rendezvous he frequented, the coffee-houses and gaming clubs, the markets (from Rag Fair to Smithfield), Vauxhall and its pleasure-seekers, the theatres, the docks and riverside taverns—all provided the subjects for his brilliantly animated panorama.

The social satire of Hogarth turned with Gillray into unbridled ferocity, freedom of expression run wild. He infused his savage scorn into his view of events at home and abroad (Plates xx and xxiii); he was venomous even in picturing George III eating a boiled egg at breakfast, vitriolic over the rural idyll of Morland, the taste of the late eighteenth century for the Gothic novel or Alderman Boydell's Shakespeare Gallery. He turned the John Bull character of Dr Arbuthnot's mild satire into a peculiar national hero—dropsical, dishevelled, malicious, guzzling—whom the Victorian caricaturists replaced by the dignified image of a farmer-squire of handsome countenance and high principles. Like the engravings of Hogarth, the coloured etchings of Gillray circumvented the connoisseur world. Exhibited in the bow window of Miss Humphrey's print shop at 27 St James's Street, they elicited the sniggers and guffaws of the populace.

They are related to the painting of the century in their illustration of an attitude, the free spirit which had enabled Hogarth and Wilson to consolidate their independent place—though displayed by Gillray in a cantankerous and exaggerated form.

The contemporary genre, portrayed by painters of a milder temper that suited the rising middle class, has its presage of the Victorian moral theme. Edward Penny (1714–91) in 1774 contrasted the lot of *The Virtuous comforted by Sympathy and Attention* (Plate 70) with that of *The Profligate punished by Neglect and Contempt* (Plate 71), the companion pictures dealing out praise and reproof in a style reminiscent of Jean-Baptiste Greuze (1725–1805). John Opie (1761–1807), though best known as a portrait painter of the generation following Gainsborough, Reynolds and Romney, displayed a talent for homely genre in such a painting as *The Village School* of 1784 (Wantage, Loyd Collection) that anticipated the work of Sir David Wilkie (1785–1841). Henry Walton and Francis Wheatley also foreshadow the nineteenth-century middle-class taste, and they were able to invest their scenes with the same charm as their rural pictures (Plates 114 and 132).

6 Artists at sea and in distant lands

THERE ARE MANY PAINTINGS of the eighteenth century that show no consciousness of a world outside Britain. The patrician men and women of the portraits, posed with graceful ease and in company with their handsome and healthy children, seem the inhabitants of an insular Elysium (Plates 121, 132, 138 and 142). The parklands where trees and water were so carefully composed, and the golden cornfields, knew nothing of infection and the hand of war. Hogarth's electioneers could roister in freedom from outside threat. Yet it was not a mere accident that caused Hogarth to be arrested as a spy while sketching at Calais in 1748; the nations were committed to war.

In spite of the previous artificial alliance and the peace kept so long by Walpole, France and Britain were drawn into the worldwide battle for trade and colonial possessions. On the Continent the Seven Years War (1756–63) was as complex and inconclusive as most European conflicts had been. For Britain, on the other hand, there were the decisive gains of maritime supremacy, an Indian empire and the vast territory in North America. The rise and importance of sea power made for the continuance of ship portraiture and the paintings of naval engagements that had developed in the previous century during the rivalry with the Dutch. The spirit of discovery was also aroused, and after the martial triumphs came the peaceable opening of a new world by Captain Cook in his crossing of the Pacific and discovery of Australia and New Zealand. The process of discovery by Cook's and other expeditions required record by accompanying artists (Plates 66 and 67).

An early link between the Dutch and British marine schools was Willem van de Velde the Younger (1633–1707), born in Leyden and trained by his father, Willem the Elder (1611–93), in Amsterdam. Both worked in England after 1672 and the younger van de Velde died at Greenwich in 1707. He had English followers in Peter Monamy (about 1690–1749), a self-taught painter who closely imitated the Dutch style, and Samuel Scott, who painted ships and sea battles until about 1735, when he turned to his views of London.

An artist of considerable powers was Charles Brooking, in whose paintings there appears a new feeling for the drama of nature and the movement of sky and sea, as well as the portrayal of the ship as an object or instrument of war (Plate 24). Brooking is said to have given some assistance to Dominic Serres (1722–93), who continued the marine tradition and by reason of an adventurous career was acquainted with the sea and ships in every aspect. A Gascon by birth, who ran away to sea, Serres had become master of a vessel trading with the West Indies when he was taken prisoner and brought to England. He accommodated himself with remarkable ease to the change of circumstances. Serres was a founding member of the Royal Academy in 1768, and was appointed Marine Painter to George III, a post in which he was succeeded by his son,

John Thomas Serres (1759–1825), who painted sea battles of the Napoleonic Wars as well as a number of scenes of the Thames (Plate 151).

The most distinguished of the expeditionary artists was William Hodges, Richard Wilson's pupil, who in 1772 went as Captain Cook's draughtsman on his second voyage around the world and reconciled the novelties of the Tahitian scenery with the existing style appropriate to picturesque landscape (Plates 66 and 67). On his third and last voyage, in 1776, Captain Cook was accompanied by John Webber (about 1750–93), son of a Swiss sculptor but born in London. Webber was a witness of the explorer's death at the hands of pilfering natives in Hawaii and made a drawing of the event, which was turned into a print by the engravers Byrne and Bartolozzi.

It was not discovery, but the tempting prospect of fresh patronage that drew a number of British artists to India. Hodges went there at the invitation of Warren Hastings in 1780. His account of the generous treatment he had received during his stay of four years persuaded Zoffany to apply to the East India Company for a passage to India. 'He expects to roll in gold dust', remarked Paul Sandby somewhat acidly when he heard this news. Zoffany was not alone in expecting lavish reward from East India Company nabobs and native princes (see Plates 139 and 140). First in the field was the portrait painter Tilly Kettle (1735–86), who set out in 1769 and stayed in India for seven years. Zoffany stayed from 1783 to 1789. Arthur William Devis (1763–1822), the son of the conversation-piece painter Arthur Devis, was among several other painters who visited India, where he spent ten years. There was a demand for miniatures on ivory, and the celebrated practitioner Ozias Humphry (1742–1810) had many commissions at Calcutta and Lucknow. Landscape was in less demand, but Hodges, Thomas Daniell (1749–1840) and the latter's nephew, William Daniell (1769–1837), found much to occupy them in views of cities, architectural monuments and scenery which they saw with eyes conditioned by the English picturesque. The Daniells—William having been first taken to India by his uncle at the age of fourteen—travelled extensively and adventurously from north to south, up the Ganges towards the Himalayas and from Madras to Ceylon. From 1786 to 1792 they were very productive. Apart from Indian views exhibited at the Royal Academy, a handsome outcome of their tours was their aquatinted *Oriental Scenery* in six volumes, completed in 1808.

There is always an element of difficulty in assessing specialist forms of painting, as it is necessary to make the distinction between a merely documentary value and the imaginative perception that belongs to the true work of art. They are not bound to be mutually exclusive, however. The specializations of the great age in Britain have been too rigorously segregated from the main creative stream by critical classification. This certainly applies to the marine painting of the time. Brooking, for example, stands out as

an artist who always had a sense of the exciting relationship and encounters of man with the elements, and in this respect he may be regarded as the worthy ancestor of Turner. The Daniells have likewise been criticized, not only in being topographical but in their choice of unfamiliar and exotic ground. Yet it was their merit to create a romantic image of tropical luxuriance where none had existed before.

The portrait painters in India perhaps claim less interest. There were some of minor rank who looked for a less competitive sphere of operations than was to be found amid the brilliant talents of London. Few gave more than perfunctory attention to the character of the people. Arthur William Devis painted *The Reception of the Sons of Tipu* with all the unreality of a scene from classical history in the manner of Benjamin West (1738–1820). Zoffany was in most ways more at home at Albemarle Street in London than in painting businessmen in Calcutta with their Hindu clients, or attempting to picture a tiger hunt with elephants.

What a difference the imaginative perception of genius could make in the rendering of the unfamiliar is shown by George Stubbs, to whom British expansion and discovery overseas brought a number of commissions to paint wild animals. His *Cheetah with two Indians* (Plates 47 and 64) adds to its superb realization of animal form, human portraits in which the gestures and expressions of another race are conveyed with an understanding no European painter has excelled. If Stubbs had spent years in India instead of remaining quietly in England he could not have achieved more authenticity. Other animals new to England were painted by Stubbs with equal skill. They included the Indian rhinoceros portrayed for the surgeon John Hunter, and the kangaroo brought back from Australia by Joseph Banks on Captain Cook's *Endeavour*. According to the miniaturist Humphry, Stubbs broke his journey home from his unfruitful visit to Italy at Ceuta, in Morocco, and there saw a horse attacked by a lion, the subject that was to haunt his imagination many times (Plates 81 and 82). But it seems more likely that the scene of the lion springing on the horse and tearing at its neck was in fact suggested by an ancient bronze Stubbs could have seen in Rome. The theme had been copied by Renaissance sculptors and became popular again with the romantic urge towards violence in the early nineteenth century. It reveals a romantic aspect of Stubbs's imagination.

7 Works of imagination

EVERY GIFTED PAINTER of the great age felt the wish to excel in some other way than by satisfying the demand for portraits. History painting, which involved a Biblical or classical subject, was traditionally regarded in Europe as the highest branch of art. There had never been any great call for it from English painters, however, and in the eighteenth century it proved one of their most difficult fields of experiment. In decorating the wall of the great staircase at St Bartholomew's Hospital with large mural paintings at his own expense, Hogarth had the idea of encouraging a national school of history painters, continuing the work of his father-in-law, Sir James Thornhill. With this thought in mind he induced his friends Highmore and Hayman to add histories to his own *Moses brought to Pharaoh's Daughter* at the Foundling Hospital.

Hogarth's *Pool of Bethesda* and *Good Samaritan* at St Bartholomew's (1735–6), *Paul before Felix* at Lincoln's Inn (1748) and the Foundling work (1746) are of interest now as decorative period pieces. One of their chief shortcomings is that they are derivative, borrowing from Murillo and the cartoons of Raphael, and quite lack the conviction and vigour of the great series inspired by his London world. One of Hogarth's last easel pictures was the much derided *Sigismonda* (1759; London, Tate Gallery), a subject from Boccaccio, who describes Sigismonda weeping over the heart of her lover Guiscardo. It was painted in rivalry with a work of the same subject, then optimistically supposed to be by Correggio. The picture deserved better treatment than the ridicule that long pursued it, yet this work also is secondary to the masterpieces of Hogarth on his own ground and in his own style.

History painting was as distant from Sir Joshua Reynolds's natural bent as from that of Hogarth and—as far as it represented the 'grand style', that standard of the highest art which was the main theme of his *Discourses*—indicates a discrepancy between Reynolds's theory and practice. The principles he set out so lucidly, on the need to generalize and to avoid the accidents and particularities of either nature or fashion— apt in reference to a fresco of the Italian Renaissance—had less relevance to the work of an English painter. From the study of Titian, Rembrandt and Rubens, he acquired his particular richness of colour and dignity of style, but of Michelangelo, who was never out of his thoughts, there is no fundamental trace in his work. The 'grand style' resolves with him into the theatrical pose of *Sarah Siddons as the Tragic Muse* (Plate 101) or the playfulness of *Three Ladies adorning a Term of Hymen* (1773; London, Tate Gallery).

Less anxiously concerned than either Hogarth or Reynolds with the European traditions of imaginative art, Gainsborough, who, according to his friend Jackson, always considered history paintings as 'out of his way and thought that he should make himself ridiculous by attempting it', was able to give his imagination free rein in what he called his 'fancy pictures' (Plate 116). They were aptly so called in that he was

'fancy free' in their conception. Anonymous peasants, rustic lovers and shadowy boat-men peopled that imaginary land and its shores, which were the beautiful inventions of his later years. Though his last picture, unfinished when he died in 1788, so far acknowledged the tradition of the classical subject as to bear the title *Diana and Actaeon* (Plate 112), this is of small significance compared with the rhythmic relation of a group of nude figures with a setting of landscape and the freedom and spontaneity prevailing throughout. Gainsborough in his imaginative work of the 1770s and 1780s produced some of the century's most original achievements.

Of complex interest was the development of Benjamin West. Born of a Quaker family in colonial America, near Philadelphia, he worked there as a young sign and portrait painter, and at the age of twenty-one was able to study further in Europe. After four years in Italy he visited London, intending to return to America, but was so well received that he stayed. He was favoured by George III, became famous and popular, and in 1768 was a founder member of the Royal Academy, where he was president, after Reynolds, for thirty years.

Rome, when West was there, was the centre of neoclassicism, the revival of an ancient purity of form, of an austere classical grandeur. This interest in the classical was preached by the German scholar, Johann Joachim Winckelmann (1717–68), and by mid-century was already practised by the Scottish painter, archaeologist and dealer in antiquities, Gavin Hamilton (1723–98). West quickly assimilated the style and his *Return of the Prodigal Son*, made to look like an antique relief and painted for the Bishop of Worcester, led to a commission for *The Departure of Regulus* (Royal Collection) from the King, who was to acquire many more of his works over the years. It is less significant that West achieved the feat of making the neoclassic history painting popular in England, than the fact that he sounded the death-knell of the genre with *The Death of Wolfe* (Plate 68). This painting was historical but not 'history', and as faithful as the artist could make it to a recent event. West is quoted by his biographer, Galt, as saying that Reynolds urged him 'to adopt the costume of antiquity as more becoming the greatness of my subject than the modern garb of European warriors. I answered that the event to be commemorated happened in the year 1758 [*sic*], in a region of the world unknown to the Greeks and Romans . . .' Reynolds seems to have been convinced, if not by the argument, at least by the picture itself.

The Death of Wolfe was a landmark and it is because of this work, rather than because of the production of masterpieces, that West is of note. After his introduction into England of neoclassicism and then of historical realism, he was to give still another sign of the century's progress of ideas in his *Death on a pale Horse*, an early product of romanti-cism in art. West befriended so many American artists in London through material

help or advice, especially in the period of difficult relationships and divided loyalties of the War of Independence of 1776–83, that his studio, it has been said, was the first effective American art school.

The outstanding portrait painter Gilbert Stuart (1755–1828) was one of those he helped, enabling Stuart between 1777 and 1787 to compete in London with the established portrait masters. He also aided John Singleton Copley (1738–1815), previously a portrait painter in Boston, to establish himself in London in 1775. The example of West led Copley to add paintings of contemporary history to his portraiture, and in this genre he showed a fire and a faculty for animating a crowded composition that assign him a place of special respect. Though the scenes had to be reconstructed with the help of the imagination, the main characters in *The Death of Chatham* (1779–80; London, Tate Gallery, on loan to the National Portrait Gallery), *The Death of Major Pierson* (1783; Plates 76 and 77) and *The Siege and Relief of Gibraltar* (Plates 127 and 128), three major works, were all portraits. The portrait element in no way diminished the force of his paintings, which showed an exceptional power.

Shakespearian drama offered an alternative to, or equivalent of, the history picture that gained increasing favour as the century went on, corresponding to the respect that was growing at the same time for Shakespeare's genius. Some painters took their lead from stage performances of the plays, and especially the scenes in which David Garrick was the outstanding actor. The numerous portraits of Garrick testify to his popularity with his painter contemporaries, and this extended to his stage appearances. In 1746 Hogarth painted Garrick in the tent scene as Richard III (Liverpool, Walker Art Gallery) at the dramatic point when he electrified his audience by the sudden convulsion of horror with which he acted Richard's start from his dream. A young Swiss, Heinrich Füssli (1741–1825), whose name was later anglicized to Henry Fuseli, was earning his living in London in the 1760s with translations and illustrations, and frequented the theatre to improve his English. He, too, was fascinated by Garrick, drawing him and Mrs Pritchard in *Macbeth* in the scene of terror (Act II, Scene II), which was painted by Zoffany at about the same time.

More inviting to a free interpretation of Shakespeare was the scheme promoted by the publisher and engraver John Boydell in 1787 to employ the country's best artists in Shakespearian themes. The larger aim, defined in the catalogue of 1789, when the Shakespeare Gallery was opened in Pall Mall, was to foster 'an English School of Historical Painting'. Yet the painters were at their best when least bound by the formal tradition. Sir Joshua Reynolds's *Death of Cardinal Beaufort* (*Henry VI*) was a learned exercise in the manner of Poussin; but a picture to arouse a more lively response was Reynolds's conception of Puck, which had nothing of the 'grand style' about it, but the

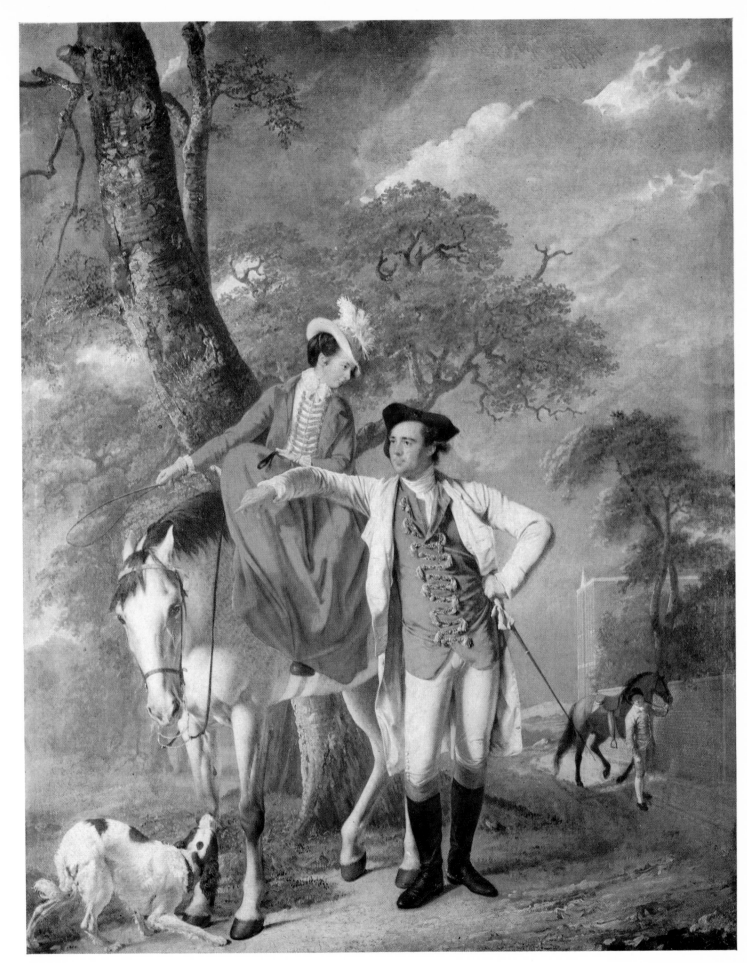

XIV JOSEPH WRIGHT OF DERBY (1734–97): *Mr and Mrs Thomas Coltman*. About 1769–73. Canvas, 50 ×40in. Private Collection

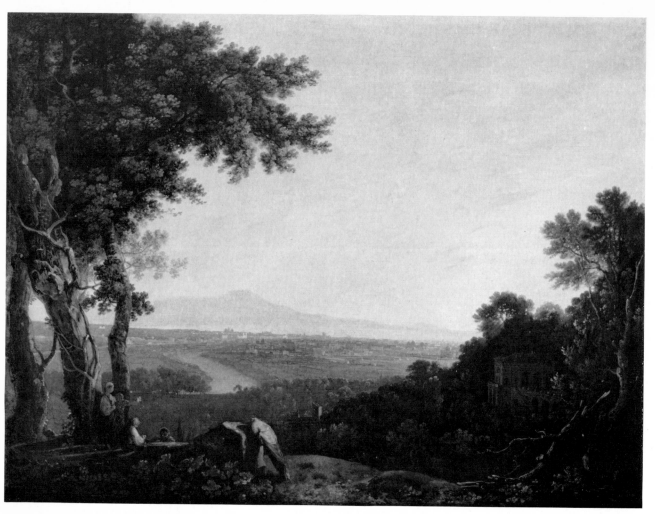

XV
RICHARD WILSON
(1714–82): *A distant
View of Rome from
Monte Mario*. About
1753. Canvas,
$39\frac{1}{2} \times 53\frac{1}{4}$in. Ottawa
The National
Gallery of Canada

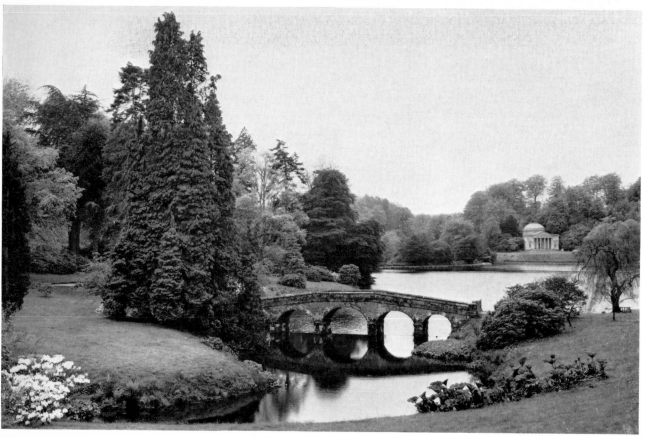

XVI
Stourhead, Wiltshire.
A view of the lake
and gardens with
a pantheon in the
distance

XVII WILLIAM HOGARTH (1697–1764): *David Garrick with his Wife*. 1757. Canvas, $52\frac{1}{4} \times 41$in. Windsor Castle. Reproduced by gracious permission of Her Majesty The Queen

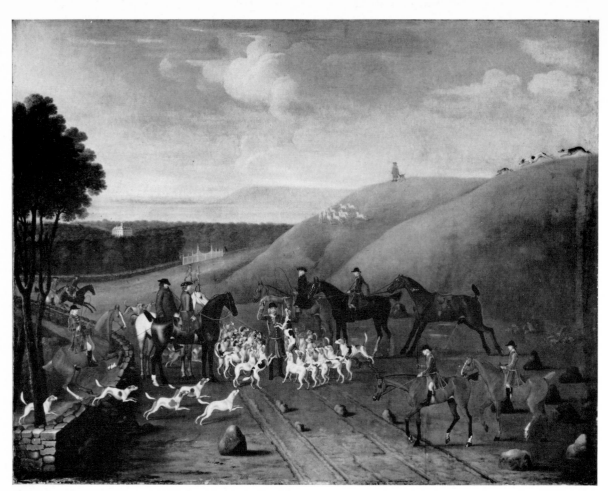

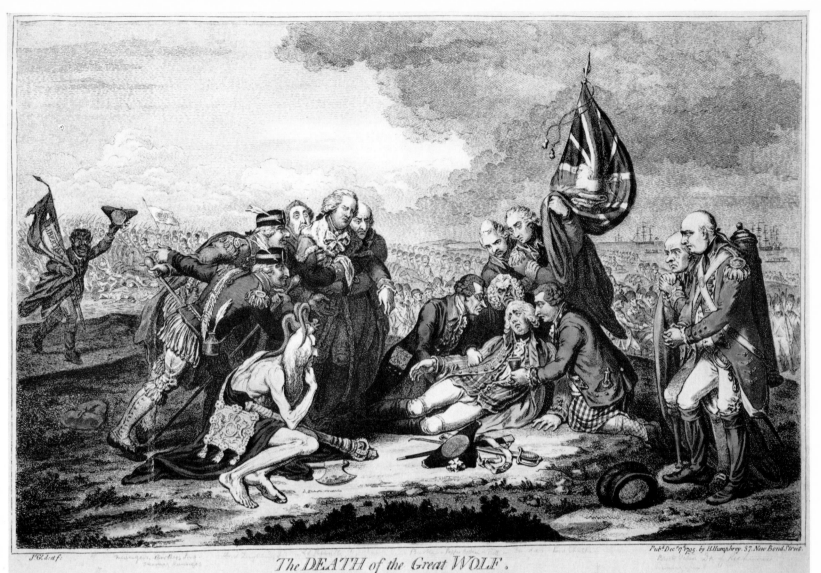

The DEATH of the Great WOLF.

_____ "We have overcome all Opposition!__ exclaimed the Messengers. __ 'I'm satisfied."__ said the Dying Hero, & Expired in the Moment of Victory.

To Beny. West Esq.r President of the Royal Academy, this attempt to Emulate the Beauties of his unequall'd Picture of the Death of Gen.l Wolfe, is most respectfully submitted, by the Author.

XX JAMES GILLRAY (1756–1815): *The Death of the Great Wolf.* 17 December 1795. A parody of Benjamin West's *Death of Wolfe* (Plate 68), it shows William Pitt 'expiring' (politically) at the moment of victory. Victory refers to the passage the next day of the Treason and Sedition Bills

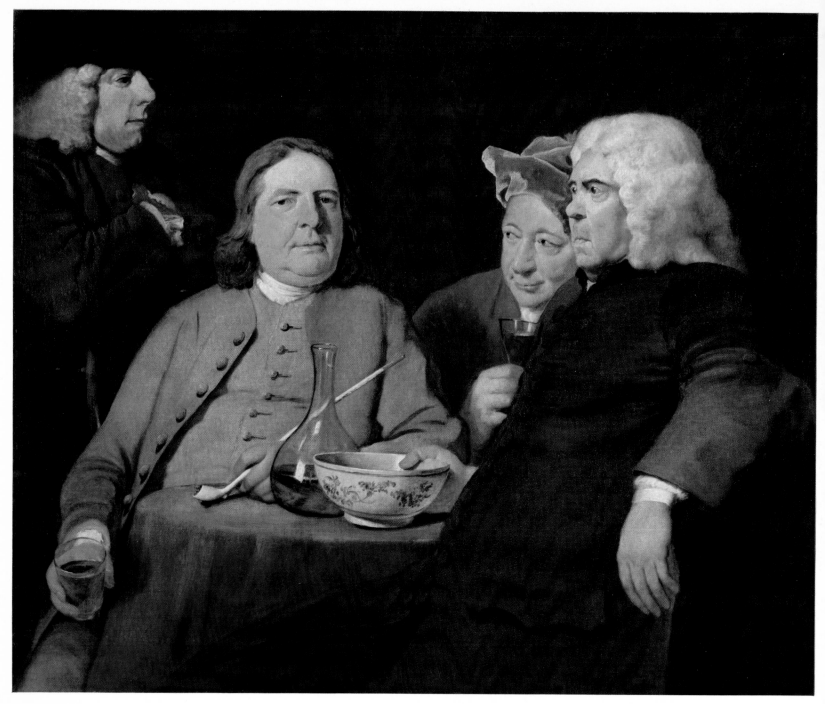

XXI JOSEPH HIGHMORE (1692–1780): *Mr Oldham and his Guests*. About 1740–50. Canvas, 41½ × 51in. London, Tate Gallery

XXIII (*right*)

JAMES GILLRAY (1756–1815): *A Peep at Christies; —or—Tally-ho and his Nimeney-pimmeney taking the Morning Lounge*. 24 September 1796. Elizabeth Farren, the actress (see Plate XXIV), is shown paying a visit to Christie's with the Earl of Derby (whose wife she later became). One of her great roles was as Nimeney-Pimeny in General Burgoyne's *The Heiress* (1786).

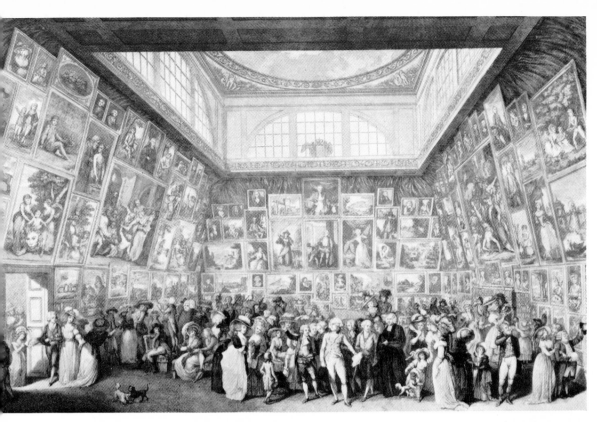

XXII PIETRO ANTONIO
MARTINI (1738–97):
*The Exhibition of the
Royal Academy at
Somerset House, 1787.*
Engraving after John
Henry Ramberg.
Sir Joshua Reynolds is
shown escorting the
Prince of Wales

XXIV (*below*)
SIR THOMAS LAWRENCE
(1769–1830): *Elizabeth
Farren, Countess of Derby.*
1790. Canvas, 94 ×57½in.
New York, The
Metropolitan Museum of
Art, Bequest of Edward
S. Harkness, 1940

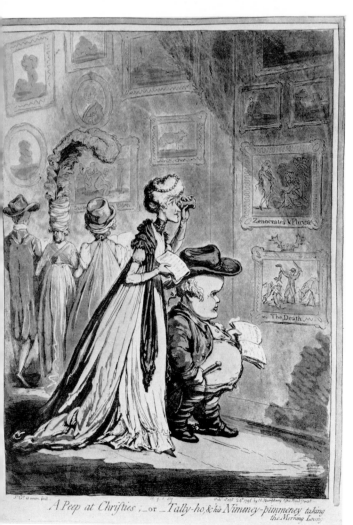

*A Peep at Christies;—or—Tally-ho, & his Nimeny-pimmeney taking
the Morning Lounge*

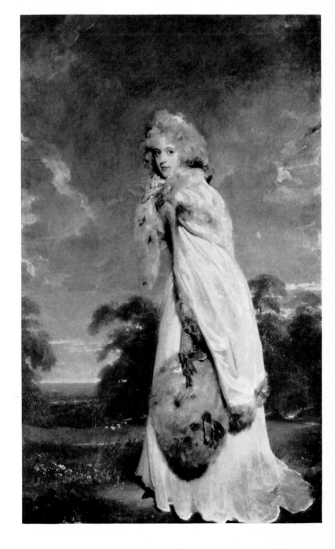

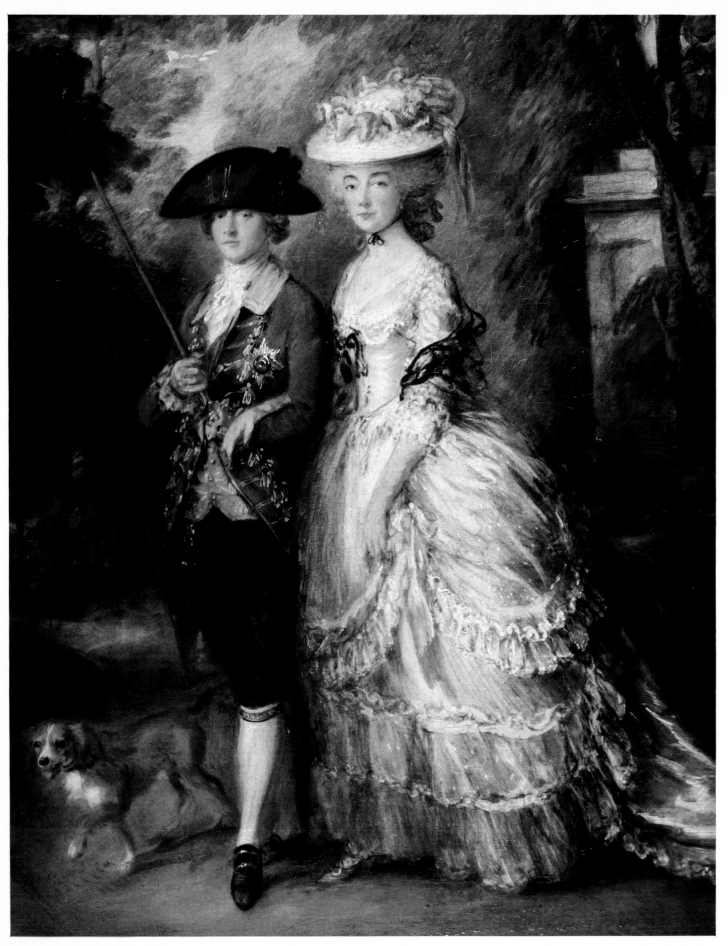

XXV THOMAS GAINSBOROUGH (1727–88): *The Duke and Duchess of Cumberland (detail)*. About 1785–8.
Canvas, 64½×49in. Windsor Castle. Reproduced by gracious permission of Her Majesty The Queen

understanding of childhood that his portraits always display, with a deft addition of elvish malice (the original picture, which was shown at the Royal Academy in 1789, is in the collection of the Earl Fitzwilliam at Milton Park).

Shakespeare inclined the painters to conceptions of mystery, wonder and emotionalism, rather than the rational calm, the refrigerated passion, of the histories of the European past. This was the effect on Fuseli, simmering between 1770 and 1779. They were years spent in Italy studying the work of Michelangelo, with less influence on Fuseli's own work than he believed it to have. His sources were literary in the main, from Teutonic folk legend to Dante and Shakespeare. The processes of the mind interested him more than the beauty of art. Fuseli was the first artist to attempt an evocation of the dream state in his *Nightmare* of 1782, and his contributions to the Shakespeare Gallery, no longer stage scenes with actors in their parts, were creations of a mood. *A Midsummer Night's Dream* (Plate 130) gave him licence to picture such a swarm of sprites and goblins at Titania's court as Shakespeare had not attempted to particularize.

For Fuseli, the Shakespearian 'dream' was indeed a dream—a suspension of reality. There are other pictures produced towards the end of the century besides those inspired by Shakespeare: interiors peopled with beings of a strange elegance and with monstrous headdresses, which seem, in dream fashion, to be symbols, standing for something other than their ostensible purport, which may have lain concealed in some hidden mental stratum.

It is perhaps accurate enough to regard Fuseli as a romantic, one of those artists in whom there was a reaction against the self-satisfaction of the century, the observance of classical rules, and the rational view and way of life. This reaction was to reach one of its extreme points in Fuseli's friend William Blake (1757–1827), who seemed unrelated to the eighteenth century except in a hearty dislike of all that Reynolds stood for. As this trend of thought and emotion grew, it bred in some an inner duality and war of ideas.

An example is afforded by John Hamilton Mortimer (1740–79), a pupil of Thomas Hudson, who stood out even in that great decade of portraiture, the 1760s, as an exceptionally brilliant young practitioner of the art. In both single portraits and conversation pieces he expressed with an admirable realism the calm and decorum of polite contemporary society. It is not surprising, perhaps, that an ambitious young artist should also have his fling at such history subjects as St Paul preaching to the ancient Britons and Caius Marius on the ruins of Carthage. What makes him a stranger psychological study is the macabre element that invaded his work. Not only, like Benjamin West, did he give his grim vision from the Book of Revelation of *Death on a pale Horse*, his love of what his biographer Cunningham termed 'the wild, the savage and the wonderful'

took varied forms. The agonies of captives and of Caliban and Lear; scenes of magic and incantation (approved by Horace Walpole in his capacity as a connoisseur of horror and inventor of the supernatural machinery of *The Castle of Otranto*); the battles of monsters and the banditti borrowed from Salvator Rosa (Plate 89), symbols of freedom and defiance—all bore witness to disquiet. A self-portrait in the 1770s with its air of defiant determination seems a first projection of the romantic outlaw-hero that Byron was to popularize in a later generation.

The career of George Romney is an even more striking instance of the same duality. The provincial portrait painter who took London by storm and in the 1770s rivalled Reynolds in celebrity, could be admired for his realistic vision and such skill as brings his *Beaumont Family* (1777–9; London, Tate Gallery) so convincingly to life. Yet in Romney there was also the romantic who aspired to the sublime, was made restless in ambition by a visit to Italy, and pictured Lady Hamilton (Plate 100), on whom he doted as the prospective heroine of many mythologies and allegories that remained only projects. With his professional skill in portraiture and his reverence for classical art, Romney had his share of the growing taste for the weird, the violent and the terrible, fostered not only by Shakespeare but also by Macpherson's *Ossian* and Gray's *Descent of Odin*. Numerous grotesque drawings show a side of his work in which there is a parallel with Fuseli and Mortimer.

The desire for more emotional expression caused a number of artists, Romney and James Barry (1741–1806) included, to take *King Lear* as their subject (Plate 123). Fuseli's pupil, John Runciman (1744–68), gives a singular illustration of how the emotional atmosphere of the drama might be made visible in his *King Lear in the Storm* (1767; Edinburgh, National Gallery of Scotland). Runciman took it on himself to place Shakespeare's 'heath' on the edge of the sea, but the furious waves breaking close to the figures convey the tempest of feeling that assails Lear, rather than a geographical shore.

8 Change of mood and end of an era

AN INTRICATE PATTERN of change can be traced in the painting of the later eighteenth century, in some degree reflecting the political and social revolutions of the time. The first stage of industrial revolution was by then under way in northern England and Scotland, though as yet with no marked effect on the capitals. Edinburgh shared in the prosperity that industry and trade brought to Scotland in the reign of George III, but her golden age is defined by the non-industrial culture of philosophers, historians and legal luminaries, and of estate owners in the surrounding region bent on the improvement of agriculture—the distinguished society which Raeburn began to portray in the 1780s.

In both Edinburgh and London the genius of Robert Adam (1728–92) added districts of classical elegance. No hint of altered circumstances disturbs the London of the Literary Club and the exclusive worlds of fashion and letters painted by Reynolds and Gainsborough. But in the work of a provincial painter, Joseph Wright of Derby (1734–97), there come into view the signs of an industrial age in the making. It was a period still of experiment and inquiry of an intellectual kind, not yet of ruthless economics. Wright portrayed the heroes of the middle-class élite in applied science, and the Leonardesque spirit of their inquiries is conveyed in two of his best-known pictures, *A Philosopher giving a Lecture on the Orrery* (about 1763–5; Derby Art Gallery), and the *Experiment with the Air Pump* (Plates 57, 60 and 61). These were works of the decade when James Watt was perfecting the steam-engine as a practical means of transport; when Richard Arkwright was building his first spinning-mills; and when Josiah Wedgwood was adapting the production of pottery to the needs of a vastly increased population.

Wright made impressive use of artificial light as the illumination appropriate to his scientific themes. His *Iron Forge* (Broadlands, Mountbatten Collection), with its glowing bar of metal, was like a forecast of mighty changes to come. Every source of fiery energy seemed to delight him, whether natural or man-made: Vesuvius in eruption (seen on his journey to Italy in 1774), a firework display in Rome, and a blast furnace. In this there was a romantic as well as a scientific element. Lamplight and moonlight had the alternative suggestion of mystery, as when he painted a night-time academy grouped around a classical statue, or the tomb of Vergil under the light of the moon. The romantic spirit declared itself, as it did in his friend Mortimer, in paintings of banditti after the style of Salvator Rosa, lurking in the seaside grottoes of the Gulf of Naples (Plate 88).

There was the atmosphere of impending revolution in a less pacific sense. If the acquisition of a great empire in the 1760s seems astonishing, no less so is the way in which a principal part of it was lost in the following decade. The American colonies

were squandered in as casual a fashion as the gamblers threw away their fortunes at Crockfords. Neither the American Declaration of Independence in 1776 nor the revolutionary storm that broke in France in 1789 can be said to have directly concerned artists in England, though no doubt some discomfort of divided loyalty was felt by Americans such as West and Copley. But the rebellious ideas of the time may reasonably be supposed to have affected the prevailing mood.

If James Barry was too self-centred to bother about politics, he had all the rebel feeling of hostility towards the establishment, and indignation that his own superlative merits were regarded with an indifference amounting to persecution. An Irishman born in Cork, Barry gives an instance of the inflated ego, the vast ambitions and defiance of all authority that were to appear again in the romantic period of the early nineteenth century. Enabled to go to Rome through the interest of Edmund Burke, he determined to excel in the 'high art' generally held to be beyond British capacity. He was made a Royal Academician in 1773, but it was characteristic that in taking up the popular subject, *The Death of Wolfe* (1776), he portrayed neither classical nor modern dress but made all the figures nude; it was also characteristic that the bad reception of the work caused him to stop exhibiting at the Academy thereafter. Yet the effort to demonstrate his lofty powers led to his toiling for seven years at his own expense on the six scenes of *Human Improvement* for the Adelphi building of the Society of Arts (Plate 103). Insult and libel directed against his fellow Academicians brought about his expulsion from the Academy in 1799.

It seems strangely appropriate that Milton should follow Shakespeare in providing themes for art and that Satan, in a sense the hero of *Paradise Lost* in desperate defiance of an established order, should come foremost in Fuseli's Milton Gallery, opened in 1799. It was a defiance that would later be called Byronic, a mood that belonged more particularly to the romantic movement than to the great century it followed. The mood reached its culmination of despair in the paranoiac dreams and tragic end of Benjamin Robert Haydon (1786–1846).

Where a period of art comes to an end is a matter of arbitrary decision, as arbitrary, say, as if the curtain were brought down with the death of Sir Joshua Reynolds in 1792. On the other hand there are trends and achievements that overlap an artificial boundary of date. Copley's *Brook Watson and the Shark* (Plate 69), the sensation of 1778 in London, anticipates the fevered excitement infused into French art by Géricault (1791–1824) some forty years later.

It is possible to think of Sir Thomas Lawrence (1769–1830; Plates XXIV, 143 and 146) as the last of the illustrious line of eighteenth-century portrait painters, though in the sparkling technique that interested Delacroix and the tense characterization of the

portraits of the Waterloo Chamber at Windsor, it can scarcely be overlooked that there is a new quality of temperament. In John Crome, a painter late to develop, there is an instance of the man of eighteenth-century outlook, who continued steadfastly in the tradition of Richard Wilson, with a placid hint of Morland.

What may be termed with some mildness of understatement as a period of transition at the turn of the century was also a period of tremendous storm, of the deadly struggles that followed the French Revolution, of the accelerated mechanical progress that brought an industrial bourgeoisie into prominence and power, of a social make-up disturbed and reshuffled. Few sensitive artists crossed the border that may be indicated by the year 1800 without undergoing some intensity of change. In a great painter on the European continent, such as Francisco de Goya (1746–1828), there is a transition from a gay rococo to the most sombre of conceptions. There is an equal intensity, albeit differently expressed, in the expansion of imaginative power, as seen in Turner (Plates 154 and 155). The eighteenth century finished with a whirlwind in which there was fresh promise of greatness.

List of plates

1 SIR GODFREY KNELLER (1646–1723): *Triumph of Marlborough*. 1706. Canvas, $35\frac{1}{2} \times 28$in. London, National Portrait Gallery

Kneller's vast practice as a portrait painter extended from the reign of Charles II—when he succeeded Sir Peter Lely as court painter—to the reign of George I; but he was particularly associated in the fullness of his fame with what is known as the 'Augustan Age', in effect, the reign of Queen Anne (1702–14). In the *Triumph of Marlborough*, painted in the year of the Duke of Marlborough's victory over the French at Ramillies, Kneller gave a pictorial equivalent of the flattering poetic dedications of the period, with a residue also of baroque allegory.

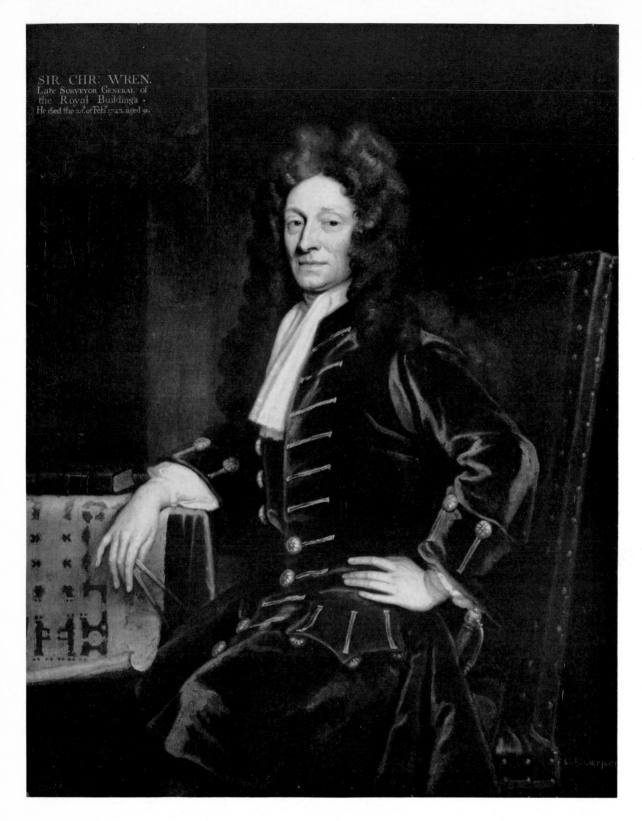

SIR CHR: WREN.
Late Surveyor General of
the Royal Buildings.
He died the 2d. of Feb? 1723. aged 91.

2 SIR GODFREY KNELLER (1646–1723): *Sir Christopher Wren*. 1711. Canvas, 49 × 39½in.
London, National Portrait Gallery

The most successful portrait painter of his day, Kneller painted sitters from varied walks
of life. Many of his most interesting portraits, however, like these two, are of artists and
men of letters. The *Wren* is typical of his more formal type of image; *Matthew Prior*, on
the other hand, is a more intimate portrait—note the simplicity of the background
and the fact that the writer is depicted without the fashionable wig of the period.

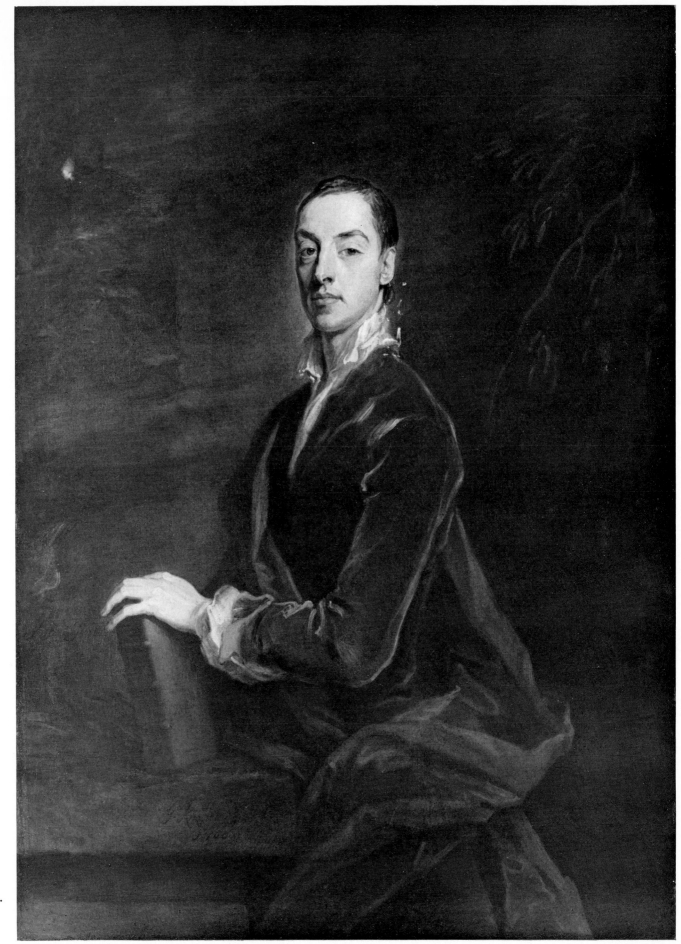

SIR GODFREY
KNELLER:
Matthew Prior. 1700.
Canvas, $54\frac{1}{4} \times 40\frac{1}{8}$in.
Cambridge,
Trinity College

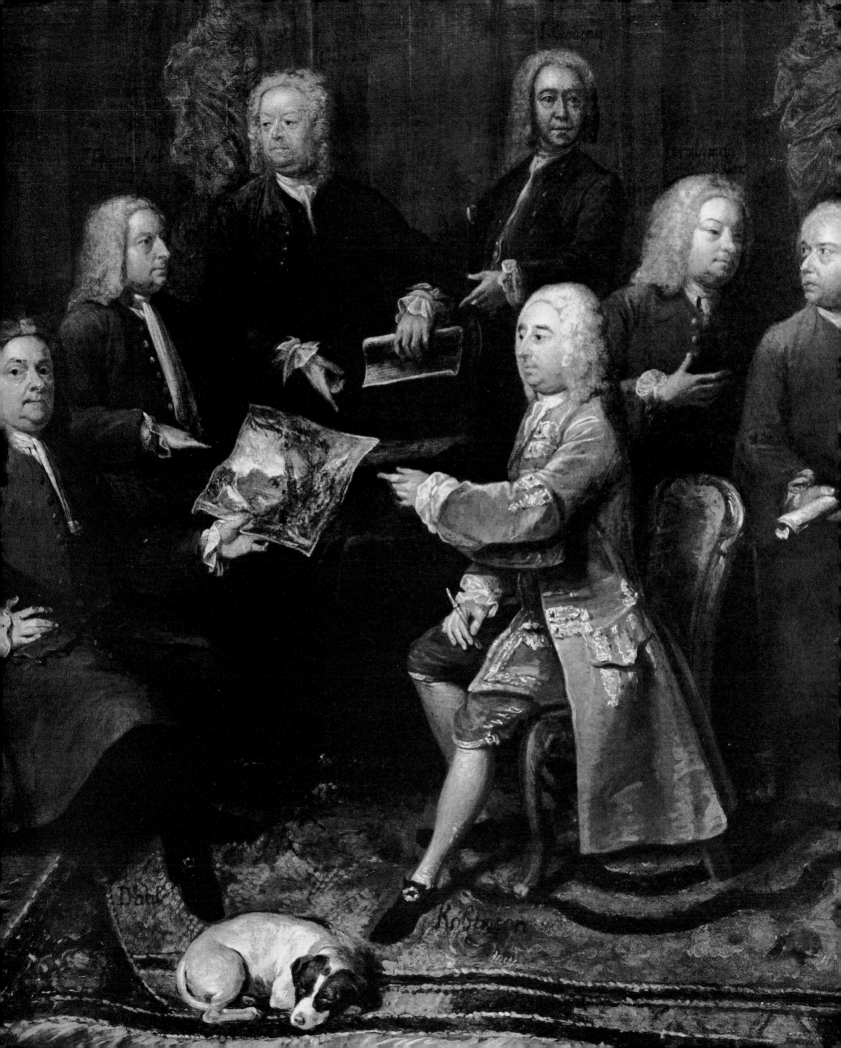

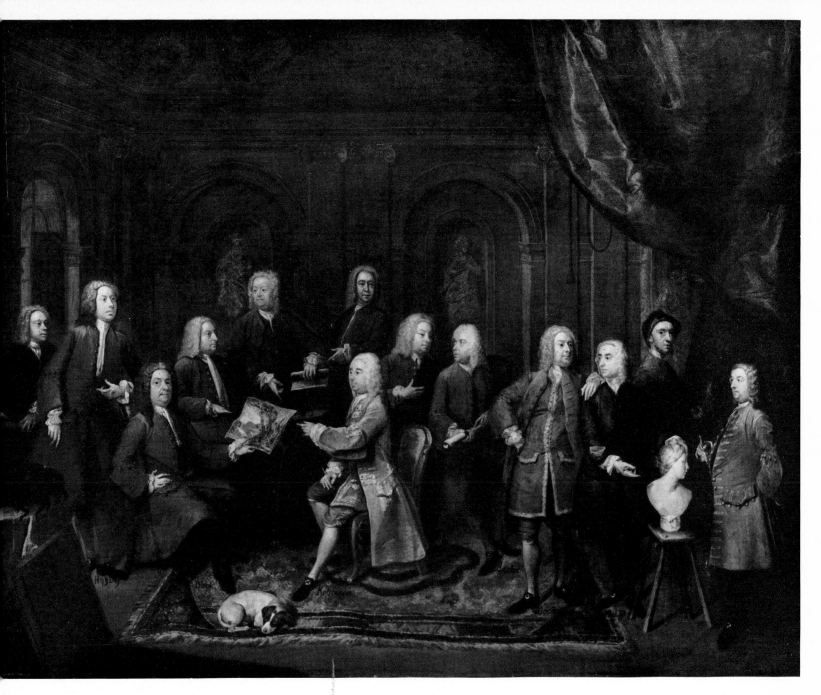

4 & 5 GAWEN HAMILTON (1698–1737): *A Club of Artists*. 1735. Canvas, 34 ×43in. London, National Portrait Gallery

Hamilton shows a movement away from Augustan pomp and, indeed, was one of those stimulated by the unconventional example of Hogarth. Vertue remarked approvingly on the 'variety and correctness of mode and manner of the time and habits' in Hamilton's 'paintings of conversations', considering him a rival to Hogarth though with 'not so much fire'. *A Club of Artists* well represents his talent.

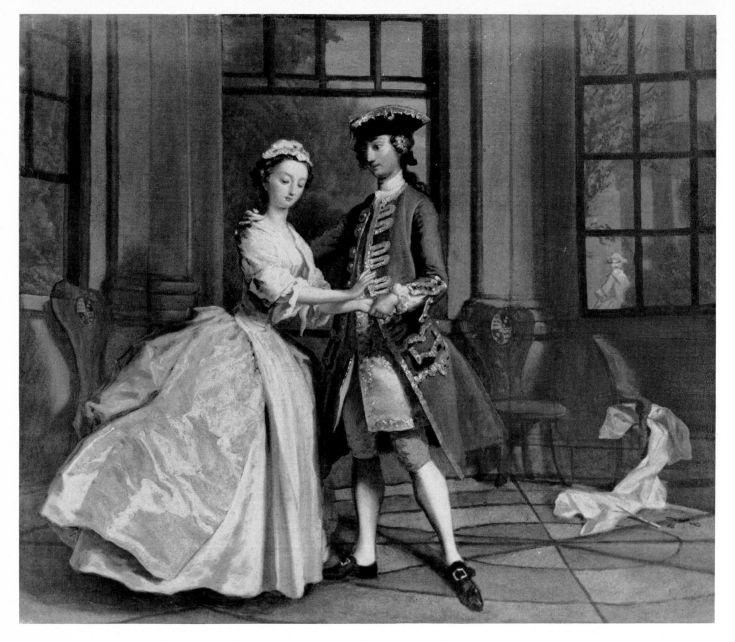

6 JOSEPH HIGHMORE (1692–1780): *Pamela and Mr B. in the Summerhouse.* 1745. Canvas, 24¾×29¾in. Cambridge, Fitzwilliam Museum

Not quite a conversation piece in the sense of being a portrait group taken from real life, this painting can be regarded as a variant of the conversation style. Highmore applied it to literary illustration in the set of twelve episodes from Samuel Richardson's enormously successful novel, *Pamela*.

7 MARCELLUS LAROON, THE YOUNGER (1679–1774): *Lovers in a Park.* About 1735. Canvas, 24¾×20½in. Collection of Mr and Mrs Paul Mellon

A product of Marcellus Laroon's middle age, after many picaresque adventures and variety of occupation as a singer, actor and soldier, his *Lovers in a Park* is an imaginary 'conversation' in which he seems distantly to recall the *fêtes galantes* of Watteau; that is, as far as the theme is concerned, for Laroon did not follow Watteau in range and subtlety of colour.

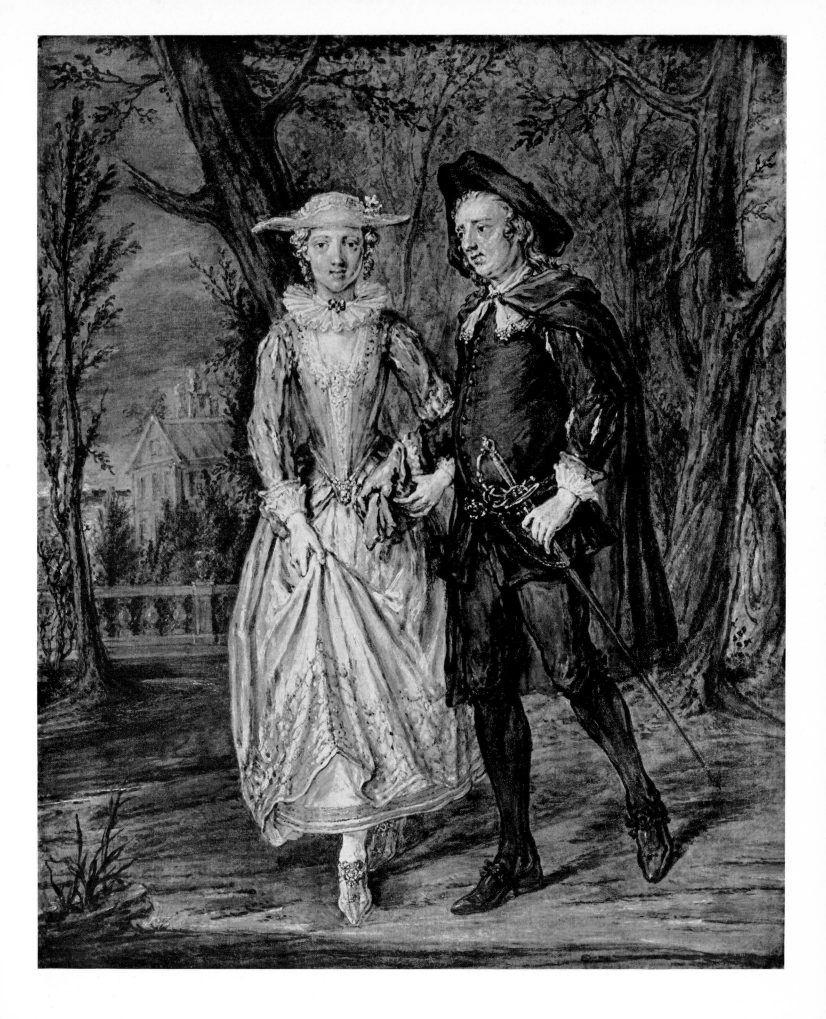

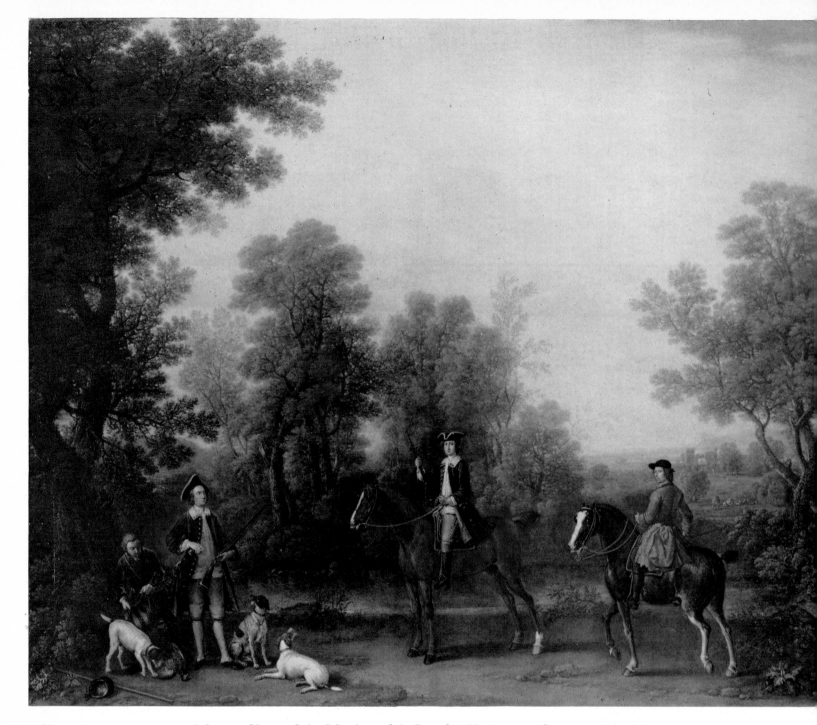

8 & 9 JOHN WOOTTON (about 1682–1764): *Members of the Beaufort Hunt*. 1744. Canvas, 78 ×95in.
London, Tate Gallery

This large canvas can be appreciated as a pioneer work in the development of both landscape and
the sporting theme. The trees are reminiscent of Claude and of the artificial type that John
Constable was to frown on, but the foliage is arranged with agreeable outline if with slight variety
of tone. It is interesting to compare the background here with the veracious Cheshire landscape
depicted by Stubbs eighteen years later in *The Grosvenor Hunt* (Plate XIX). Wootton evidently gave
special thought to obtaining a lifelike effect in the informality of grouping of figures and animals;
he succeeded in producing a design in which they fit naturally together. The picture represents
George Henry, third Earl of Litchfield (1718–72) on horseback, and his uncle, the Hon. Robert Lee,
the fourth Earl (1706–76), with gun, in the Beaufort Hunt coat.

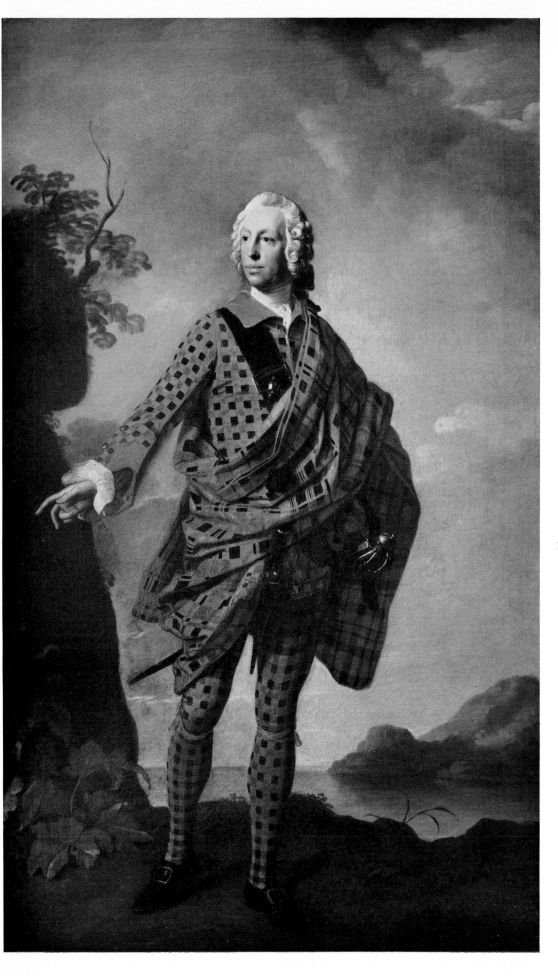

10 ALLAN RAMSAY (1713–84):
Norman, 22nd Chief of MacLeod.
1748. Canvas, 88×54in. Skye,
Dunvegan Castle, Collection of
Mrs MacLeod

This painting represents a striking
solution of the 1740s to the proble[m]
of imparting dignity to the full-
length portrait without succumbi[ng]
to the baroque tendency to the
grandiose and assertive. It was
painted in the first period of
Ramsay's great success, when he w[as]
influenced by his studies in Italy;
the pose of the figure is actually
based on the *Apollo Belvedere*, a
Roman statue in the Vatican that
was then widely regarded as one
of the greatest works of antiquity.
The present picture also shows ho[w]
well Ramsay could interpret male
as well as female character.

WILLIAM HOGARTH (1697–1764): *Captain Thomas Coram of the Foundling Hospital*. 1740. Canvas, 94 × 58in. London, Thomas Coram Foundation for Children

In this portrait Hogarth still employs emblematic accessories in a baroque manner—the globe and maritime background recalling the career of the master-mariner and shipwright, the roll of parchment he holds being the Royal Charter for the Foundling Hospital. But he manages to suggest that they are emblems of middle-class dignity and not of empty pride, subsidiary to the benevolence and conscientiousness of character in his sitter that he brings out so well. *Captain Coram* ranks as one of the great masterpieces of the century. This was the portrait, Hogarth said, 'I painted with most pleasure and in which I particularly wished to excel'. See also detail (Plate 13).

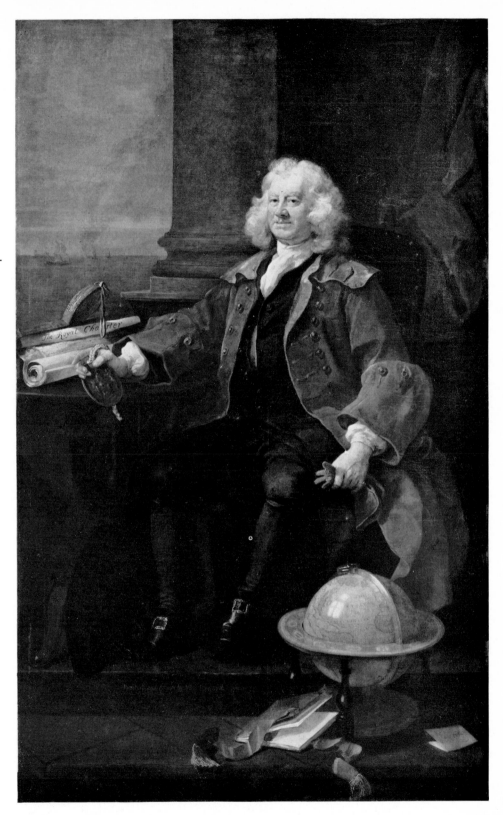

13 WILLIAM HOGARTH (1697–1764): Detail
from *Captain Thomas Coram* (Plate 11)

ALLAN RAMSAY (1713–84): *Self-portrait*. About 1739. Canvas, 23½ × 18in. London,
National Portrait Gallery

This portrait seems to have been painted soon after Ramsay returned from his first
Italian journey. It suggests the lively personality and intelligence of a man who in the
course of his career numbered Dr Johnson, David Hume and Horace Walpole
among his friends; corresponded with Voltaire and Diderot; and painted
Jean-Jacques Rousseau at Hume's instigation.

14 THOMAS GAINSBOROUGH (1727–88): *Mr and Mrs Robert Andrews*. 1749. Canvas, 27½ ×47in. London, National Gallery

15 FRANCIS HAYMAN (1708–76): *The Milkmaids' Garland, or May Day*. About 1740. Canvas, 54 ×94½in. London, Victoria and Albert Museum

Although Gainsborough was not a pupil of Hayman but of the French engraver, Gravelot, there are sufficient links between Hayman's work and that of Gainsborough to show that in his student and early years the latter was certainly influenced by Hayman, Gravelot's colleague as teacher of painting at the academy in St Martin's Lane. Hayman's career is not well documented. Born in Exeter, he is said to have been the pupil of the obscure portrait painter, Robert Brown, a follower of Thornhill. Hayman went to London when he was young and worked as a scene painter for Fleetwood, proprietor of the old Drury Lane Theatre, whose widow he later married. He was president of the Royal Academy's precursor, the Incorporated Society of Artists, and a founder member of the Academy in 1768. Through his friendship with Hogarth, he took to painting conversation pieces and small portraits such as suited the less than aristocratically opulent patron. He also collaborated with Gravelot in book illustration.

But the importance of his example to Gainsborough was in the comparatively unaffected naturalism of conversation pieces set in the open air in rural surroundings. Gainsborough's *Mr and Mrs Robert Andrews*, probably painted soon after their marriage in 1748 (the church of St Peter's, Sudbury, is in the background), is a masterpiece in this genre.

Hayman was apparently joined by Hogarth and Gravelot in producing decorative panels for the supper boxes at Vauxhall Gardens. The example of his graceful, semi-naturalistic style here illustrated refers to an old May Day custom whereby the milkmaids donned special headdresses and danced from door to door of their customers, who each gave them some recompense.

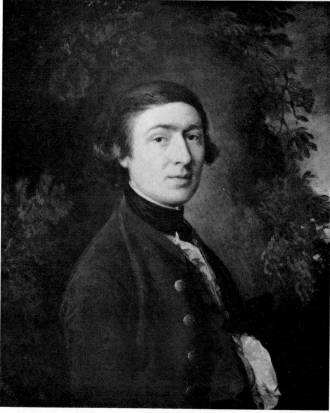

Self-portrait of Thomas Gainsborough (1758–9)

Self-portrait of Hayman (about 1745–50)

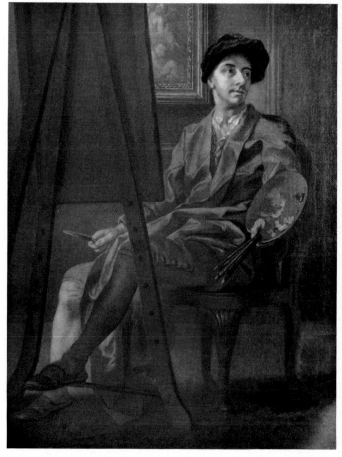

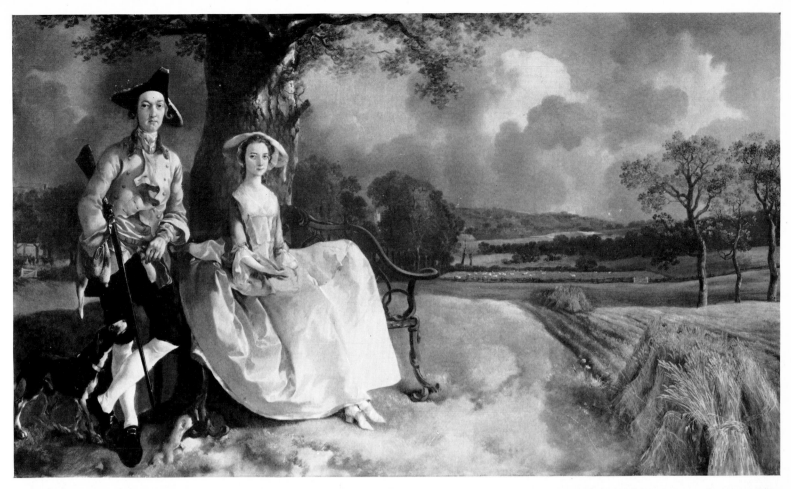

14

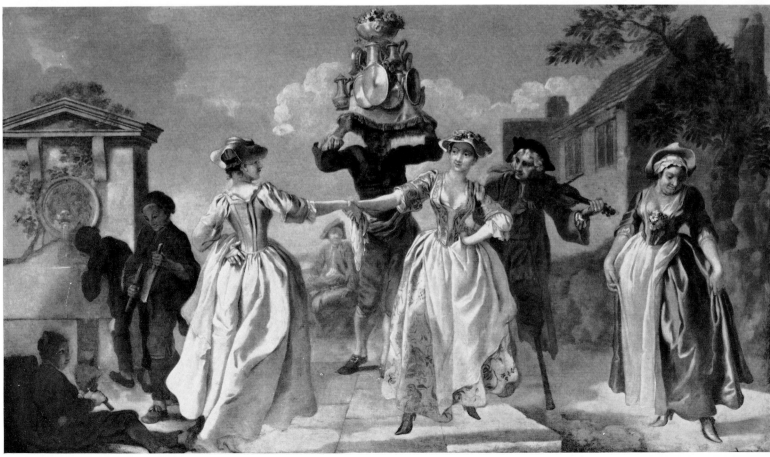

15

16 WILLIAM HOGARTH (1697–1764): *The Roast Beef of Old England* (*Calais Gate*). 1748–9. Canvas, 31 ×37¼in. London, Tate Gallery

Autobiography, insular prejudice, satirical comment and brilliant painting are combined in this celebrated work. It was inspired by Hogarth's visit to France in August 1748, during a truce period between France and England. On his return from Paris to Calais he began to sketch the gate and was arrested as a spy in consequence, though released when his captors were satisfied he was an artist. He took his pictorial revenge as soon as he got home. There is already a hint of Gillray's ruthless satire mixed with the humour and directed equally at superstition (the background procession), the greedy friar, the famished-looking French soldiers, Irish mercenaries and Jacobite exile (after the '45)—all in contrast to the happy state of insular affairs indicated by the good English sirloin destined for the inn at Calais, the 'Lion d'Argent'. The gate is made prison-like and the crow above it vaguely ominous, like Poe's Raven. See also detail (Plate 18).

17 JOSEPH HIGHMORE (1692–1780): *Samuel Richardson*. 1750. Canvas, 20 × 13¾in. London, National Portrait Gallery

Highmore's understanding of character and ability to make a convincing likeness are well shown in this small full-length portrait, one of the two portraits of the novelist by him now in the National Portrait Gallery. One can appreciate from both of them the remarkable, self-made man, who by dint of industry and some more subtle operation of ability, combined 'improvement' with an anticipation of the psychological novel. They met about 1744 through Highmore's illustrations to Richardson's novel of 1740, *Pamela*.

18 WILLIAM HOGARTH (1697–1764): Detail from *The Roast Beef of Old England* (Plate 16

The sharpness of Hogarth's observation of real life is here strikingly illustrated. In his remarks 'on various prints' he speaks of the fisherwomen of Calais as having faces 'of absolute leather'; and so he paints them. T hand about to descend on Hogarth's shoulc is a reference to his arrest for spying.

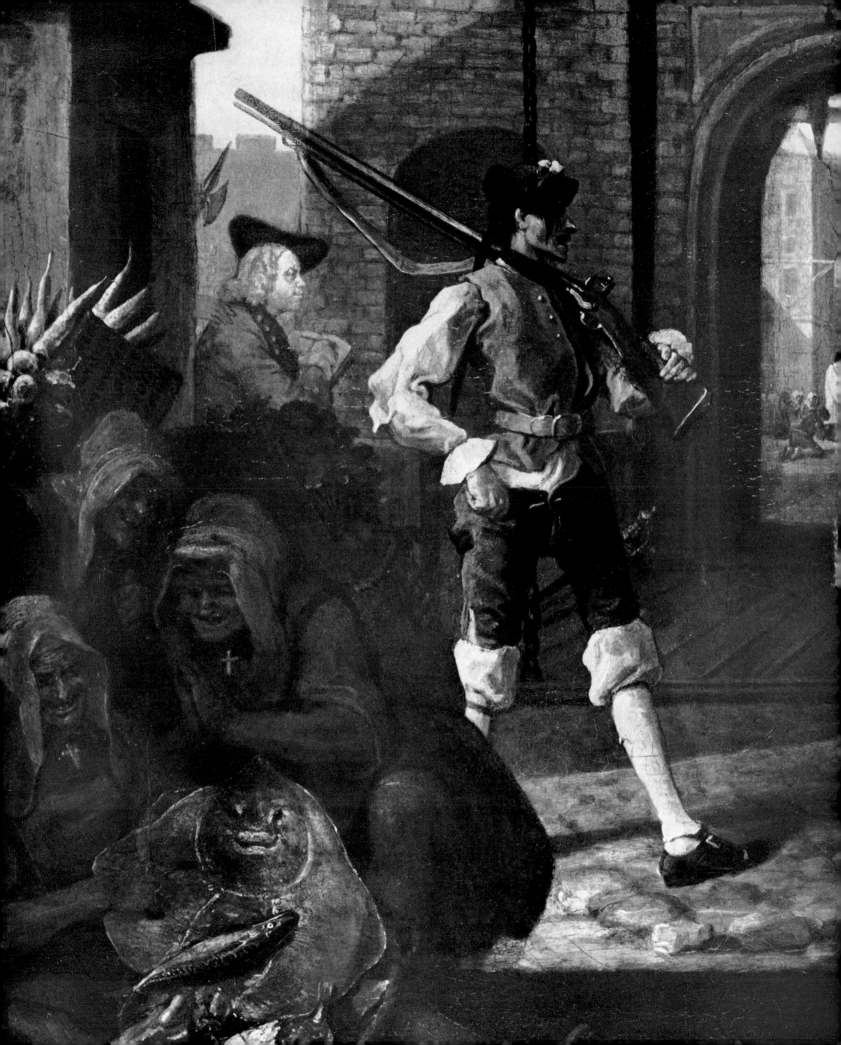

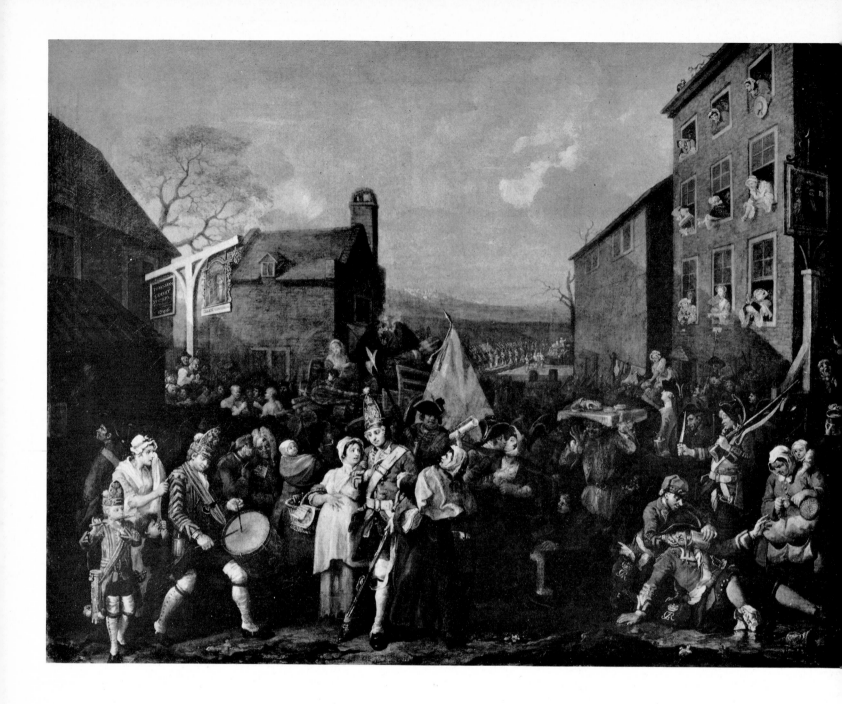

19 & 20 WILLIAM HOGARTH (1697–1764): *The March of the Guards towards Scotland in the Year 1745 (March to Finchley)*. 1746. Canvas, 40 × 52½in. London, Thomas Coram Foundation for Children

The winning ticket in Hogarth's lottery of 1750, one of those he gave to the Foundling Hospital, gained for the Hospital this famous work. It represents the bibulous leave-taking of the Guards about to set off northwards to suppress the Jacobite rising of 1745. The scene is near the 'Adam and Eve' public house on the Tottenham Court Road, and though there is an indication of disciplined formation in the background, order is wanting in the groups immediately before the spectator's eye, especially in the tipsy group at the right (see Plate 135). The satire contains more broad fun than serious point. The picture may have been suggested by a print of Watteau's *Départ de Garison*, but is painted with all Hogarth's own vivacity and reveals many superb passages when studied in detail.

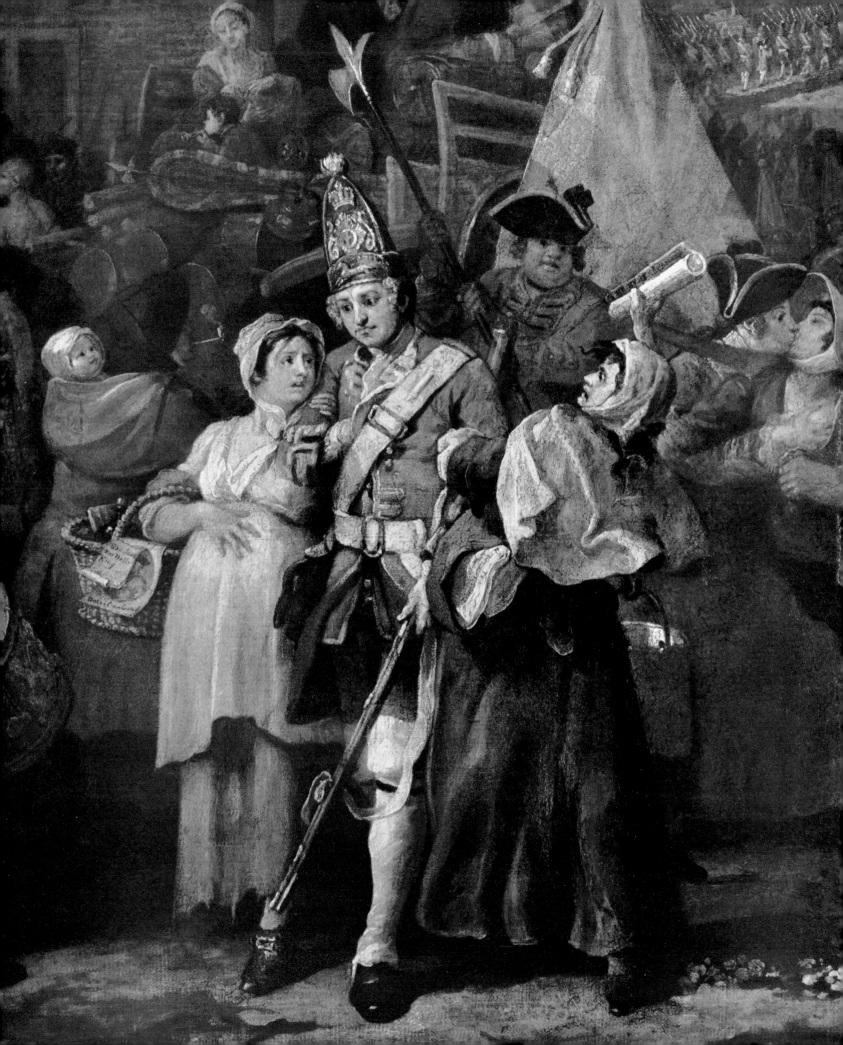

21 & 22 SIR JOSHUA REYNOLDS (1723–92): *Joseph Wilton*. 1752. Canvas, 30 ×23½in. London, National Portrait Gallery

Depth of light and shade with little modification of colour gives a romantic interest to this portrait of Reynolds's especial friend among the sculptors of the time. Wilton (1722–1803) had the advantage of training in France and Italy, where he spent eight years. He was appointed stagecoach carver to the royal family and made the model for the coronation coach for George III. A series of monuments in Westminster Abbey provided him with a fortune which, says William Sandby, 'enabled him to live in a style of luxury proportioned to his means'. He was the keeper of the Royal Academy until his death.

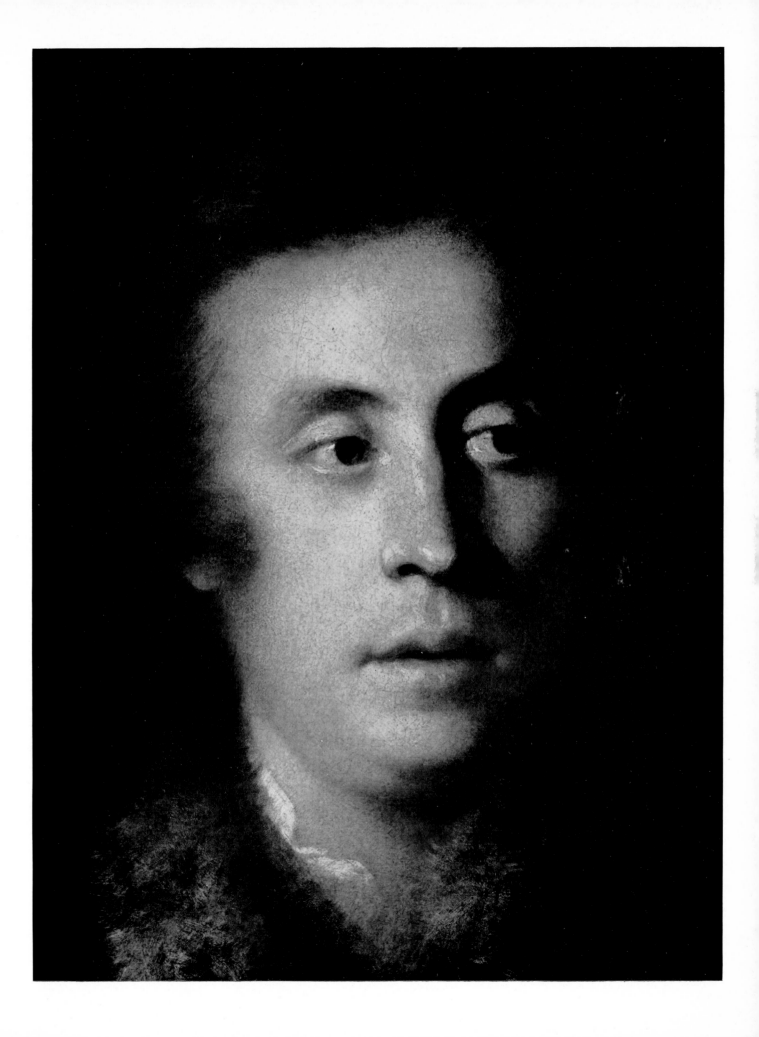

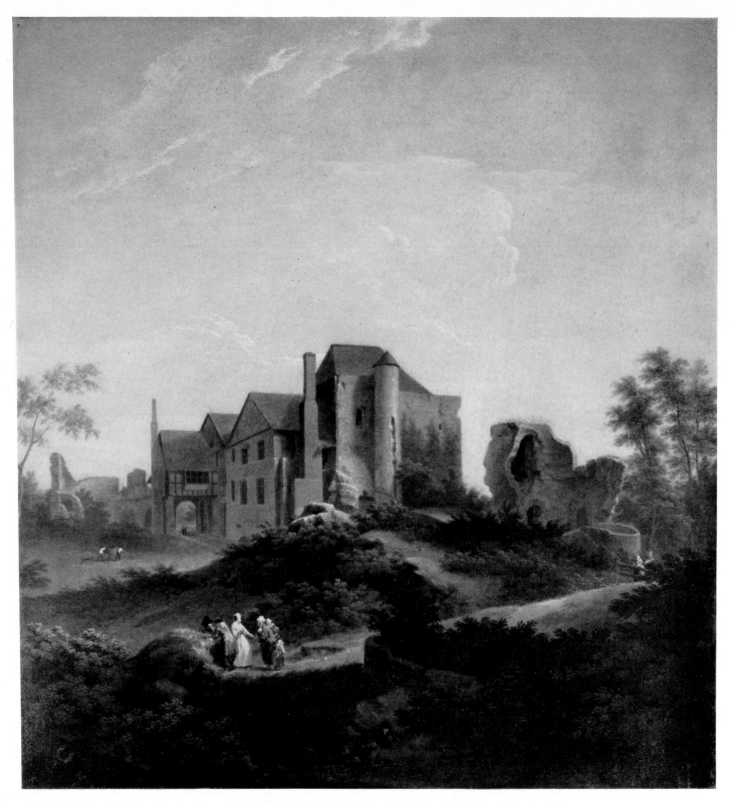

23 GEORGE LAMBERT (about 1700–65) and William Hogarth (1697–1764): *Ruins of Leybourne Castle*. About 1740. Canvas, 40½ ×38in. London, Ministry of Public Building and Works

Lambert and Hogarth were close friends and in painting were wont to give each other a hand from time to time. Lambert was not incapable of adding incidental figures in the landscape painting, of which he was a pioneer, but in this instance Hogarth's figures enliven a canvas that might otherwise have been too solemn.

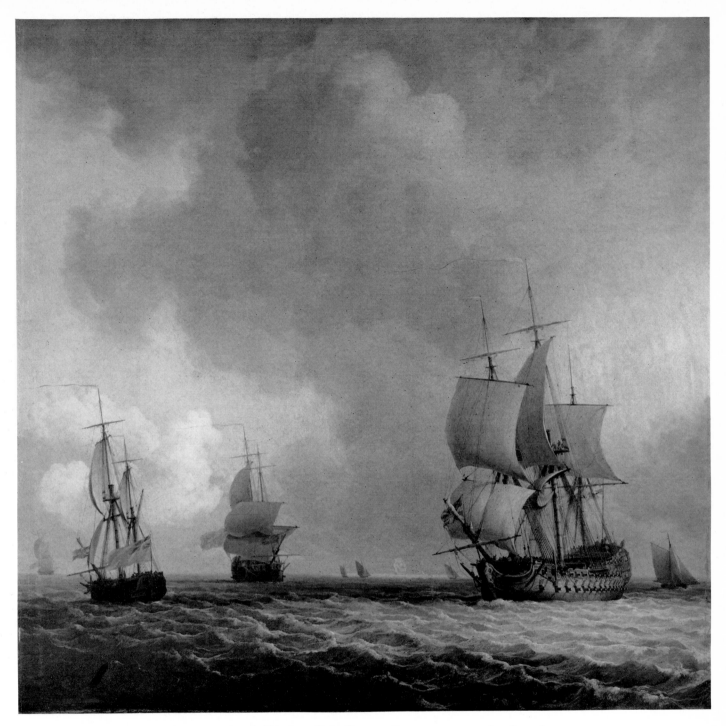

24 CHARLES BROOKING (1723–59): *A Ship in a light Breeze*. Canvas, 27 ×27in. London, National Maritime Museum

The artist's obvious knowledge of all the complicated details of masts, sails and rigging might well have come from his working at Deptford dockyard before he took to painting, though he was also described by Sawrey Gilpin as one who 'had been much at sea'. A seaman in the age of sail would necessarily have been preoccupied with the breeze, as here and in numerous other works where the artist shows great skill in the rendering of wind and wave. This type of seascape had its origins in Dutch marine paintings of the seventeenth century, and in particular the works of Willem van de Velde the Younger, who died at Greenwich in 1707.

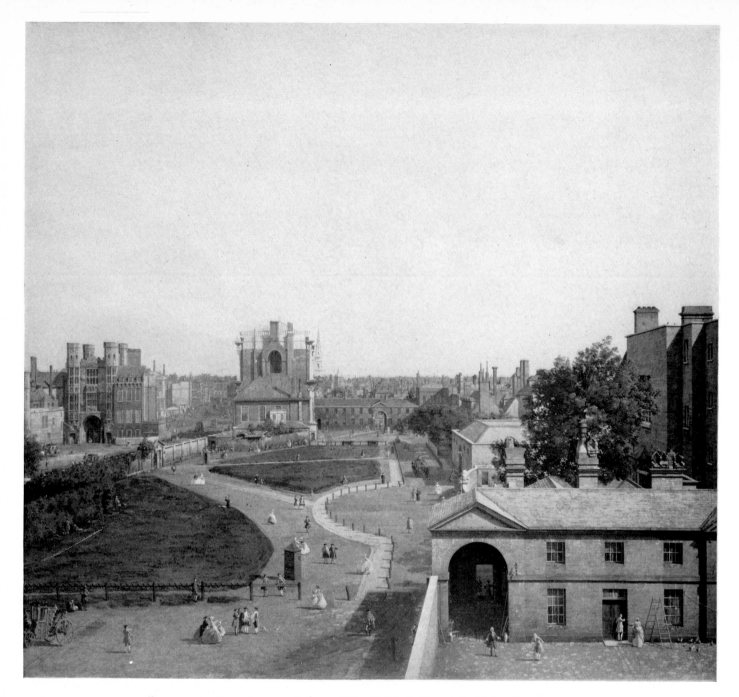

25 ANTONIO CANAL (known as Canaletto; 1697–1768): *Whitehall and the Privy Garden from Richmond House.* 1746. Canvas, 43 ×47in. Goodwood House

This is one of the finest of Canaletto's English views; in the right foreground can be seen part of the stables of Richmond House and part of Montagu House beyond. In the centre and to the left is the Privy Garden, with the Banqueting Hall at the far end. Opposite the Banqueting Hall, on the left, is the sixteenth-century 'Holbein Gate'.

26 WILLIAM MARLOW (1740–1813): *Capriccio: St Paul's and a Venetian Canal.* Canvas, 51 ×41in. London, Tate Gallery

The *capriccio* was an architectural 'entertainment' practised by painters in Italy such as Pannini, Piranesi and Guardi, who freely arranged buildings and topographical details with fanciful effect; it was given an English application in this work by Marlow, who travelled in Italy in the 1760s. The canal flowing beneath St Paul's imparts a surrealist strangeness to the well-known scene.

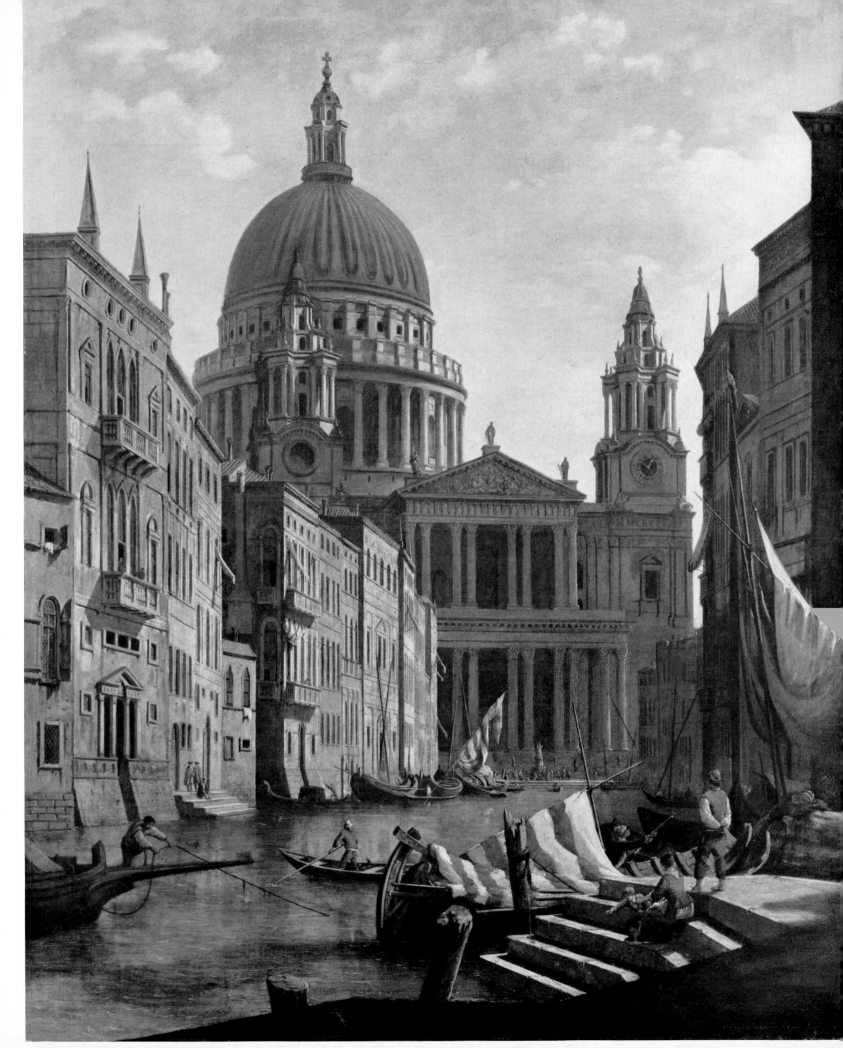

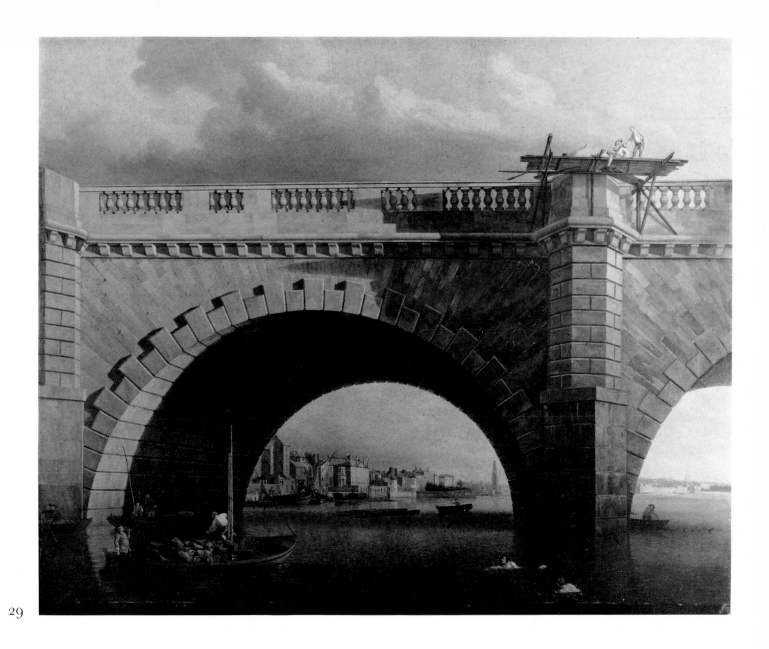

29

27 RICHARD WILSON (1714–82): *The Thames near Twickenham*. 1762(?). Canvas, 18¼ ×28¾in. London, Tate Gallery

28 SAMUEL SCOTT (about 1702–72): *The Thames at Deptford*. Canvas, 20½ ×37¾in. London, Tate Gallery

29 SAMUEL SCOTT: *An Arch of Westminster Bridge*. Canvas, 50½ ×64in. London, Tate Gallery

The Thames was a great source of inspiration to eighteenth-century painters. Wilson's sense of light and space and the 'meditative love of nature' on which Ruskin remarked, appear in his view (one of several versions) of the Thames near Twickenham. The standpoint was the right bank of the Thames, nearly opposite the grounds of the early Georgian country house, Marble Hill.

Deptford had a special interest for the marine painters because of its shipyard; Samuel Scott was one of those attracted by the picturesque wharves and waterfront. The example of Canaletto may have led him to paint his many views of Westminster.

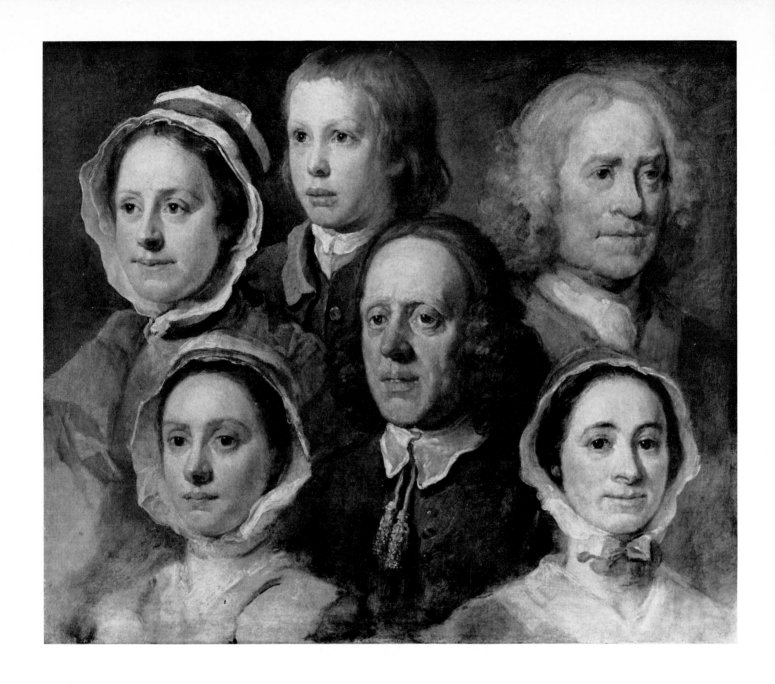

30 & 31 WILLIAM HOGARTH (1697–1764): *Heads of six of Hogarth's Servants*. Canvas,
24½ ×29½in. London, Tate Gallery

Little is known of Hogarth's servants, or of the circumstances in which this portrait
of them was produced. As it was not referred to in the first edition of Nichols's
Biographical Anecdotes, 1781, but is mentioned as being in Mrs Hogarth's possession
in the second and third editions, 1782 and 1785, it may be assumed that the portrait
was taken for granted as a household document rather than a work for public display.
The fact that only the heads are finished tends to support this view. The interest is
that of character rather than pictorial design. It is almost as if a set of characters from
a novel by Fielding (so much Hogarth's counterpart in literature) had suddenly come
to life. Averse as he was to what he called 'phizmongering', he evidently enjoyed the
unaffected portraiture of types whom he was under no persuasion to flatter.

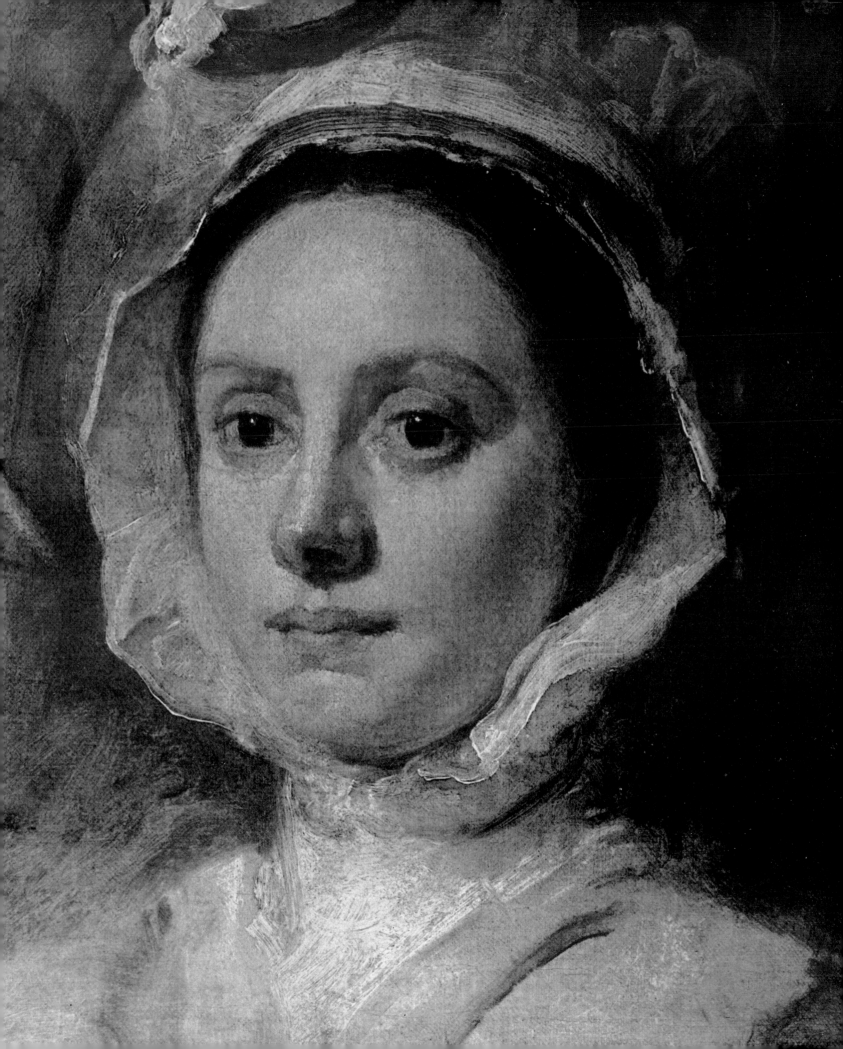

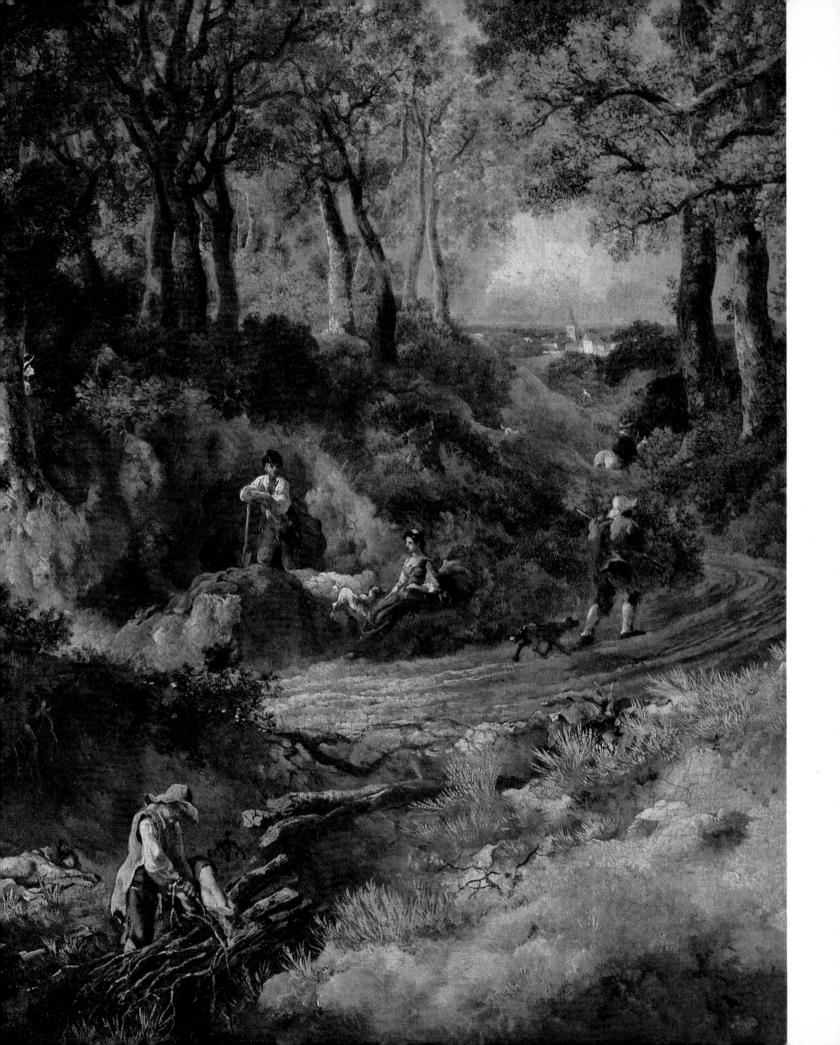

THOMAS GAINSBOROUGH (1727–88): *Gainsborough's Forest* ('*Cornard Wood*'). About 1748.
Canvas, 48 × 61 in. London, National Gallery

This painting magnificently represents the first, East Anglian phase of Gainsborough's landscape
style. Though the young artist at the probable date of its production gives evidence of the experience
gained in copying and restoring Dutch pictures, Ruisdael especially, the result is fresh and original
and closely reminiscent of East Anglia, as Constable realized with delight. The direct study of
nature appears in the observation of tree forms, the delicately aerial sky and the sensitive variations
of colour. The painting provides a remarkable contrast with the imaginary landscapes of
Gainsborough's later years, though the different scale of values then adopted has its compensation
in a more generalized and imaginative quality.

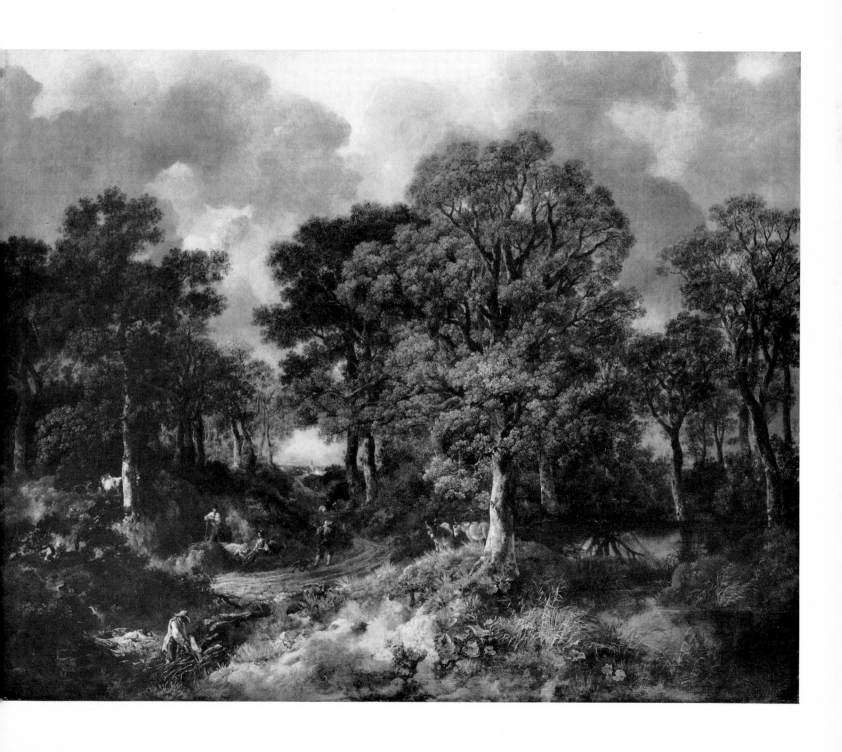

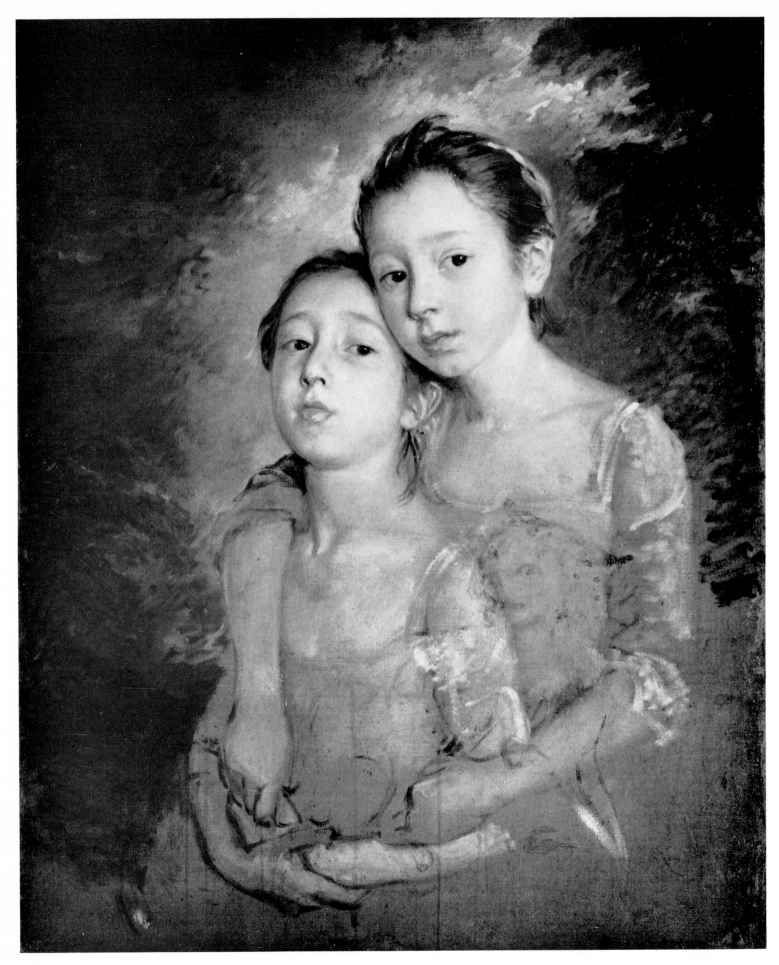

34

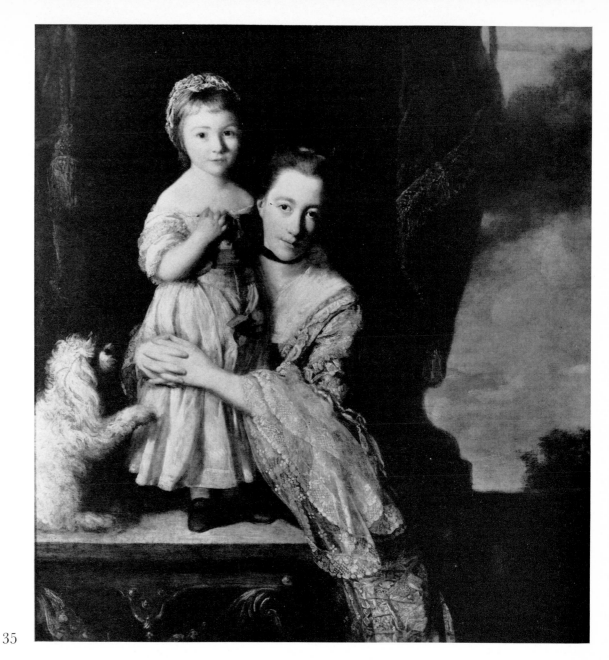

35

35 SIR JOSHUA REYNOLDS (1723–92): *Georgiana, Countess Spencer with her Daughter Georgiana, afterwards Duchess of Devonshire.* About 1762. Canvas, 48¾×45in.
Althorp, Earl Spencer

The variety that was one of Reynolds's great assets showed itself in the varied composition of his portraits rather than in any wide scope of subject; and it is delightfully apparent in his paintings of children. There is a charming seriousness in this portrait, and the dog contributes to the impression of a spontaneous moment.

34 THOMAS GAINSBOROUGH (1727–88): *The Painter's Daughters.* Canvas, 29¾×24¾in.
London, National Gallery

The eighteenth-century masters were especially happy in their portraits of children, in which both Gainsborough and Reynolds excelled. This portrait, in which Gainsborough's two daughters, Mary and Margaret, are exquisitely portrayed as small girls, was probably among the last pictures of Gainsborough's Suffolk period before he moved to Bath in 1759.

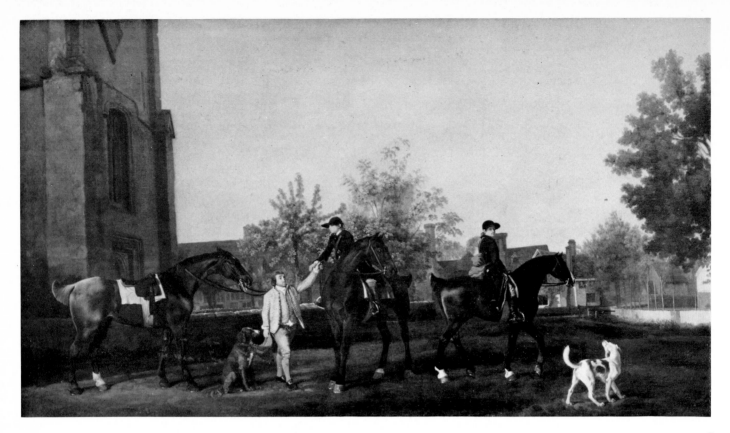

36

37

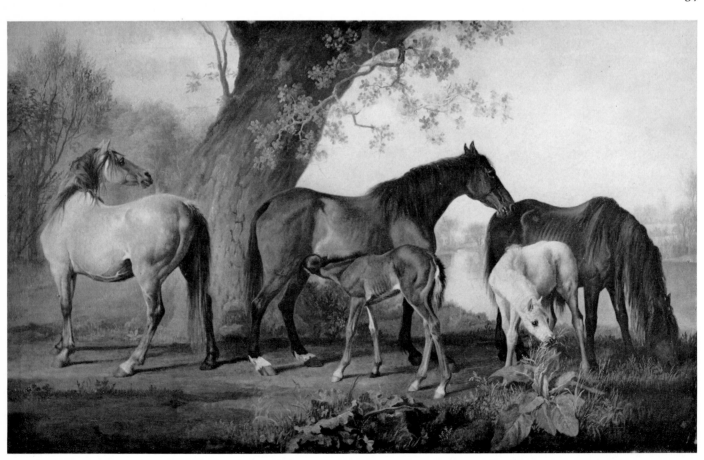

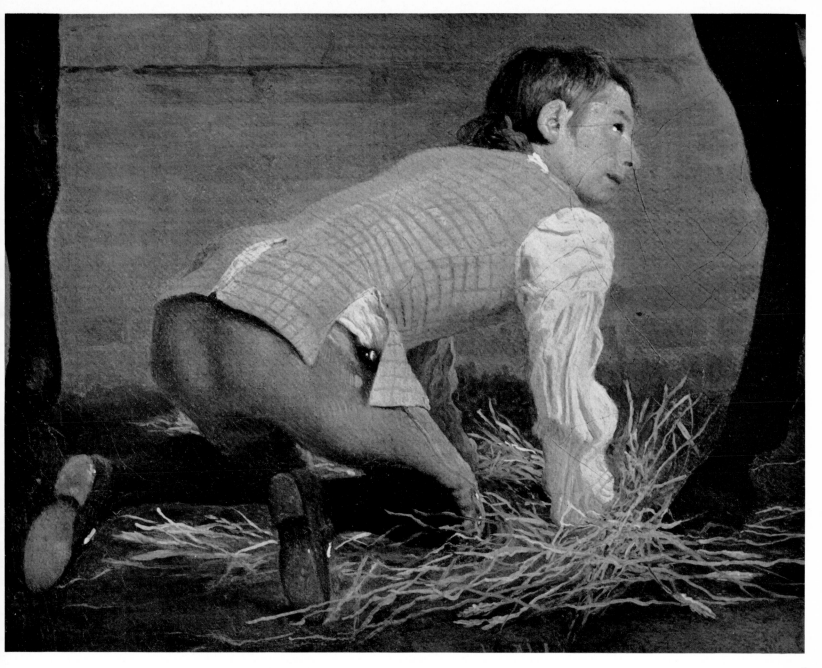

36 GEORGE STUBBS (1724–1806): *Huntsmen setting out from Southill, Bedfordshire*. 1760s (probably before 1768). Canvas, 24 × 41½in. Marquess of Bute

37 GEORGE STUBBS: *Mares and Foals by a Stream*. 1763–4. Canvas, 23½ × 39½in. Duke of Grafton

38 GEORGE STUBBS: *The Stable Boy*. Detail from *Gimcrack* (Plate 62)

Both the *Huntsmen* (see also detail, Plate 91) and the *Mares and Foals* (see also detail, Plate 50) show Stubbs's exquisite sense of design, and in particular his preference for an arrangement of forms parallel to the surface of the picture, as in a frieze. Perhaps the most remarkable of Stubbs's achievements as an artist is that this subtle feeling for the overall design of a painting was combined with an equally strong regard for detail, no matter how trivial. The stable boy in *Gimcrack* is but one of a whole gallery of individualized portraits in his work, painted with a degree of patient and sympathetic objectivity that is surprising in view of the strictly hierarchical society for which the artist was working.

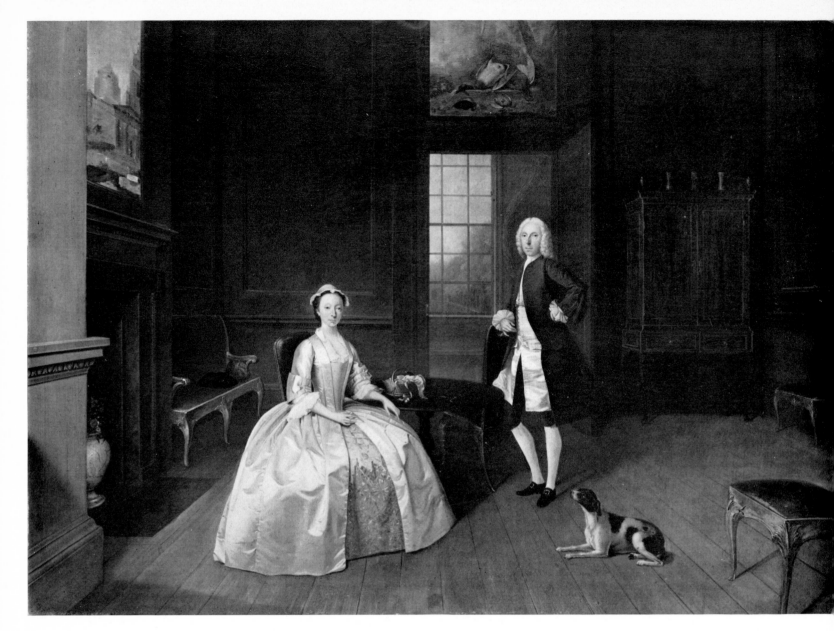

39 ARTHUR DEVIS (1711–87): *William Atherton and his Wife, Lucy*. About 1740. Canvas, $36\frac{1}{4}\times50$in. Liverpool, Walker Art Gallery

In this conversation piece the frugal style of the painter, reflecting the somewhat stilted manner of Pieter Tillemans, whose pupil Devis was, accords with an interior setting of an austere kind. But the linear sharpness establishes a fascinating consistency between personality, costume and architecture and suggests the aristocratic atmosphere of pre-industrial Preston (one of the last strongholds of Stuart loyalty). As Preston was Devis's native place, it was fitting that he should portray William Atherton (1702–45), mayor of the city, and his wife, whom he married in 1730. One likes to think that the overmantel painting, a *capriccio* of Roman architecture in which the Castle of St Angelo is a main feature, was perhaps a souvenir of a honeymoon tour in Italy. Works of this type were produced especially for the English visitors.

40 JOHANN ZOFFANY (1733/4–1810): *Queen Charlotte with her two eldest Sons*. About 1794. Canvas, 44¼×50⅞in. Windsor Castle. Reproduced by gracious permission of Her Majesty The Queen

Zoffany renewed the fashion for the conversation piece in works elaborately designed for the upper level of society and much to the liking of George III and his consort. This example shows the Queen with the Prince of Wales (later George IV; see detail, Plate 96) and the Duke of York. Both children are in fancy dress, a fashion evident in other paintings of the period—for example, Reynolds's *Master Crewe* (Plate 95) and Gainsborough's *Blue Boy* (Plate 74). The artist has been lavish with detail, such as the dressing-table with its various toilet articles and the mirror in which the Queen's reflection is seen (see detail, Plate 42).

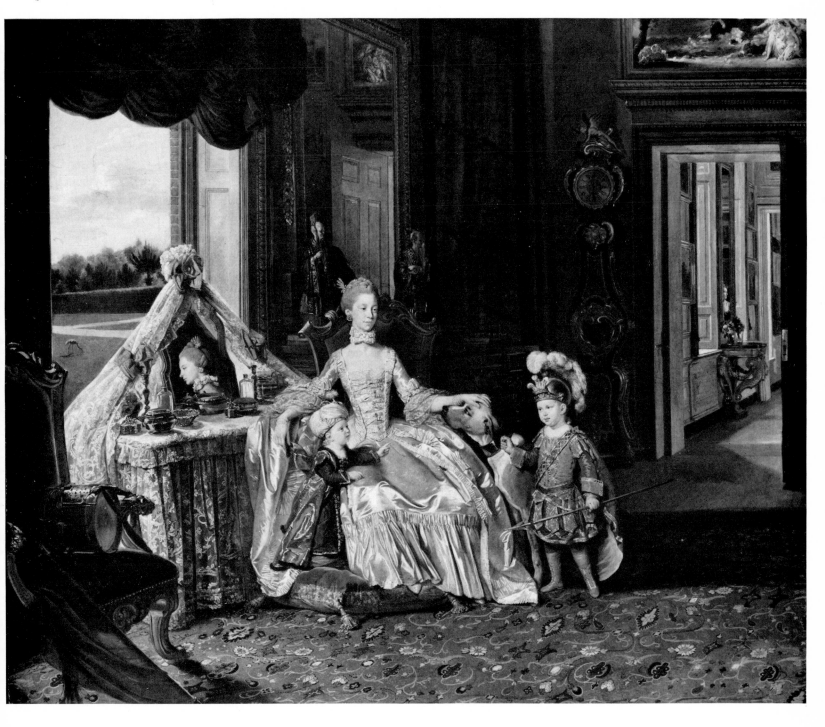

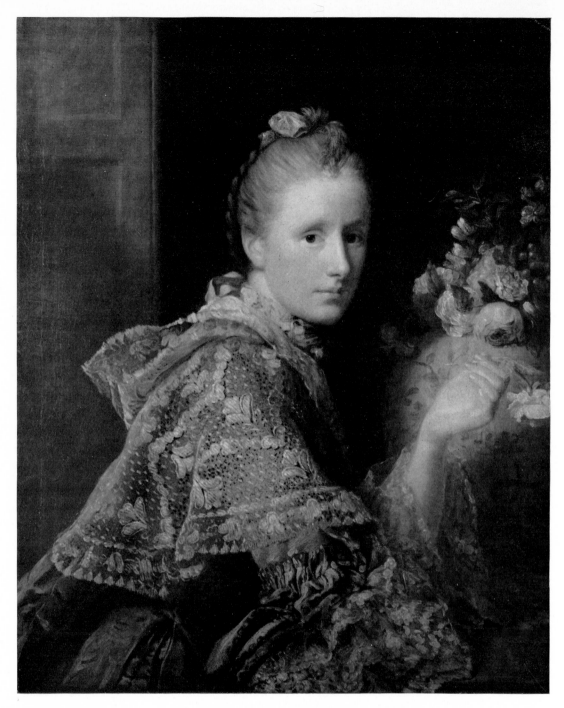

41 ALLAN RAMSAY (1713–84): *Margaret Lindsay, the Painter's Wife*. About 1755.
Canvas, $29\frac{1}{4} \times 24\frac{3}{8}$in. Edinburgh, National Gallery of Scotland

In this portrait of his second wife Ramsay's gifts found complete expression, and it is
by general consent the loveliest of his works. Grace and informality are beautifully
combined.

 Margaret Lindsay, who eloped with Ramsay in 1751, was the elder daughter of
Sir Alexander Lindsay of Evelick and Amelia Murray, a daughter of the fifth
Viscount Stormont. According to Robert Adam, she was 'a sweet, agreeable,
chatty body'. She died in 1782, two years before Ramsay's death.

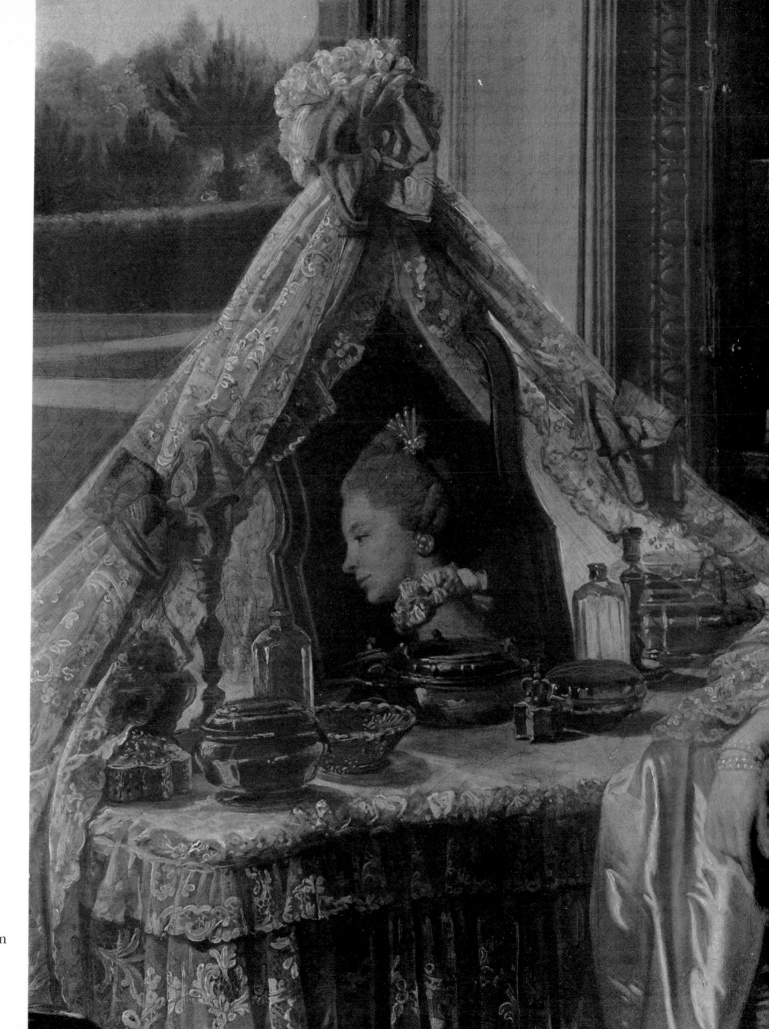

JOHANN
ZOFFANY
(1733/4–
1810):
*Queen
Charlotte*.
Detail from
Plate 40

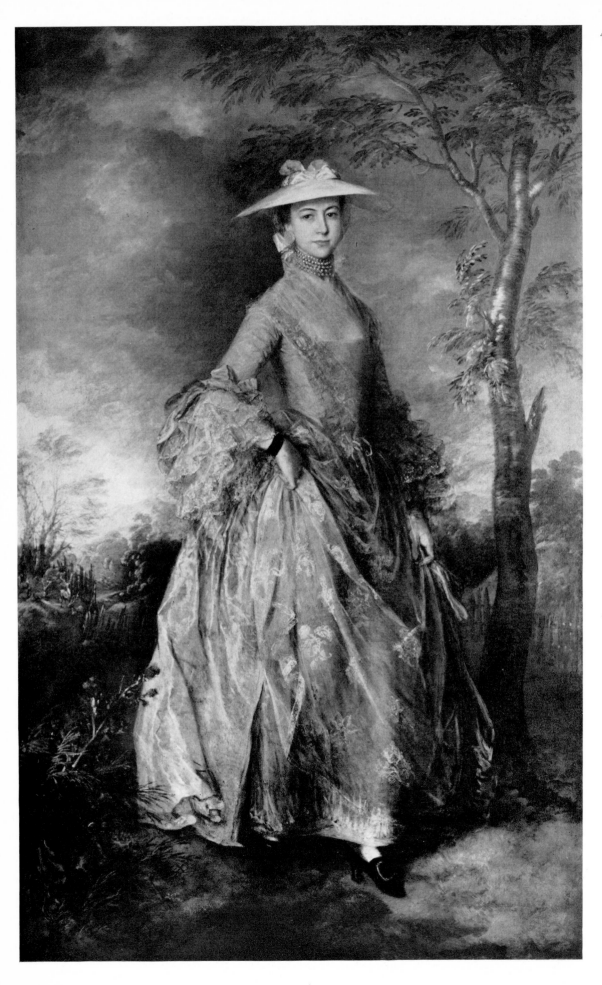

43 THOMAS GAINSBOROUGH
(1727–88): *Mary, Countess Hou*
About 1760. Canvas, 96 ×6oin
London, Kenwood

The enchanting combinations
light colour in this portrait are
unsurpassed in Gainsborough's
work or that of any other artist
among his English
contemporaries. The costume
the Countess—who was married
to Richard, later Earl, Howe, i
1758 when she was twenty-six—
and her appearance of youth
suggest that the picture was
painted early in Gainsborough'
stay at Bath, in the beginning o
the 1760s.

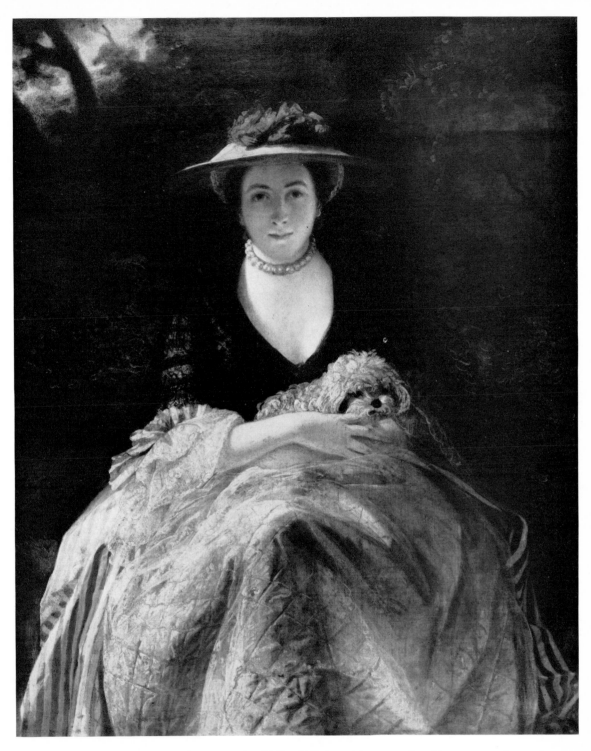

44 SIR JOSHUA REYNOLDS (1723–92): *Nelly O'Brien*. About 1763. Canvas, 50¼ ×40in. London, Wallace Collection

This is one of Reynolds's finest works. When he painted Nelly O'Brien, he was entering upon a period of great success. He had not yet begun those experiments to increase the richness of pictorial tone that were often to prove disastrous. The quality and variety of colour and the niceties of reflected light are beautifully preserved.

Partly because of his role as president of the Royal Academy, and partly also because of his *Discourses*, it is easy to imagine Reynolds as the practitioner of a grandiose and generalized style, but nothing could be further from the truth. Many of his finest pictures, in fact, are masterpieces of informality.

45 WILLIAM HOGARTH (1697–1764): *The Shrimp Girl*. Canvas, $25 \times 20\frac{3}{4}$in. London, National Gallery

As an impression quickly sketched in oils, this is unusual among Hogarth's portraits, but it possesses an amazing vivacity. Hogarth seems to have used only the simplest palette, but the play of tones in the flesh painting has delicacy as well as a naturalistic warmth.

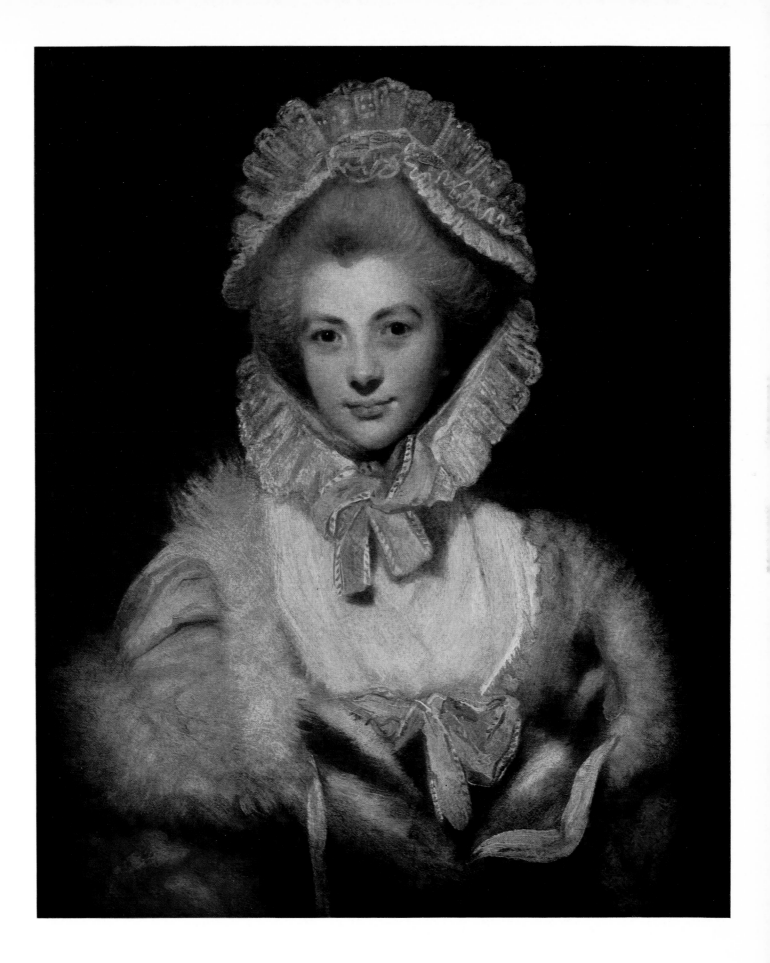

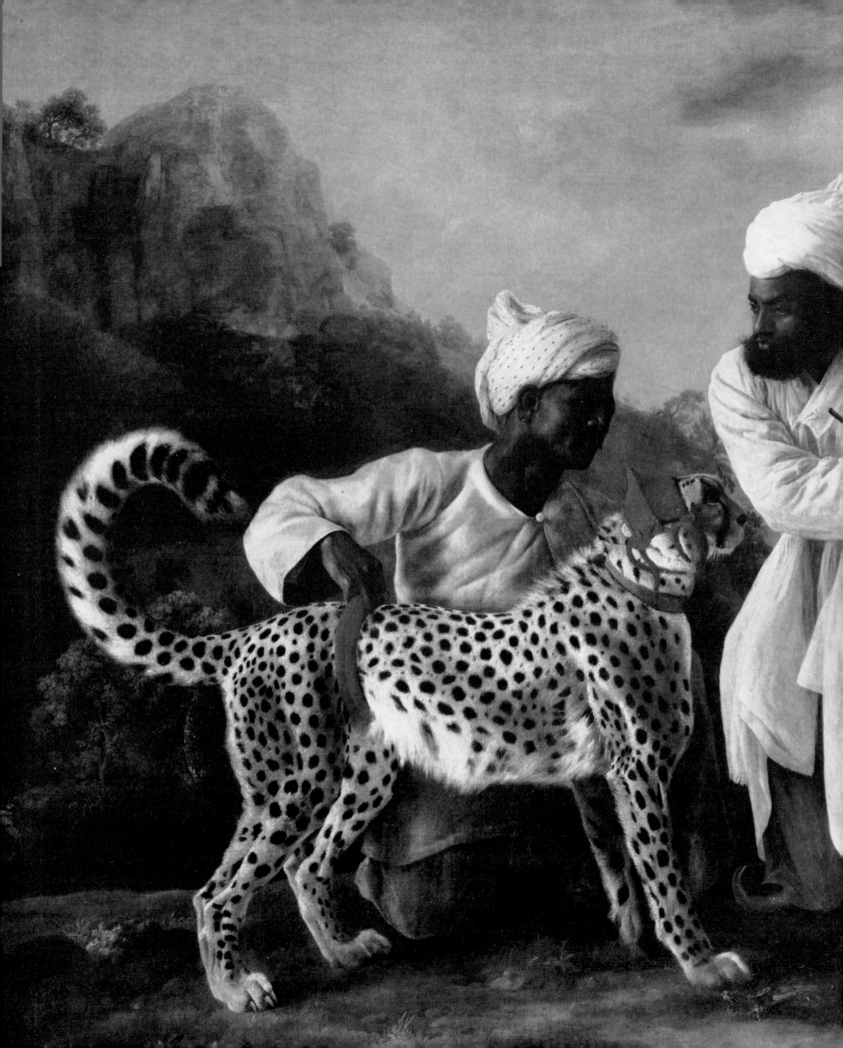

47

GEORGE STUBBS (1724–1806): *A Cheetah with two Indians*. About 1765. Canvas, 81 × 107in. Manchester, City Art Gallery

Though Stubbs was not a painter of the historic themes that called for grandeur of treatment, it would not be out of place to speak of the 'grand style' in a work so remarkable as this. The picture was painted to commemorate the gift of a cheetah to George III by Lord Pigot, Governor of Madras. The cheetah was sent to England in the care of two Indian servants and was set to hunt a stag in Windsor Great Park. The stag on the right was painted out in the 1880s, presumably on the grounds that it was too near the 'hunting tiger' that was to pursue it. Stubbs presumably intended an emblematic opposition of the animals, however, rather than a realistic distance between them.

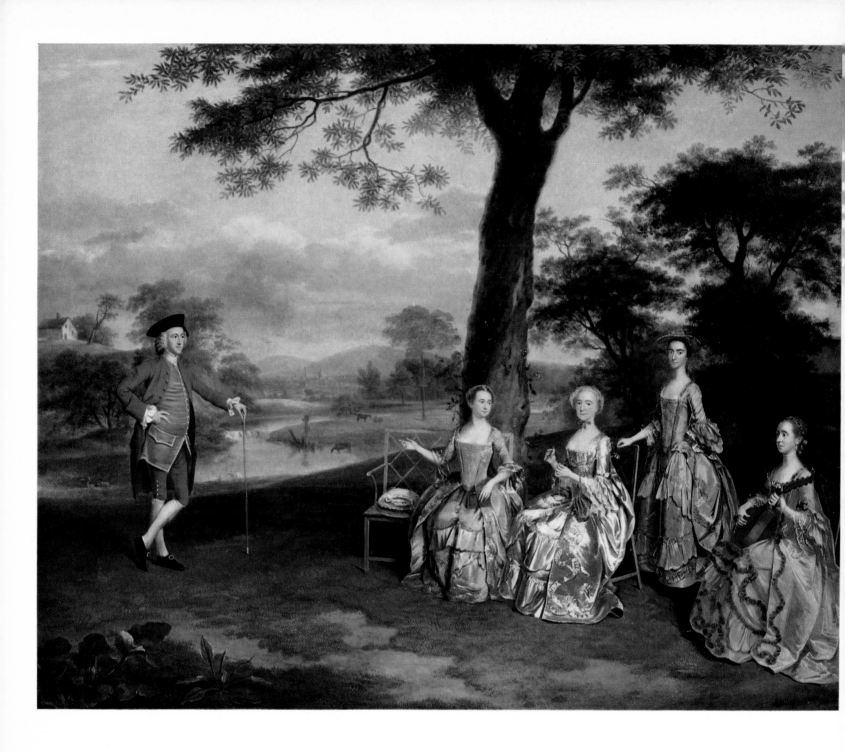

48 & 49 ARTHUR DEVIS (1711–87): *The Rookes-Leeds Family*. About 1763. Canvas, 36 × 49in. Private Collection

A later work than the artist's portrait of Mr and Mrs Atherton, this open-air conversation piece, though basically similar in manner, shows some relaxation of austerity and a more adventurous composition. A remark to the same effect might be made of the dress shown, in any comparison of the two works. It indicates the consistency of eighteenth-century fashion over a long period, but a growing elaboration and greater use of colour mark the second half of the century. It is assumed that the Rookes-Leeds group was painted no earlier than 1763, as only three daughters are portrayed. The fourth daughter would no doubt have been included, had she not died in that year. Edward Rookes, who stands so magisterially apart, added the name of Leeds to his own on marrying Mary Leeds of Royds Hall, Bradford, in 1740.

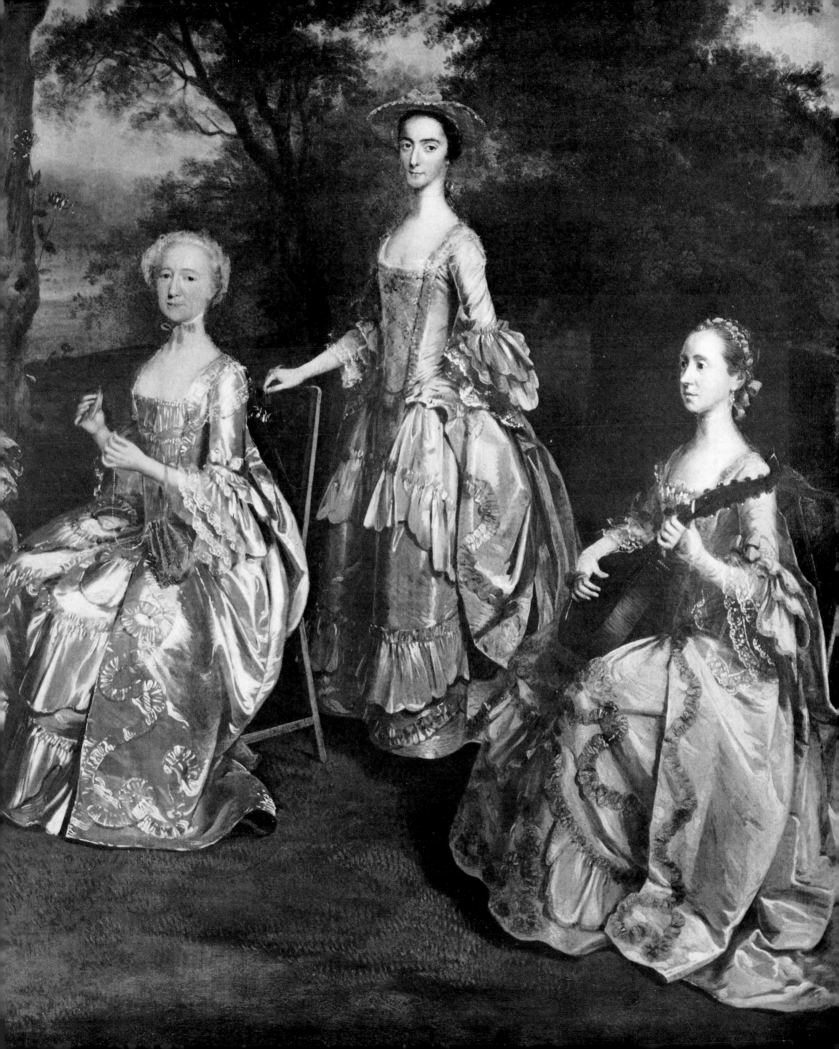

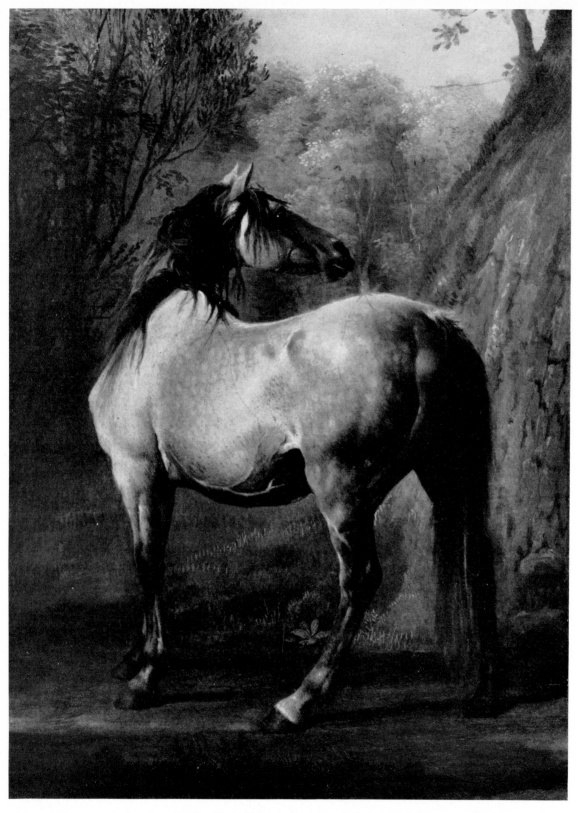

50 GEORGE STUBBS (1724–1806): Detail from *Mares and Foals by a Stream* (Plate 37)

51 & 52
GEORGE STUBBS:
Details from *The Grosvenor Hun*
(Plate XIX)

Stubbs dissected the horse wit
an analytical zeal worthy of a
Renaissance artist, and painte
the animal with an astonishing
skill. *The Grosvenor Hunt* is not
only one of Stubbs's own majo
achievements but is probably
finest English hunting picture
of its kind ever painted.

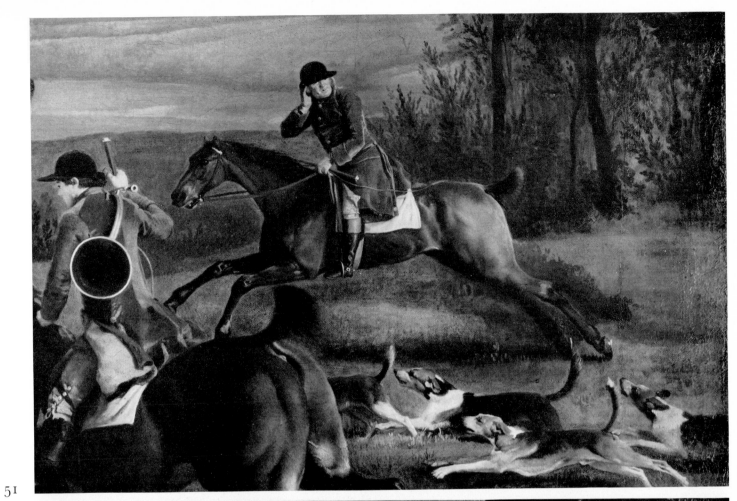

51

52

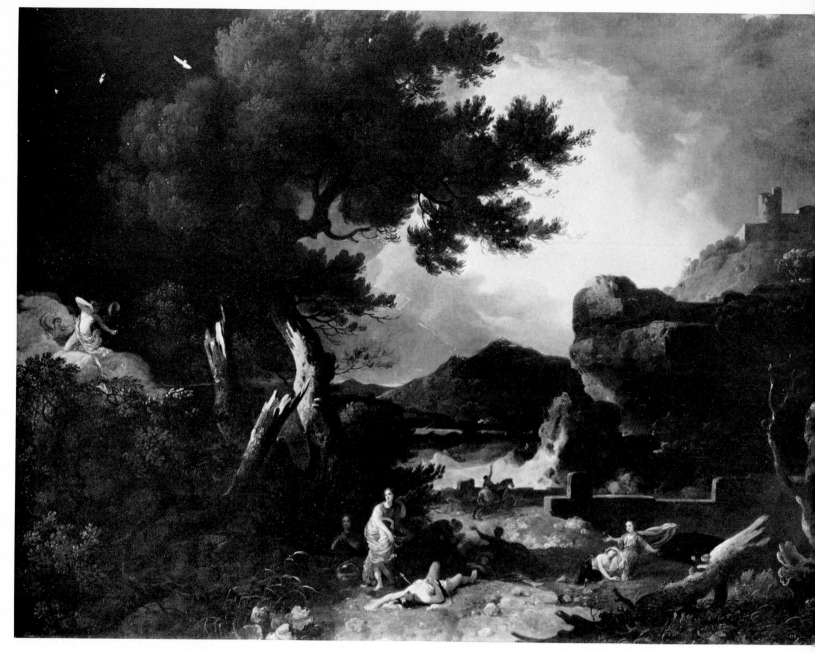

53 RICHARD WILSON (1714–82): *The Destruction of Niobe's Children.* 1760. Canvas, $57\frac{1}{4} \times 74\frac{1}{2}$in.
Collection of Mr and Mrs Paul Mellon

Wilson returned to England (after his years spent in Italy) about 1756, and sought to make an
impression by combining landscape and mythology in a way that had become popular in the
previous century and remained much in favour with English connoisseurs. One of his first pictures
in this classical vein, of which three versions exist, was the punishment of Niobe for the sin of pride
by the destruction of her children, her sons being slain by Apollo's darts and her daughters destroyed
by Diana; Niobe herself was turned to stone. The painting was shown at the first exhibition of the
Society of British Artists in 1760, where Wilson exhibited regularly until he became a founder
member of the Royal Academy in 1768.

BENJAMIN WEST (1738–1820): *Venus lamenting the Death of Adonis*. 1768. Pittsburgh Museum of Art, Carnegie Institute

It has been said of Benjamin West that he had everything an artist could want except genius. But in spite of the shortcomings of his work, it had an historical importance as an index of changing modes of expression. The neoclassic tendencies he had acquired in Rome gave him a success exceptional for a history painter in England in the 1760s; the present picture is characteristic of this phase. To embody in turn the classic, realist and romantic phases of his century was a feat in itself, which West was to achieve.

55 RICHARD WILSON (1714–82): *Snowdon from Llyn Nantlle*. Early 1760s(?). Canvas, 39½ ×49in. Liverpool, Walker Art Gallery

Wilson is quoted (Edward Dayes, *Essays on Painting*, 1805) as saying that 'everything the landscape painter could want was to be found in Wales'. Although his genius was developed in Italy, it found its magnificent fruition in the land of his birth. He was probably among the first painters to reveal the beauties of Wales in art, although Wales soon became a regular part of the artist's itinerary; the young Turner, for example, followed in Wilson's footsteps in Snowdonia in 1798 and 1799.

THOMAS GAINSBOROUGH (1727–88): *The Harvest Waggon*. 1767 (?). Canvas, 47¼×57in.
Birmingham, Barber Institute of Fine Arts

This great example of Gainsborough's imaginative landscape style was painted at a time when he
had become an enthusiast for the work of Rubens. *The Harvest Waggon* shows the Flemish master's
influence in Gainsborough's effort to carry energetic movement through the composition, and the
group of figures in the wagon makes a vigorous diagonal on the same compositional principle as
Rubens often employed. The free and fluent movement of the brushstrokes gives an indication of the
technique of restless brilliance Gainsborough was also to apply to drawings.

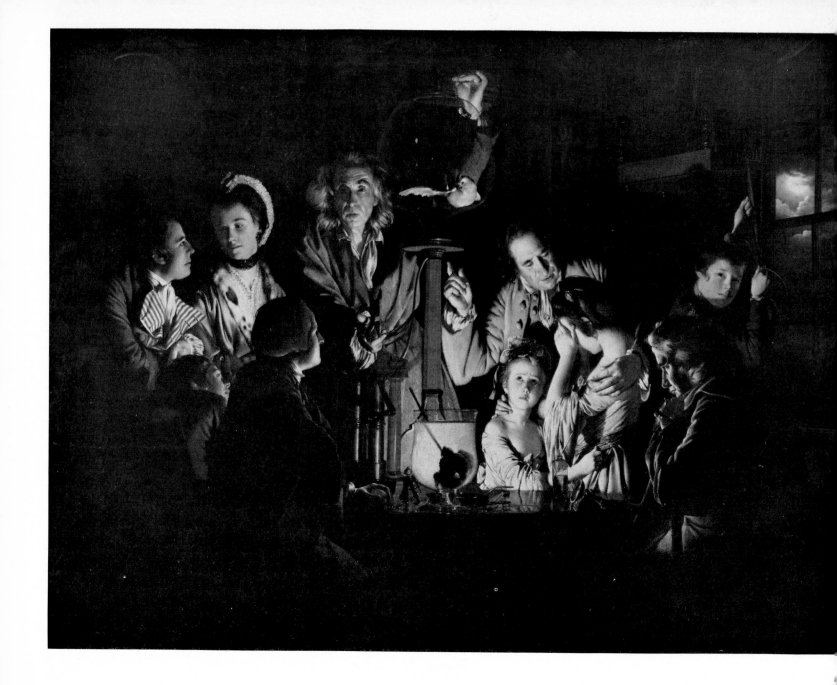

57 JOSEPH WRIGHT OF DERBY (1734–97): *Experiment with the Air Pump*. About 1768. Canvas, 72 ×96in. London, Tate Gallery

58 & 59 JOHANN ZOFFANY (1733/4–1810). *Bransby, Parsons and Watkins in 'Lethe'*. About 1766–70. Canvas, 39½ ×40in. Birmingham City Art Gallery

Different as these two pictures are in subject and feeling, they are of related interest in the use of the shadows projected by artificial light to give an intensification of character. This is one of the several facets of Wright of Derby's best-known work, in which he reflects the intellectual preoccupation with experiment so characteristic of the dawning industrial age. See also details (Plates 60 and 61).

Zoffany's expert faculty for giving the sensation of theatre appears in this scene from the 1766 performance of David Garrick's *Lethe* at Drury Lane Theatre. The players illustrated are Astley Bransby as Aesop, William Parsons as The Old Man and Watkins as The Servant.

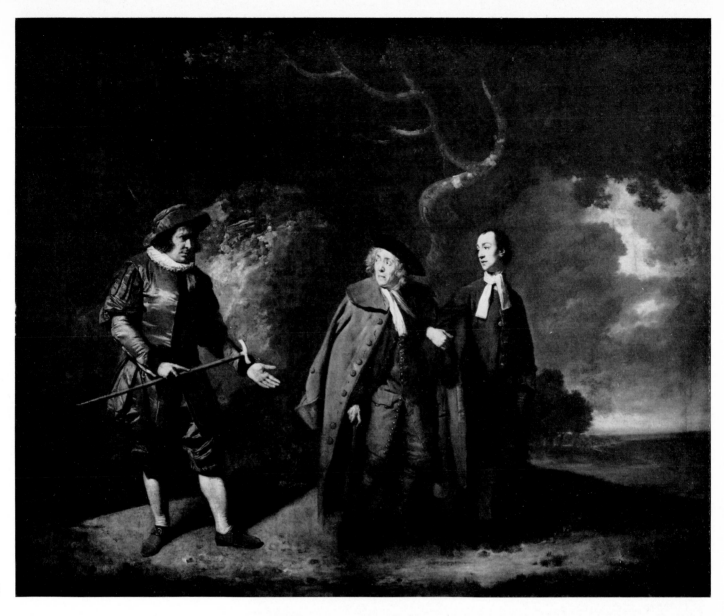

58

59

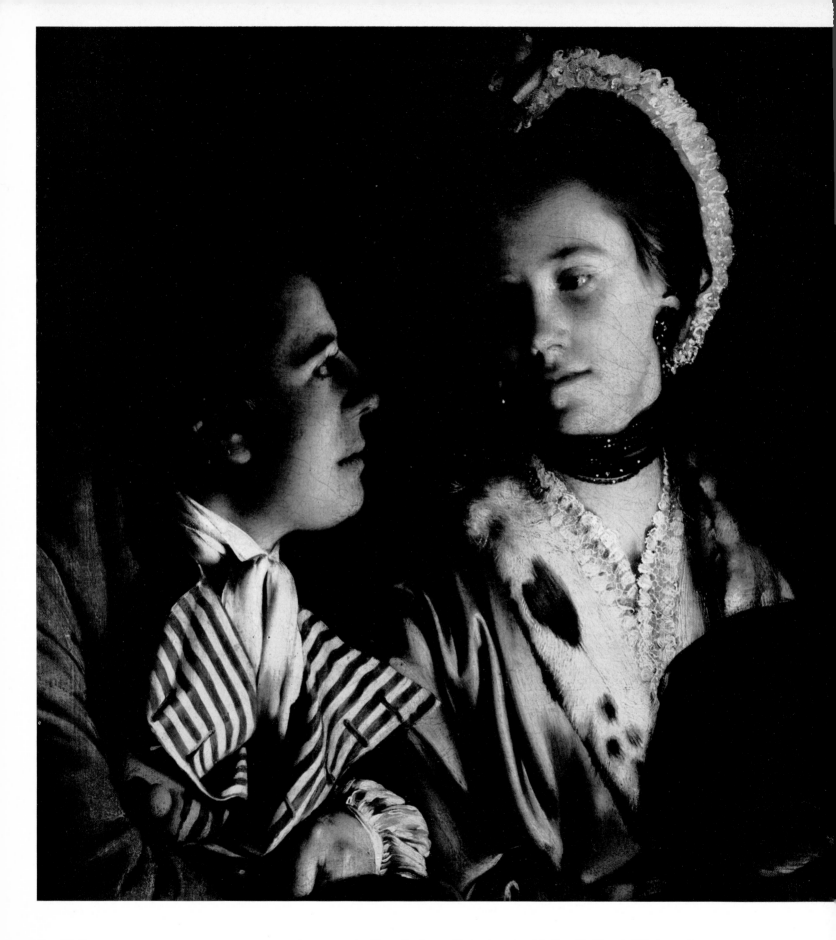

60 & 61 JOSEPH WRIGHT OF DERBY (1734–97): Details from *Experiment with the Air Pump* (Plate 57)

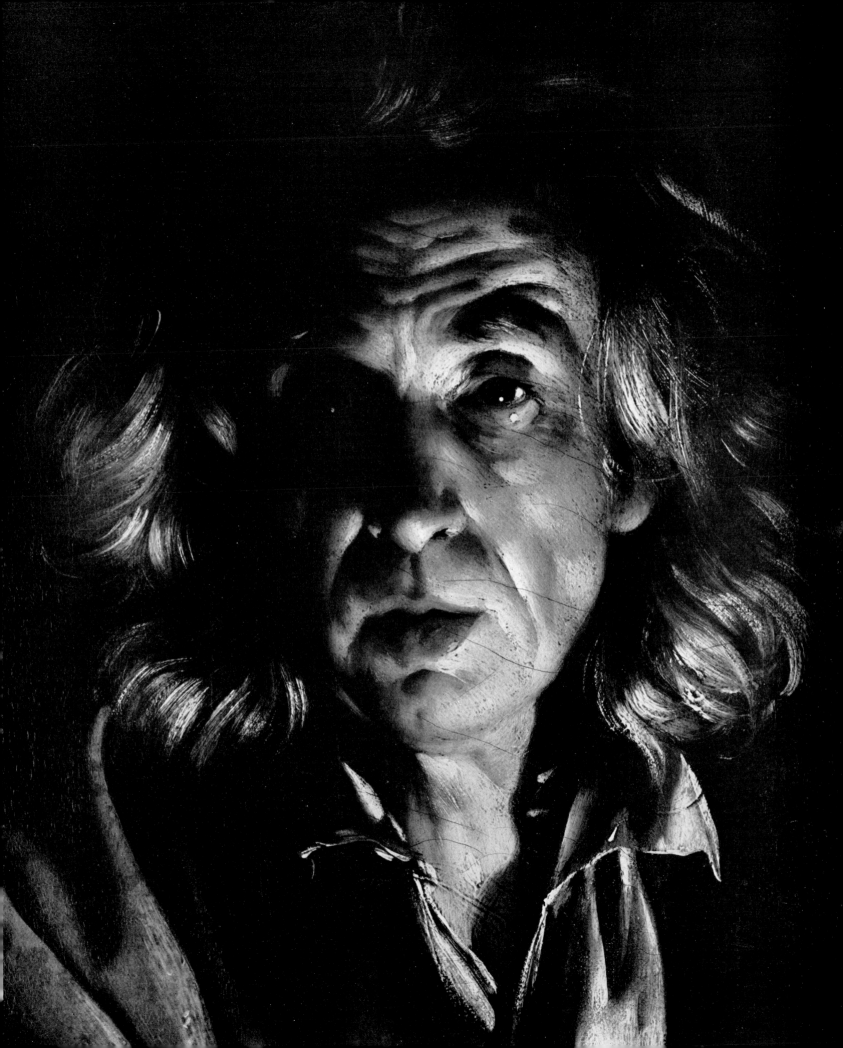

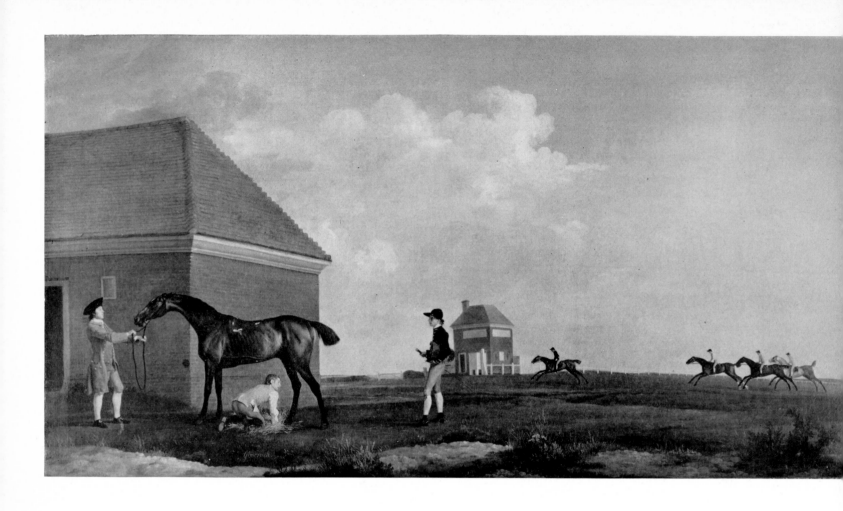

62 & 63 GEORGE STUBBS (1724–1806): *Gimcrack with a Groom, Jockey and Stable Boy on Newmarket Heath.*
About 1765. Canvas, 40 × 76in. Private Collection

Painted for Viscount Bolingbroke (when he was the owner of the celebrated racehorse portrayed), this picture is one of Stubbs's greatest works. The simplicity and completeness of the design and the sense of space are alike remarkable. It is two episodes in one, for Gimcrack appears in the foreground outside the Rubbing-Down House at Newmarket, and in the background as an easy winner in one of the 27 out of 35 races in which he came in first. This in no way interferes with the unity of the composition. Stubbs evidently worked out a geometrical relation of forms with extreme care—a reason why a simple building like that at the left, which might so easily have been dull, becomes an interesting shape against the varied outline of horse and groom. The riders at the rear have their necessary place in the whole plan.

With the faculty of a great master for transcending the limits of so specialized a genre as the sporting picture, Stubbs displays his gift of characterization in the figures included: the groom, in whom one can see a recognizable type; the stable boy (see detail, Plate 38), whose kneeling pose is observed with so much naturalism; and the approaching jockey, who wears Lord Bolingbroke's colours (detail, opposite). The artist still adhered to the impossible convention of the gallop with both fore and hind legs of the horses outstretched, but the sensation, if not the actuality, of movement is given none the less.

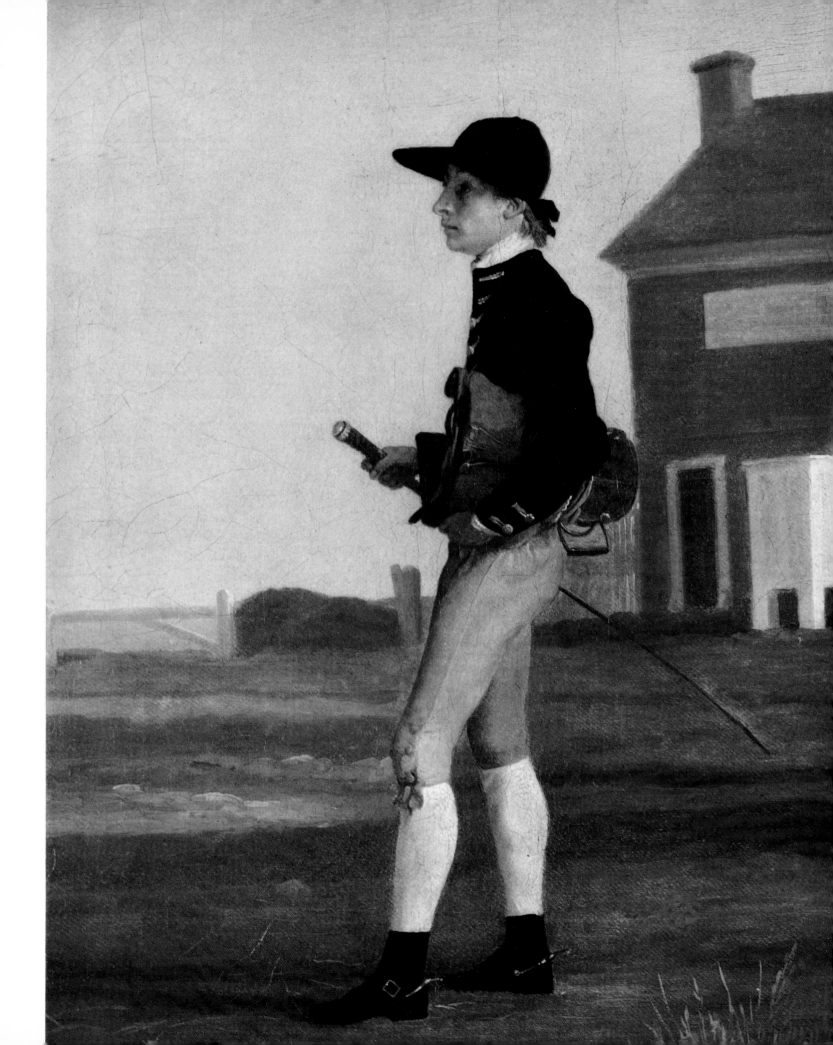

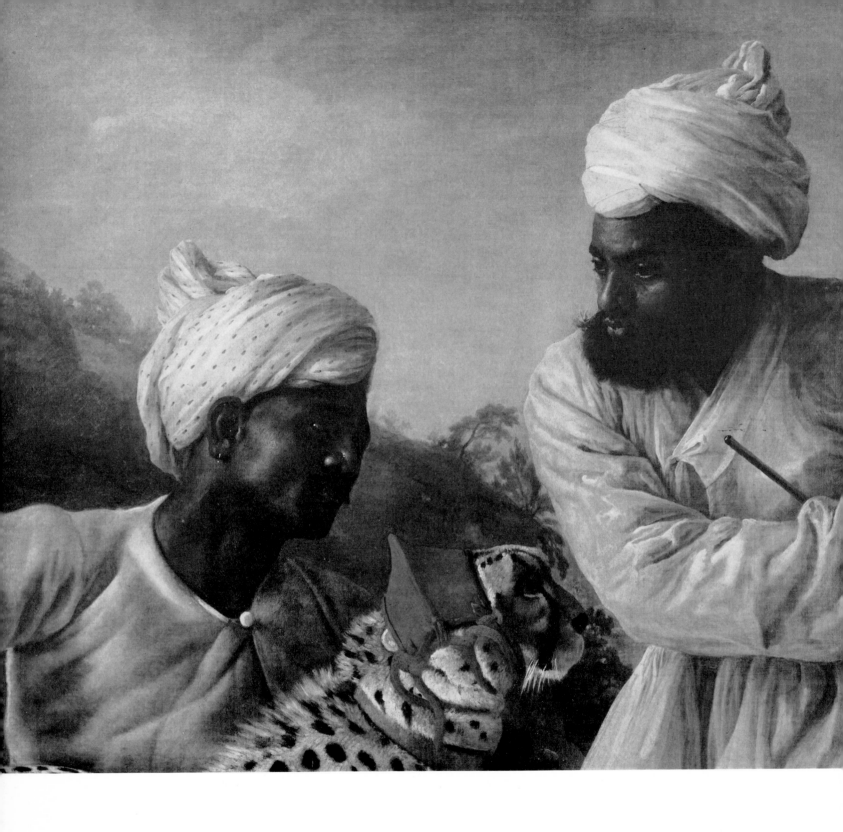

GEORGE STUBBS: (1724–1806):
Detail from *A Cheetah with two
Indians* (Plate 47)

SIR JOSHUA REYNOLDS
(1723–92): *Omai*. Canvas,
93 ×57½in. Castle Howard

Both Stubbs and Reynolds in the
portraits here reproduced are
distinctly successful in portraying
the types which overseas expansion
brought into English ken. With his
great gift of empathy, Stubbs not
only portrays the two Indian
servants realistically, but seems
also to penetrate deeply into their
psychology. A newer phenomenon,
from the South Seas, was Omai,
whom Reynolds paints with less of
an impression of strangeness.
Dr Johnson, who was struck by the
'elegance' of Omai's behaviour,
accounted for it with typical
incisiveness as follows: 'Sir, he had
passed his time while in England,
only in the best company; so that
all he had acquired of our manners
was genteel. As a proof of this,
Sir, Lord Mulgrave and he dined
one day at Streatham; they sat with
their backs to the light fronting
me so that I could not see distinctly;
and there was so little of the savage
in Omai that I was afraid to speak
to either lest I should mistake one
for the other.'

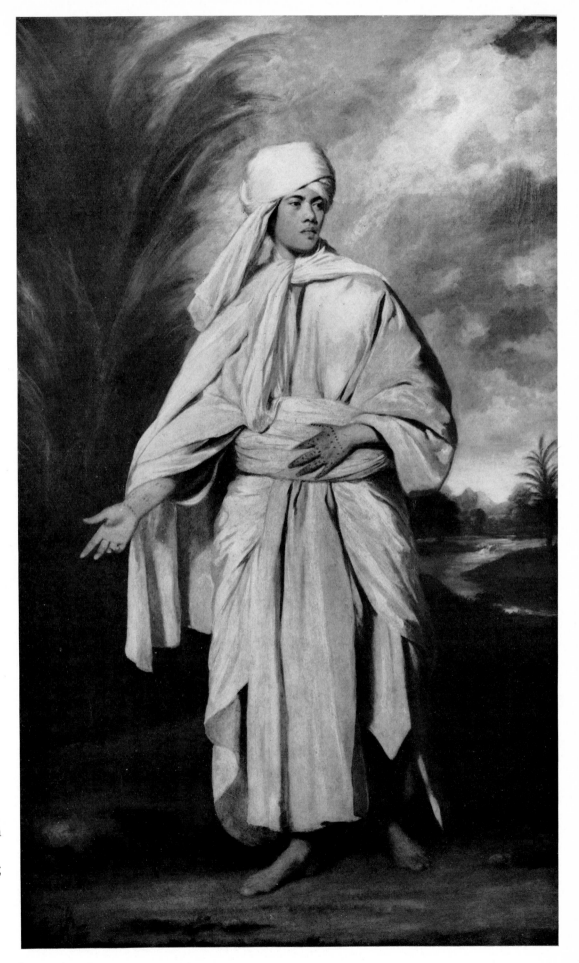

66 WILLIAM HODGES (1744–97): *A Crater in the Pacific.* About 1775–7. Canvas, 40 ×50in. Brighton Museum and Art Gallery

A central event in Hodges's varied career was his appointment as draughtsman to Captain Cook's second expedition to the South Seas. This was in 1772, when the artist was twenty-eight. His drawings were published with the narrative of the expedition and on his return at the end of three years he also painted views of Tahiti and other islands for the Admiralty. This painting is an example.

57 WILLIAM HODGES (1744–97): *View in Dusky Bay, New Zealand.* 1776. London, The Lords
Commissioners of the Admiralty

Hodges was a consistent follower of the style of Richard Wilson, whose pupil he had been, and it
was with eyes conditioned by Wilson's civilized breadth of vision that he recorded the appearance
of the exotic places he visited. Hodges came to Dusky Bay on board Captain Cook's *Resolution*
in 1773. The views in the Pacific were the prelude to more pictorial adventure; in 1780 Hodges, like
other English artists attracted by stories of the fortunes to be made in India, sailed for Madras.

68 BENJAMIN WEST (1738–1820): *The Death of Wolfe.* 1770. Canvas, 59½ ×84in. Ottawa, The National Gallery of Canada

General James Wolfe (1727–59), who led the British to decisive victory over the French in the siege of Quebec in September 1759, met a hero's death in the engagement, which was to become a popular artistic subject, portrayed also by such artists as Penny, Barry and Romney. West's painting was revolutionary in that the figures are in contemporary, rather than the traditional classical dress. Reynolds is said to have strongly advised West against using modern dress, but on seeing the finished painting he admitted that West had achieved a great success. The picture represents a new type of history painting, marking the beginning of the shift away from classical subjects to the rendering of national, contemporary events. The composition clearly evokes the traditional representation of the Mourning over the dead Christ.

59 JOHN SINGLETON COPLEY (1738–1815): *Brook Watson and the Shark*. 1778. Canvas, $71\frac{3}{4} \times 90\frac{1}{2}$in. Washington, D.C., National Gallery of Art

Like *The Death of Major Pierson* (Plate 76) this painting (which created a sensation when shown at the Royal Academy in 1778) is an example of Copley's fondness for an intensely dramatic situation that already anticipates the romantic movement. Brook Watson (1735–1807), born in England and orphaned when very young, went to live with a relative in Boston who, in 1747, sent him on a voyage to the West Indies. It was on this voyage that he lost his leg to a shark in the harbour of Havana; this is the incident Copley depicts. Just as a certain anticipation of Delacroix may be found in *The Death of Major Pierson*, so there is a foretaste of the nightmare and anguish of Géricault's *Raft of the Medusa* (Paris, Louvre) in the *Brook Watson*.

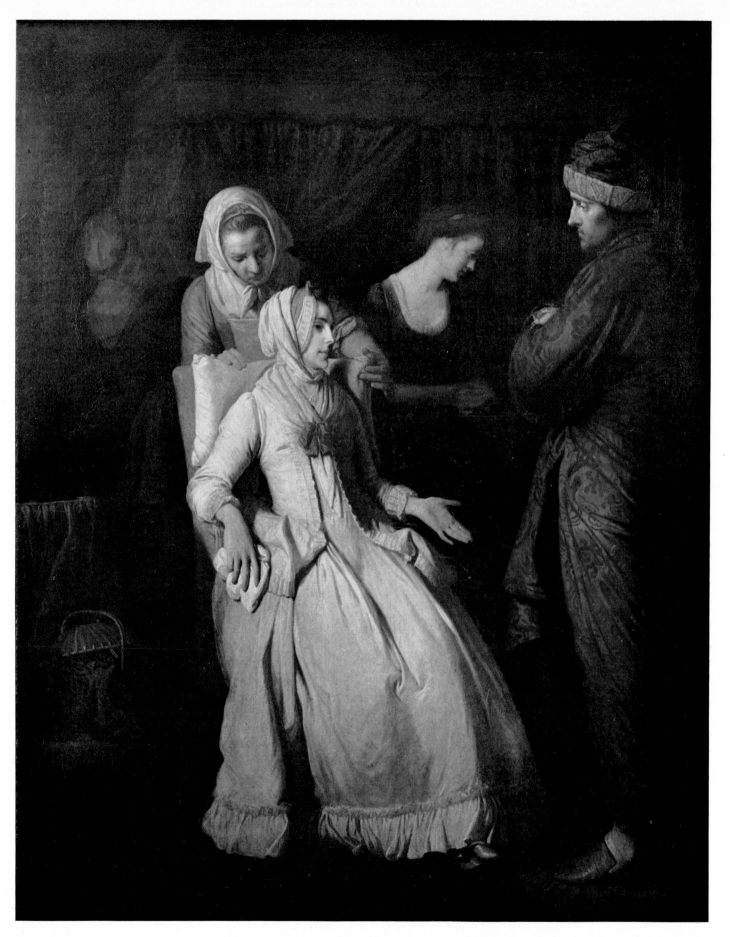

70 EDWARD PENNY (1714–91): *The Virtuous comforted by Sympathy and Attention.* 1774. Canvas, 50 × 40in. Private Collection

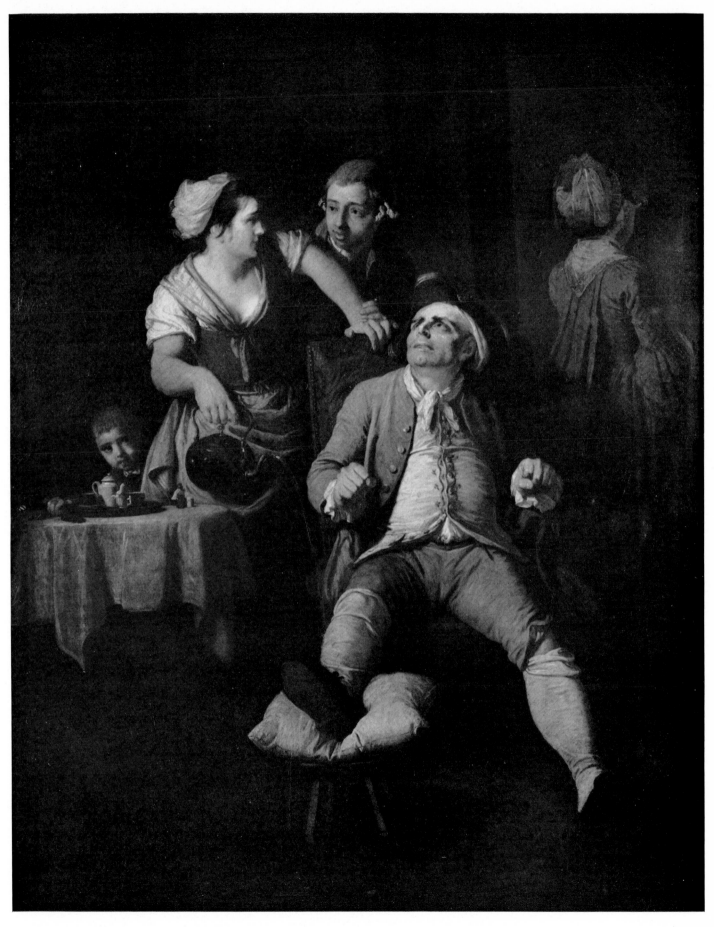

71 EDWARD PENNY: *The Profligate punished by Neglect and Contempt.* 1774. Canvas, 50 ×40in. Private Collection

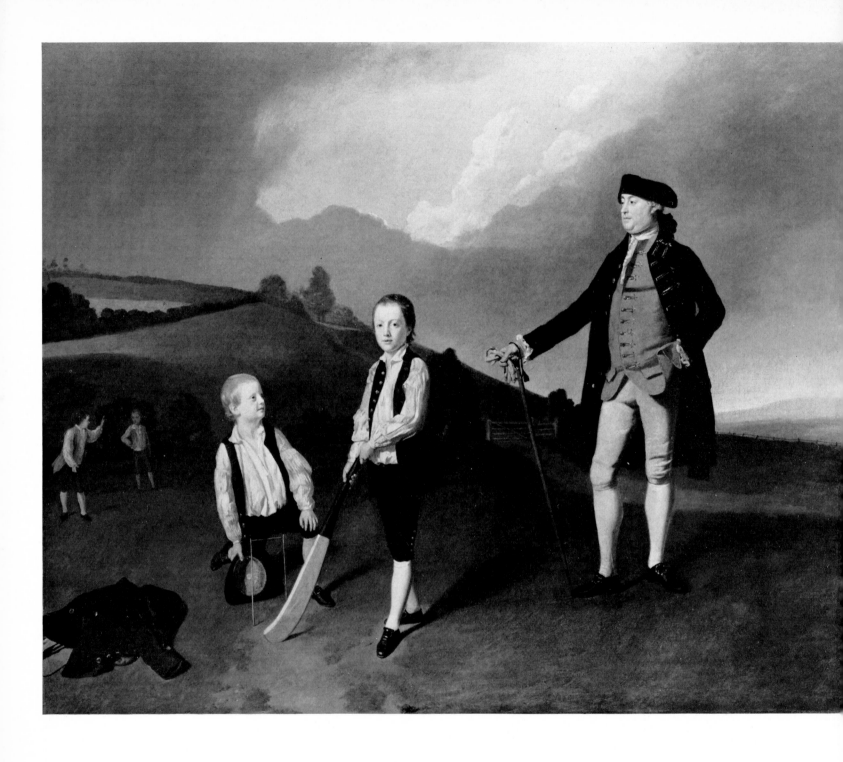

72 HENRY WALTON (1746–1813): *Cricket Scene at Harrow School*. About 1771. Private Collection

73 HENRY WALTON: *A pretty Maid buying a Love Song*. 1778. Canvas, 37 × 29in. Private Collection.

Henry Walton, like Edward Penny, marks a stage in the development of a middle-class genre, not venturing into such depths as Hogarth had brought to view, nor on the other hand aspiring to the heights of history painting. The characters of *A pretty Maid buying a Love Song* have already a nineteenth-century look in the relation pointed out not only between youth and age but between the well-to-do and the poor. Walton was a careful observer, and though there is no great aesthetic value in his picture of cricket at Harrow, it reports with interesting precision on the nature of the game at that time.

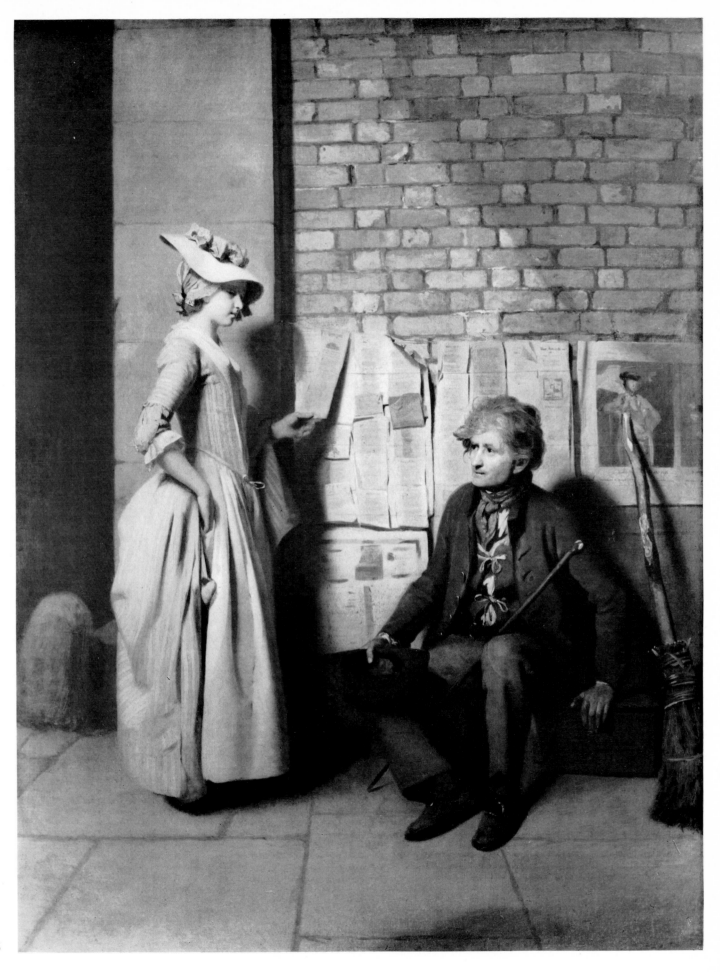

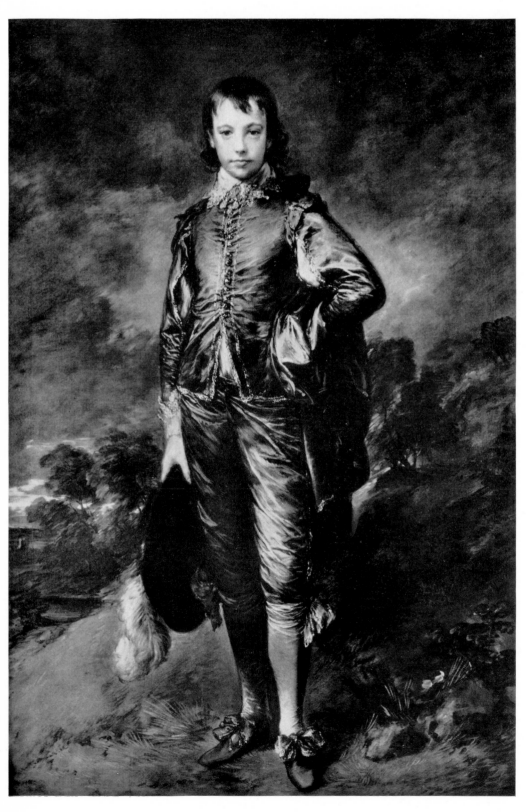

74 THOMAS GAINSBOROUGH (1727–88): '*The Blue Boy*'. 1770 (?). Canvas, 70 ×48in. San Marino, California, Henry E. Huntington Library and Art Gallery

75 THOMAS GAINSBOROUGH (1727–88): *The Artist's Daughters*. Early 1770s. Canvas, 91 ×59in. Private Collection

The portrait of Master Jonathan Buttall, who has gained anonymous fame as 'The Blue Boy', represents the vogue for fancy dress, which Reynolds and Zoffany also illustrate (Plates 95 and 96). The 'Van Dyck' costume he wears is a reminder of the influence the seventeenth-century master had on Gainsborough's style and aims. He is said to have adopted the colour scheme in answer to the challenge that blue could not be successfully made the dominant factor in a painting—which Gainsborough (whether or not the story is true) was well able to disprove. The picture of his daughters when they were mature young women should be compared with his image of them as children (Plate 34).

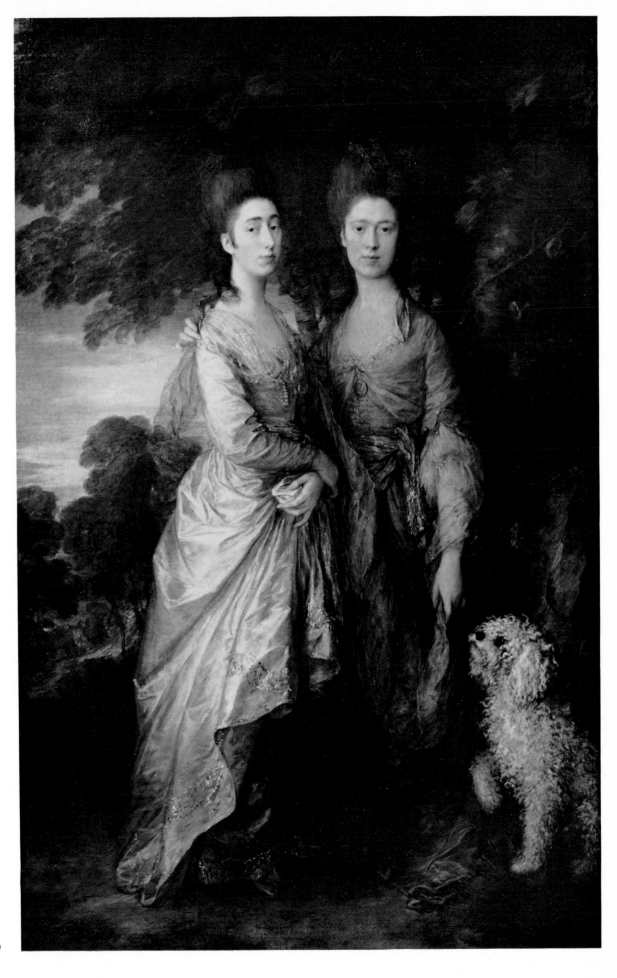

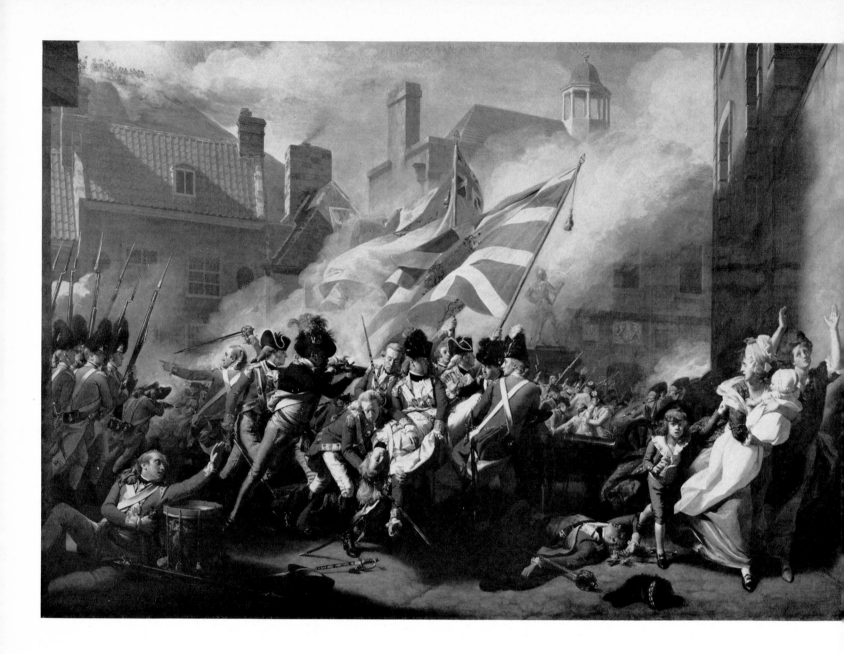

76 & 77 JOHN SINGLETON COPLEY (1738–1815): *The Death of Major Pierson.* 1783. Canvas, 97 × 143in. London, Tate Gallery

Copley followed West in the depiction of contemporary history in the grand manner that the latter pioneered with his *Death of Wolfe* in 1771 (Plate 68). Besides *The Death of Major Pierson,* Copley's two other chief works in this mode are *The Death of the Earl of Chatham,* depicting Chatham's collapse in the House of Lords when advocating the acknowledgement of American independence, painted in 1779–80 (London, Tate Gallery; on loan to the National Portrait Gallery), and *The Siege and Relief of Gibraltar* (Plate 127). Major Pierson was commander of the British garrison and the Jersey Militia when the French, under Baron Rullecourt, attacked St Helier, Jersey, on 6 January 1781. Pierson, who was only twenty-four, was killed in the battle, and the mêlée centres round the removal of his body from the field in Copley's picture of the event. He gives it a tremendous verve and it is remarkable that such a large canvas should be so spirited and so little laboured in appearance. The figures of the women with the infant and small boy, hurrying from the scene to the right, convey a classic sense of tragedy.

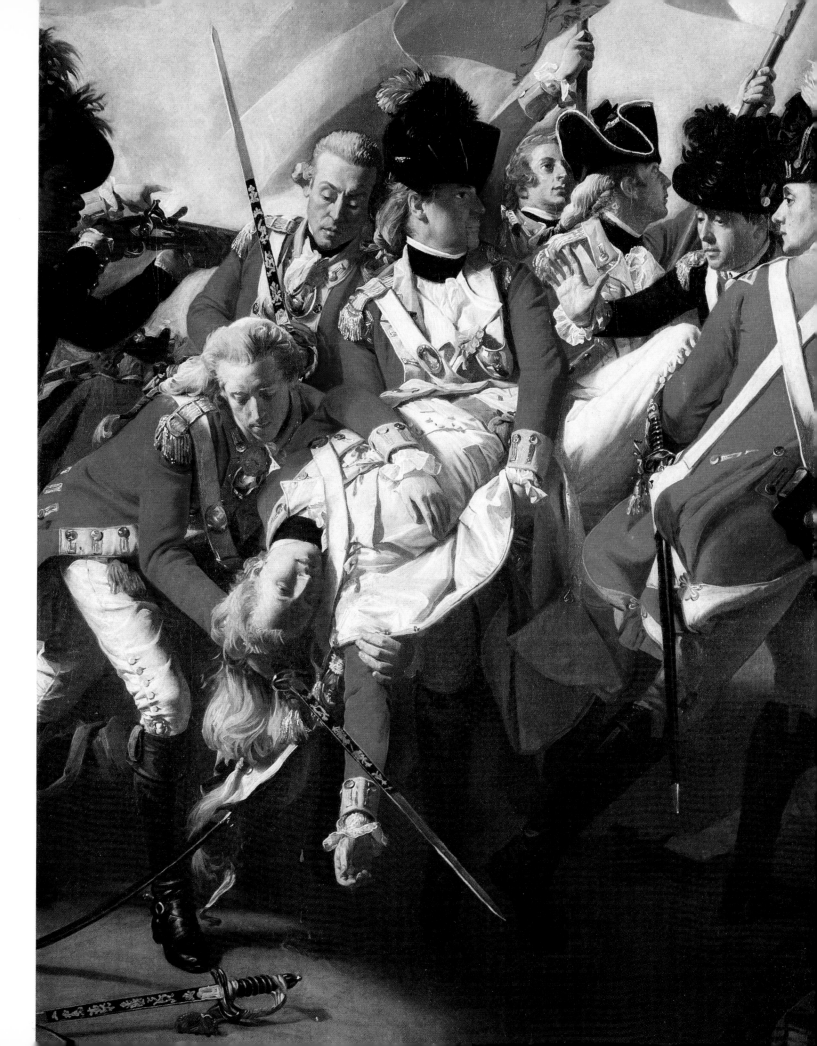

78

GEORGE STUBBS (1724–1806):
The Reapers (*detail*). 1784. Panel,
35½ ×54in. Private Collection

Stubbs painted a number of
versions of farming subjects in
the same way as he produced
variants on the themes of mares
and foals (Plates 37 and 50) and
of a horse attacked by a lion
(Plates 81 and 82). He made
many drawings and studies of
reapers and haymakers, and
evidently used them in composing
the finished works in oil and also
in enamel colours on wedgwood
plaques; there are versions of the
reapers in both media. He gave
characteristic care and
deliberation to the design of this
painting. The attitudes of the
reapers at work under the
surveillance of the farmer on his
horse are nicely differentiated;
at the same time Stubbs
introduces a rhythm of
movement into the whole line of
workers, punctuated by the
standing figures of the girls
gathering up the corn for the
stooks. It is a picture that also
conveys how lovely rural
England was in the eighteenth
century. What Arthur Young
called 'the magic of property'
had made the land a delight to
the eye. The trees and hedges
had a special beauty; bounteous
harvests, such as Stubbs depicts,
repaid the attention landowners
had been giving to improved
methods of cultivation.

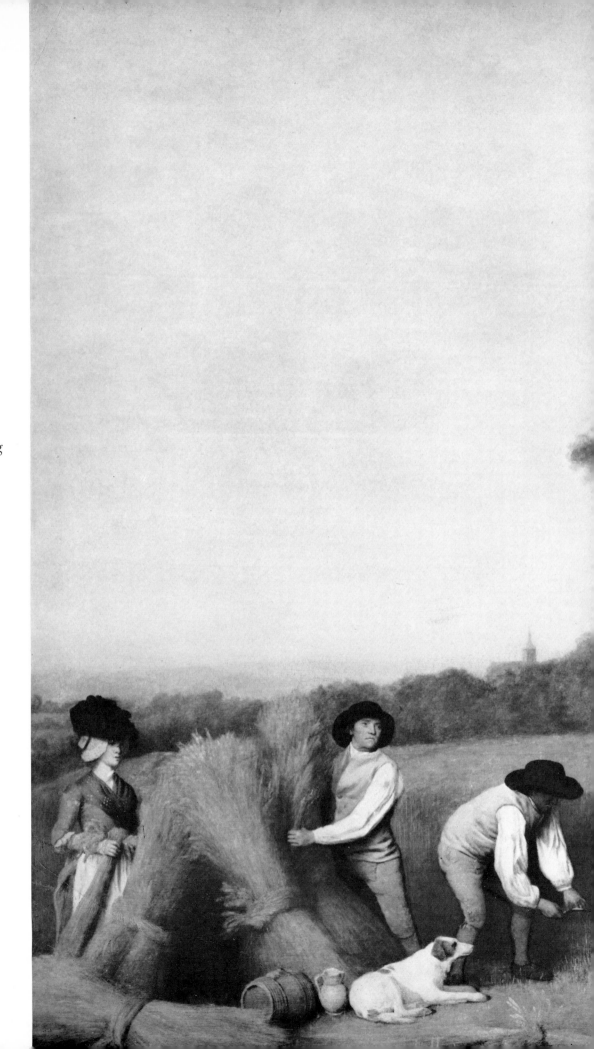

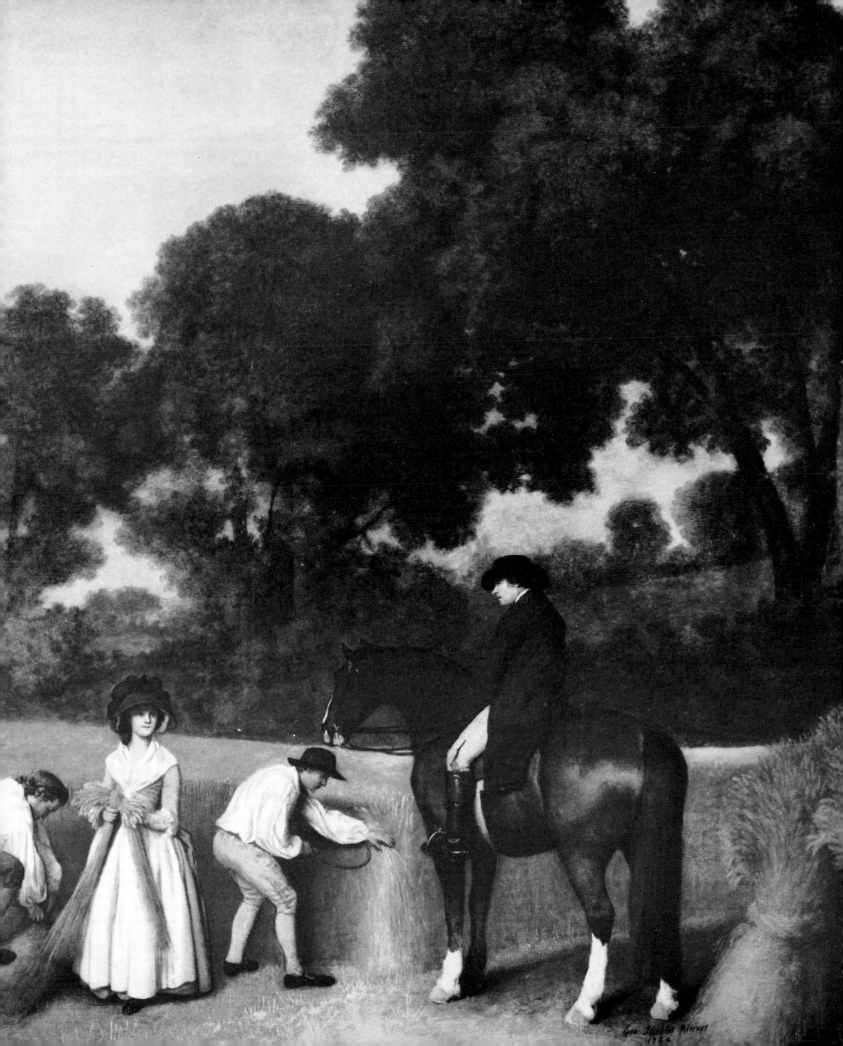

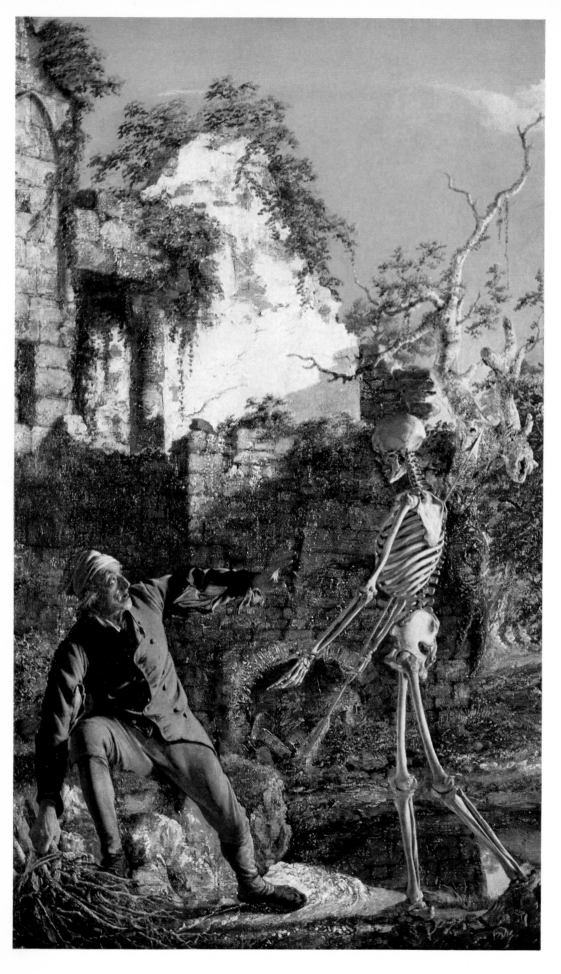

79 JOSEPH WRIGHT OF DERBY:
Detail from Plate 80

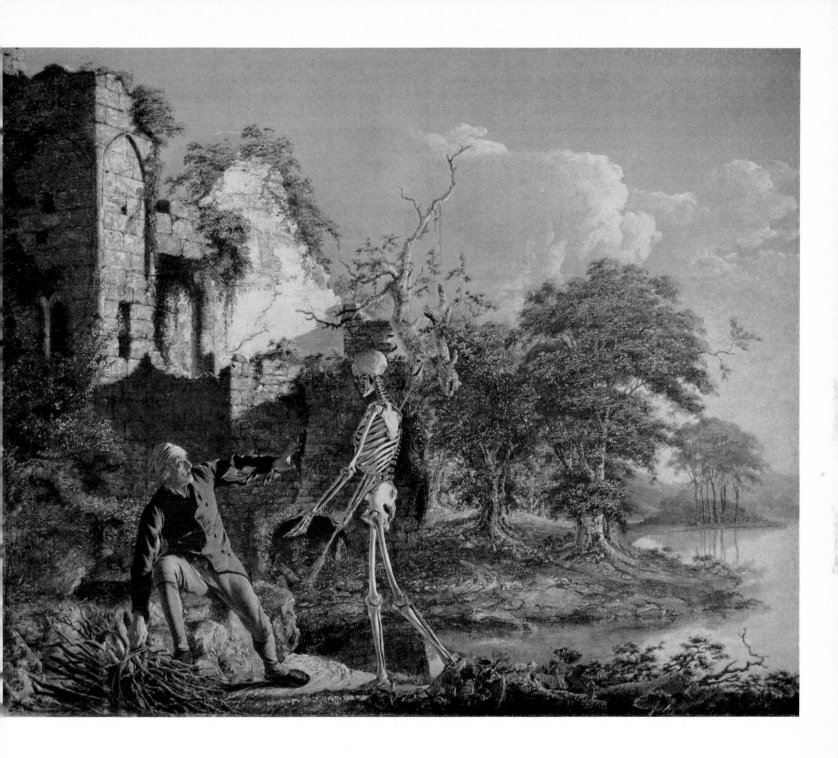

80 JOSEPH WRIGHT OF DERBY (1734–97): *The old Man and Death*. About 1774. Canvas, 40 × 50in. Hartford, Wadsworth Atheneum

The movement towards romanticism is already perceptible in the later years of the eighteenth century in paintings expressive of strong emotion. It was a mood that inclined artists in their choice of Shakespearian subjects to prefer King Lear and Macbeth and otherwise to concern themselves with subjects in which there was violent feeling to be given external form. Wright concentrates in this painting on terror and its physical manifestation. The fear of death is clearly imprinted in the countenance of the old man.

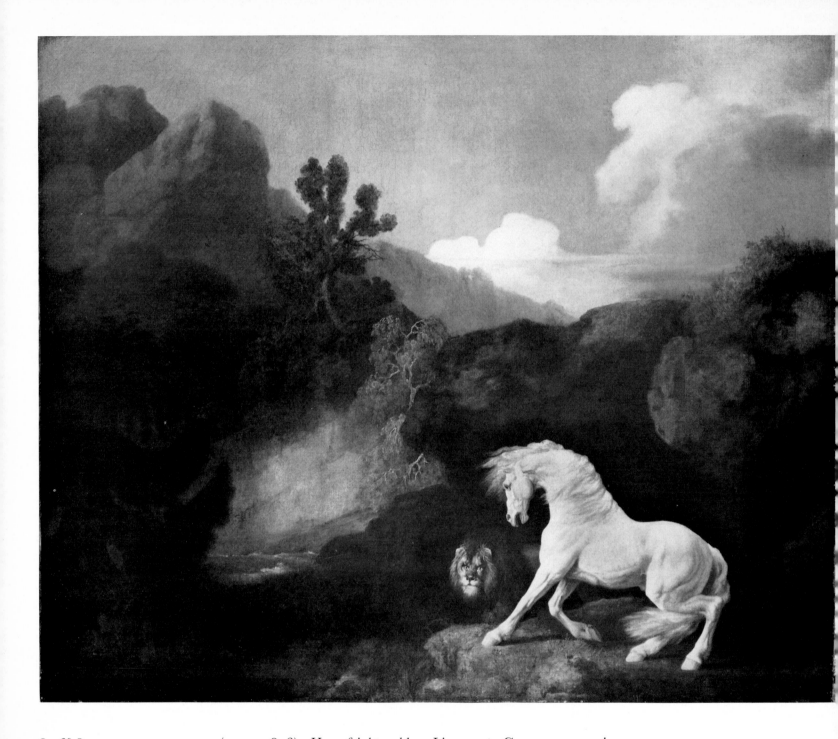

81 & 82 GEORGE STUBBS (1724–1806): *Horse frightened by a Lion*. 1770. Canvas, 40 ×50in.
Liverpool, Walker Art Gallery

Animal terror and violence—themes which haunted the imagination of artists both
in France and England at the turn of the century—appealed to the romantic in Stubbs.
He applied a complex ingenuity to the theme of horse and lion, not only producing
several versions of the lion's attack but of the different phases of the encounter. The
fright of the horse, sensing the lion's skulking presence, precedes the lion's spring on
to the horse's neck. Mr Basil Taylor has given a considerably more convincing
origin for Stubbs's conception of the theme than Ozias Humphry in *The Sporting
Magazine* for May 1807; Mr Taylor relates it to an ancient sculpture to be seen in
Rome rather than to the doubtful actual presence of a lion in north Africa seen by
Stubbs on his way back from his visit to Italy.

83 & 84 PHILIP JAMES DE LOUTHERBOURG (1740–1812): *A Midsummer's Afternoon with a Methodist Preacher*. 1777. Canvas, 38 × 49¾in. Ottawa, The National Gallery of Canada

De Loutherbourg was an artist of varied attainments and interests, whose work includes battle scenes, rural genre and landscapes. In spite of an appearance of rural tranquillity, the painting reproduced here records a phase of eighteenth-century life as momentous as any 'drum and trumpet' episode—the open-air meetings conducted by John Wesley and his fellow evangelists when no longer allowed to preach in Anglican churches. That de Loutherbourg witnessed such a meeting and that it left a vivid impression on him is a conclusion that may be drawn from the absence of any effort to heighten the effect by artifice of composition. It is a sober eye-witness statement, carrying conviction that this is just how everything appeared—the Methodist preacher earnestly holding forth in his pulpit, and strollers whose attitude and finery suggest something of the sceptical resistance of the century to 'enthusiasm'.

85 THOMAS PATCH (1725–82): *A distant View of Florence*. About 1763. Canvas, 46 ×91¼in. Kensington Palace. Reproduced by gracious permission of Her Majesty The Queen

86 THOMAS JONES (1743–1803): *View of the Bay of Naples*. 1780. Canvas, 36 ×50½in. Private Collection, formerly in the possession of M. Bernard

87 THOMAS JONES: *Rooftops, Naples*. 1782. Canvas, 5¾ ×13¾in. Oxford, Ashmolean Museum

There were many interesting painters of the great period who spent much time abroad. Among them was Thomas Patch, who went to Florence in 1756 and remained there for the rest of his life, painting views of the city and caricature groups of the Grand Tourists of the time. The panoramic view of Florence represents Patch's serious efforts and was taken from high ground presumably in the region of Bellosguardo.

Another artist with special links with Italy was the Welsh painter, Thomas Jones, who recorded his debt in art to 'that great man and my old master', Richard Wilson, whose pupil he was from 1763 to 1765. Jones's oil studies of Naples are accounted his most original productions. Although he was also prolific in watercolour, it was especially in his small paintings of buildings in oil on paper that he produced works which were unusual in colour and design. It is possible that in these paintings he was influenced by the French landscape painter, Pierre-Henri Valenciennes (1750–1819), who travelled in Italy and whom Jones could have met at Rome or Naples.

88 JOSEPH WRIGHT OF DERBY (1734–97): *A Grotto in the Kingdom of Naples with Banditti.* 1779. Canvas, 48 ×68in. Private Collection

89 JOHN HAMILTON MORTIMER (1741–79): *Bandit taking up his Post.* Late 1770s. Canvas on panel, 14 ×10⅛in. Detroit Institute of Arts

The vogue for pictures of banditti in the latter part of the eighteenth century reflected the esteem in which Salvator Rosa, painter of so many bandit-like figures, was held, and the fascination for artists of a picturesque southern Italy of peasants and outlaws. As they were friends, it is not surprising to find Wright and Mortimer both providing their versions of the theme about the same period. Mortimer's painting is assigned to the middle or late 1770s and Wright's is signed and dated 1779. Mortimer's bandit, with his roughness of gesture and run-down, semi-military appearance, is the more Salvatorian in character. Wright was as much taken up with the strangeness of rock formation in the cavern that sheltered his bandits as with the figures themselves.

89

90

91

90 THOMAS GAINSBOROUGH (1727–88): *White Dogs: Pomeranian Bitch and Puppy*. About 1777. Canvas, 32¾×44in. London, Tate Gallery

91 GEORGE STUBBS (1724–1806): Detail from *Huntsmen setting out from Southill* (Plate 36)

92 GEORGE STUBBS: *Poodle in a Boat*. Canvas, 50×40in. Collection of Mr and Mrs Paul Mellon

The eighteenth-century masters painted animals beautifully; dogs as well as horses were among their favourite subjects. They had a special interest for the portrait painter in contributing to the informality and intimacy of effect so often sought, and were extremely useful in completing a composition. Gainsborough, Reynolds and Stubbs all painted them incidentally, and here Gainsborough's picture makes an excellent portrait group with canine 'sitters' only. The dogs belonged to his friend, C. F. Abel, and the portrait was made for their owner in return for lessons on the viol da gamba, the musical instrument of which Gainsborough was particularly fond. As in his paintings of human beings, he concentrated on the eyes for expression. Carefully observed in perspective the eyes of the larger dog especially sparkle with life.

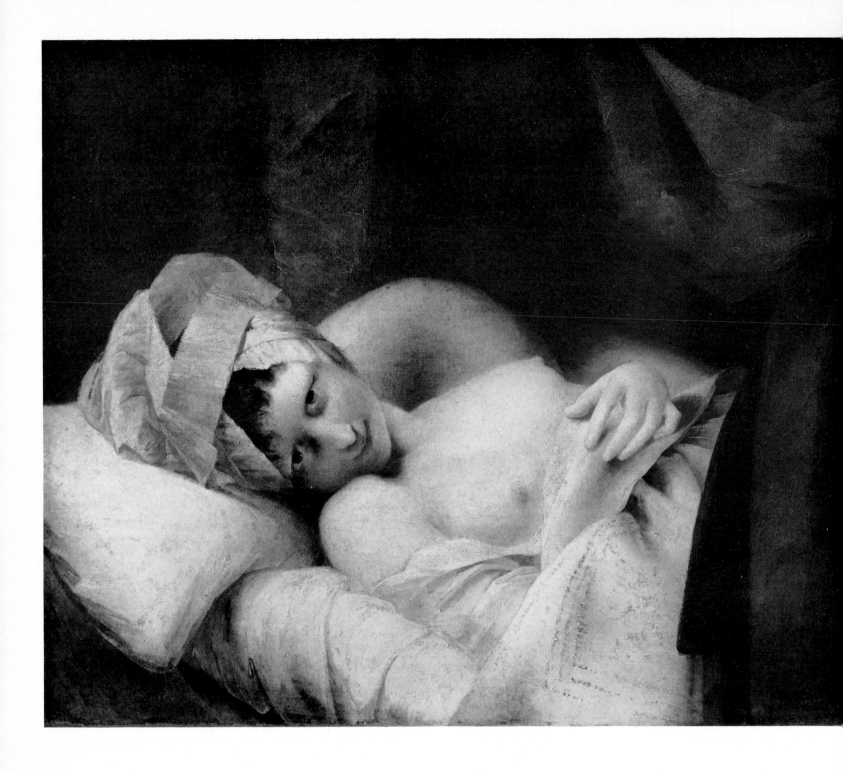

93 THE REVEREND MATTHEW WILLIAM PETERS (1742–1814): *Woman in Bed.* 1777. Canvas, 24 ×29½in. Private Collection

This picture, sometimes known by the title of *Lydia*, was one of a number of versions, and when exhibited at the Royal Academy in 1777 it caused some controversy as being 'daring'. If this quality is identified with a certain coquettish charm and an ably painted mixture of the voluptuous and the ingenuous, it could be regarded as typical of the artist. He painted much besides, however, and of a different kind after he became a clergyman. He first studied art in Dublin, found patronage that enabled him to go to Italy when twenty-one, and on his return gained success as a painter of portraits and 'fancy pictures'. He was elected a Royal Academician in the year he exhibited the *Woman in Bed*.

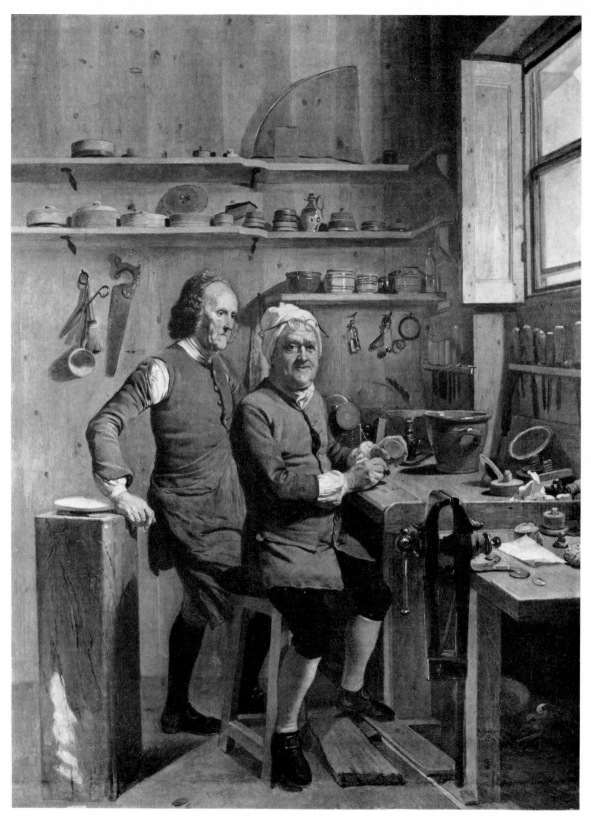

94 JOHANN ZOFFANY (1733/4–1810): *John Cuff with an Assistant.* 1772. Canvas, $35\frac{1}{4} \times 27\frac{1}{4}$in. Windsor Castle. Reproduced by gracious permission of Her Majesty The Queen

The subject of Zoffany's portrait has been identified as John Cuff, Master of the Spectacles Company in 1748, who was employed as maker of microscopes by George III. The painting gives another aspect of the interest in scientific subjects that Joseph Wright of Derby had already displayed in his orrery and air-pump pictures (Plate 57).

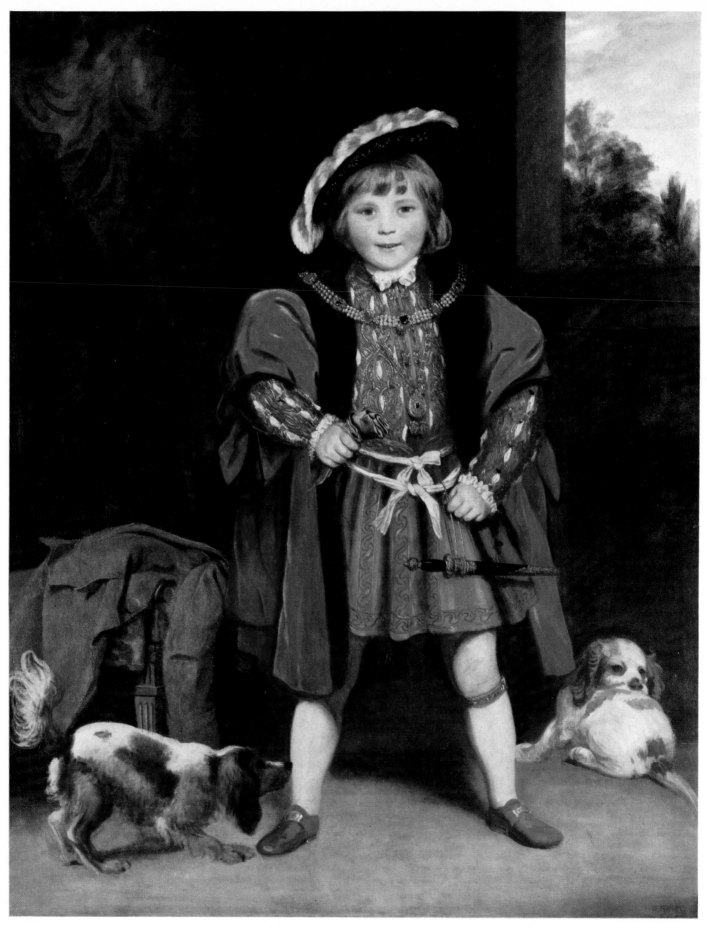

95 SIR JOSHUA REYNOLDS (1723–92): *Master Crewe as Henry VIII*. 1776. Canvas, 55 ×44in. Private Collection

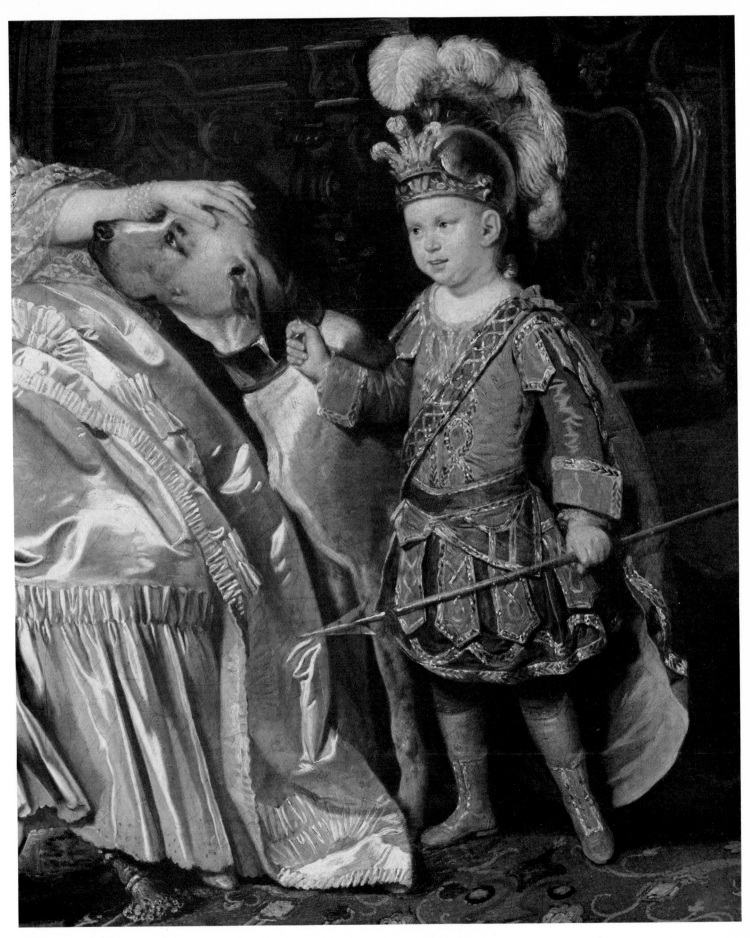

96 JOHANN ZOFFANY (1733/4–1810): *The Prince of Wales*. Detail from Plate 40

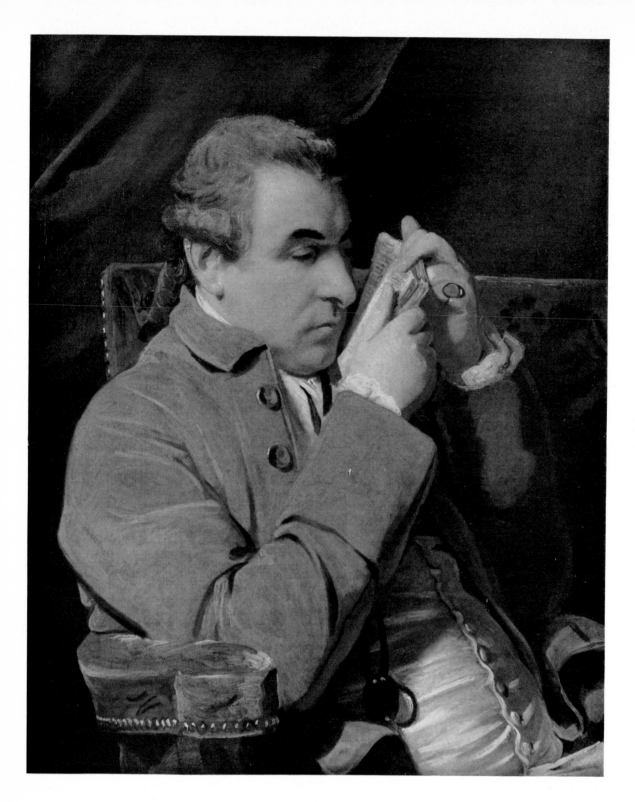

97
SIR JOSHUA REYNOLDS
(1723–92): *Joseph Baretti*. 17
Canvas, 29 × 24 in. Collectio
Viscountess Galway

Reynolds was at his best in th
portrait of the Italian man o
letters which so distinctly
projects a character in expre
and gesture. Baretti was a fri
of Dr Johnson, who together
with Burke and Garrick gave
evidence on his behalf at the
Old Bailey in 1769, when he
acquitted of the murder of a
man who attacked him in the
Haymarket. Baretti compile
an Italian-English dictionary
wrote a *Discourse on Shakespear*
among other works, and tran
lated six of Reynolds's
Discourses into Italian.

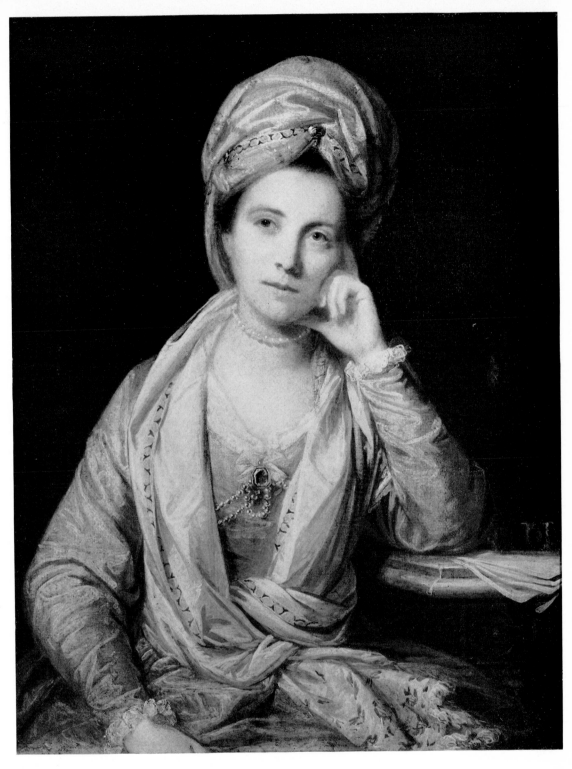

98 SIR JOSHUA REYNOLDS (1723–92): *Annabella (Nancy Parsons),
Viscountess Maynard*. 1769. Canvas, 36¼ ×28in. New York,
The Metropolitan Museum of Art, Fletcher Fund, 1945

This is one of Reynolds's most elegant and least pretentious society
portraits. It was painted at the height of his powers and well illustrates
his genius in conveying the character and mood of his sitter.

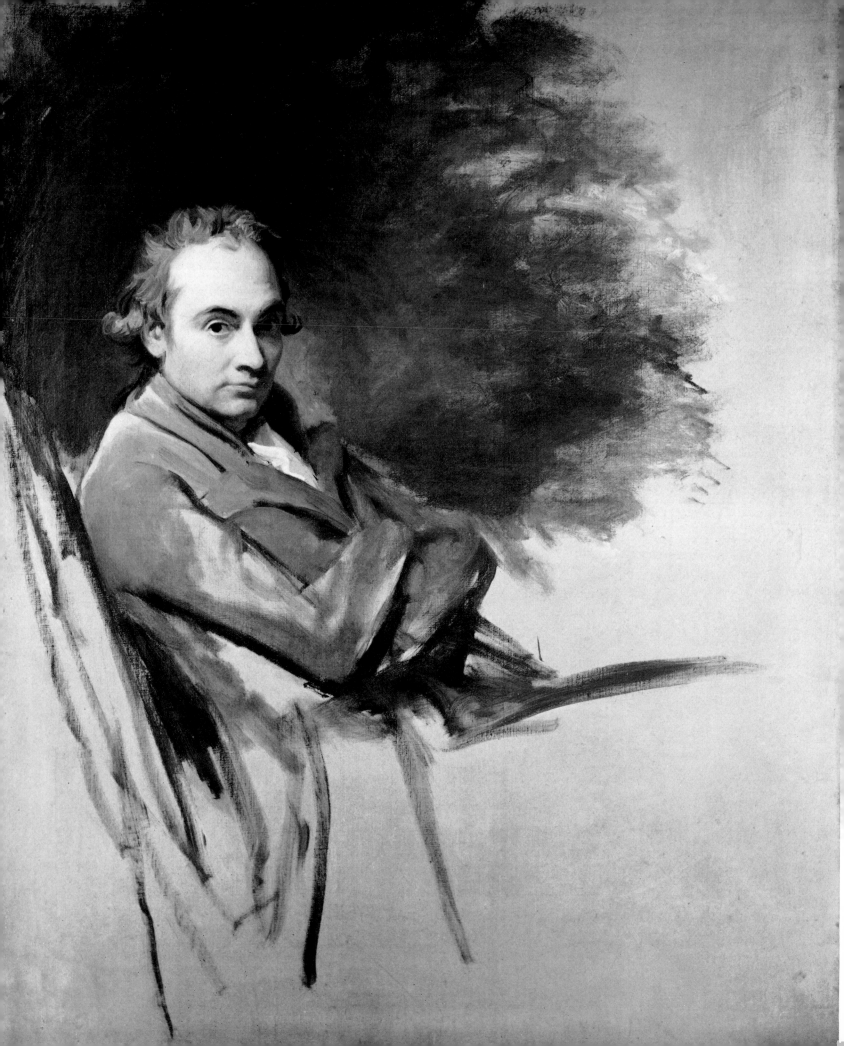

Something of Romney's
neurotic temperament may be
divined in the self-portrait
painted during one of the
artist's visits to his friend
William Hayley at Eartham,
in Sussex, probably in 1782.
The psychological effect is
heightened by the unfinished
state of the work, which was
undertaken at Hayley's
request. Romney wished to
complete it in London, but
Hayley induced him to leave
it at Eartham just as it was.

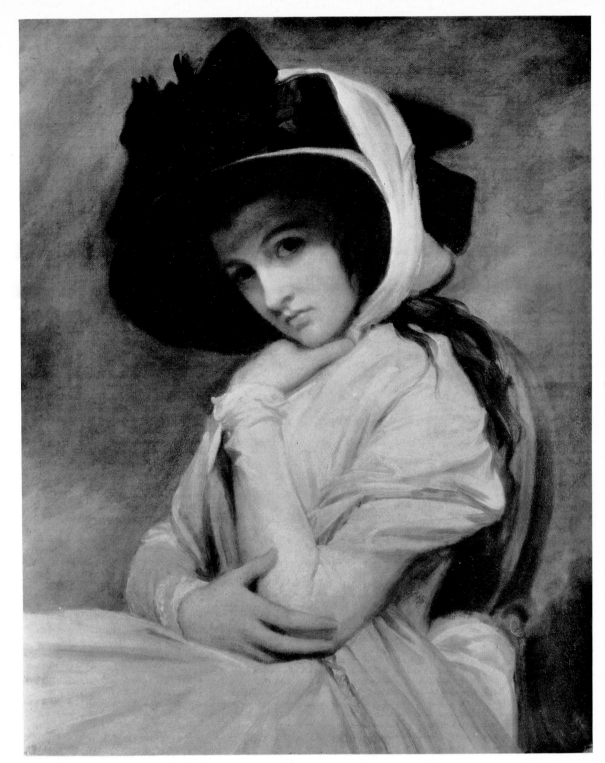

100 GEORGE ROMNEY: *Emma Hamilton*. About 1783. Canvas, San Marino,
California, Henry E. Huntington Library and Art Gallery

The beauty of Emma Hart (1761?–1815), who became Lady Hamilton,
was celebrated by Romney in his many portraits and a still larger
number of drawings in which he imagined her in a variety of historical,
allegorical or merely fanciful roles. The period between 1782, when she
was first brought to Romney's studio by Charles Greville, and 1786,
when she went out to Naples to Greville's uncle, Sir William Hamilton,
was the first phase of this obsessional activity.

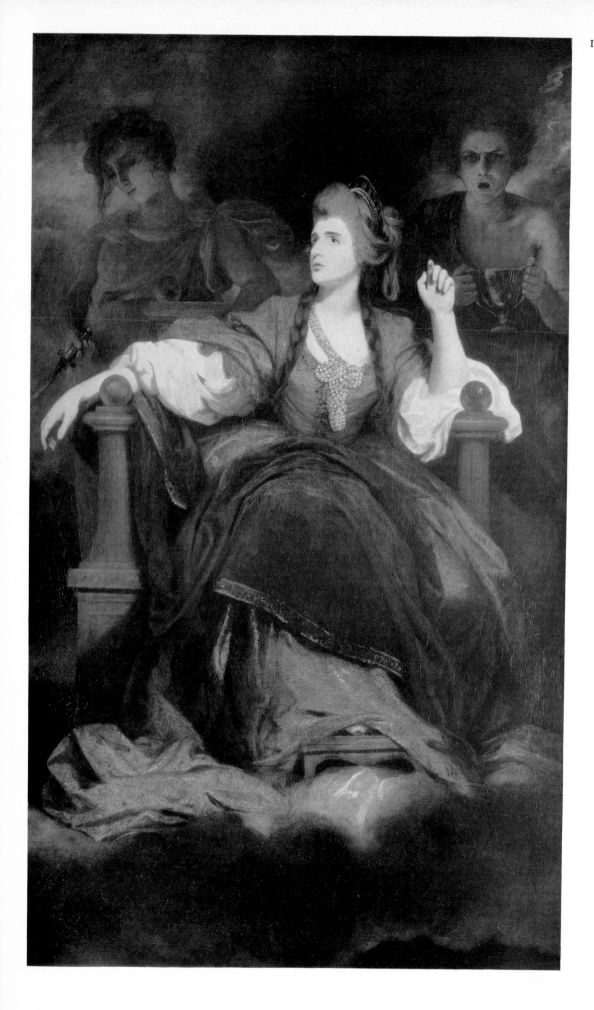

101 SIR JOSHUA REYNOLDS (1723–92
Sarah Siddons as the Tragic Muse.
1784. Canvas, 93 ×57in. San
Marino, California, Henry E.
Huntington Library and Art
Gallery

In a sense this famous work is an
application of Reynolds's idea of
the 'grand style', though a
distinction is to be made between
a generalized conception of the
Muse (which he does not give) and
the portrait of the great actress
playing a part with the theatrical
air he renders so well. The design
is based on the figure of Isaiah
from Michelangelo's Sistine
ceiling.

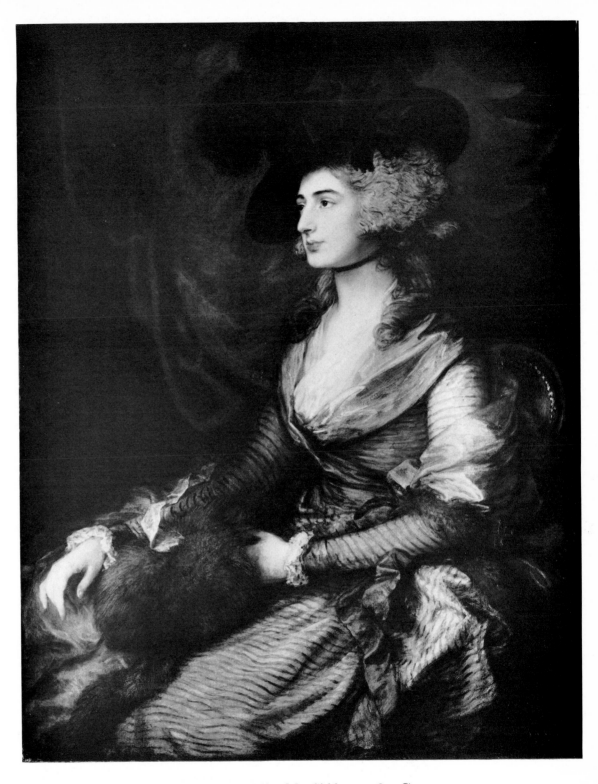

102 THOMAS GAINSBOROUGH (1727–88): *Mrs Siddons*. 1785. Canvas, 49¾ × 39¼in. London, National Gallery

The differences of temperament between Reynolds and Gainsborough appear strikingly in their respective portraits of Mrs Siddons. It is the charm of the woman and not the dramatic display of a member of the Kemble family superbly living up to its histrionic tradition that Gainsborough conveys. The picture was not completed without trouble, however, and he is credited with the petulant remark, 'Confound the nose, there's no end to it!'

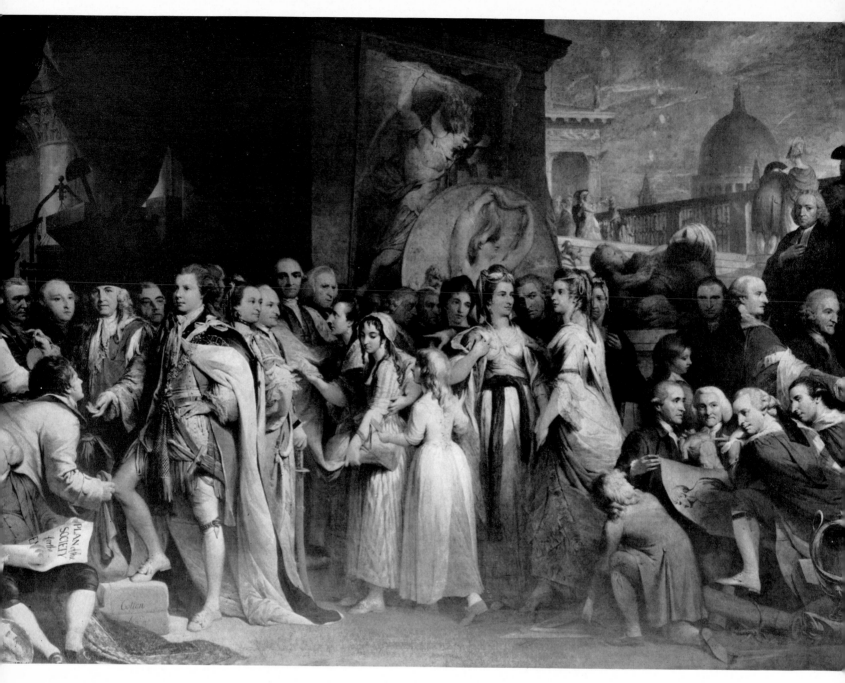

103 JAMES BARRY (1741–1806): Detail from the murals representing 'Human Culture'.
1777–83. London, Royal Society of Arts

104 JAMES BARRY: *Self-portrait*. 1780 to 1804. Canvas, 32 ×25in. Dublin, National Gallery
of Ireland

Barry was one of the most extraordinary personalities in the art of his time. He
represents the psychological knot that bound in agonized twists the coldly intellectual
aspirations of neoclassicism with all the emotional pangs of romanticism. The
combination of the two threads in the comparatively simple and direct genre of
portraiture enabled him to produce portraits that can be regarded without reservation
as excellent. Among them are his several self-portraits. His supreme effort was the
paintings he toiled at from 1777 to 1783 with the theme of 'The Progress of Human
Culture', which he volunteered to paint free of charge for the Society of Arts.

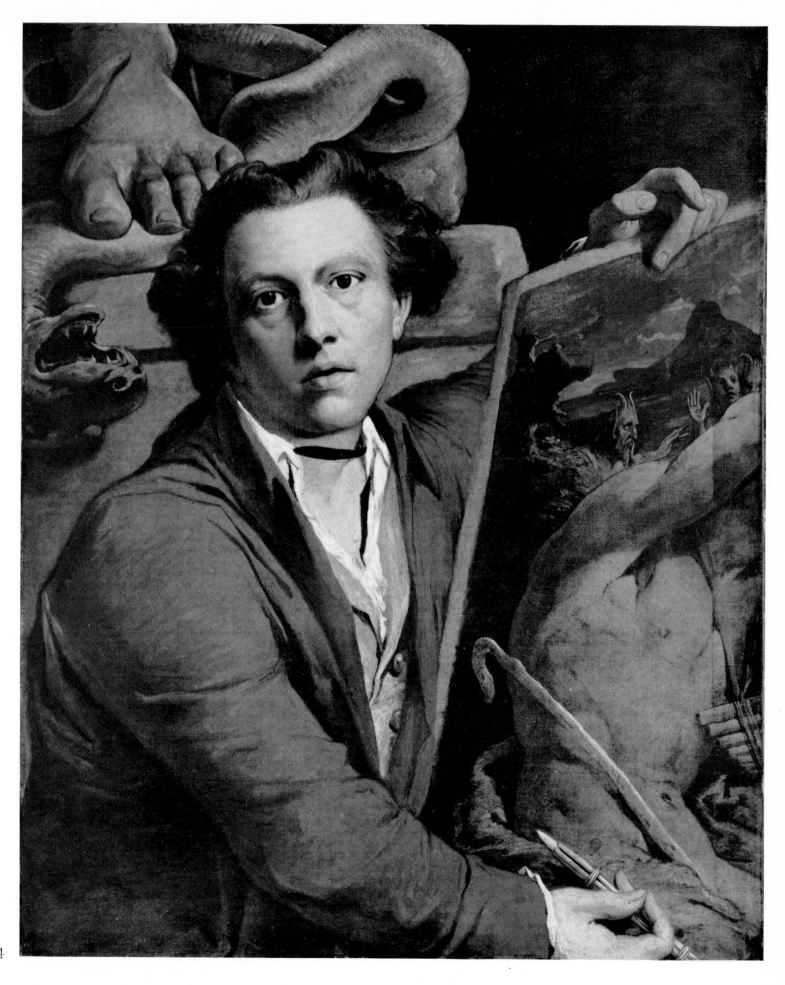

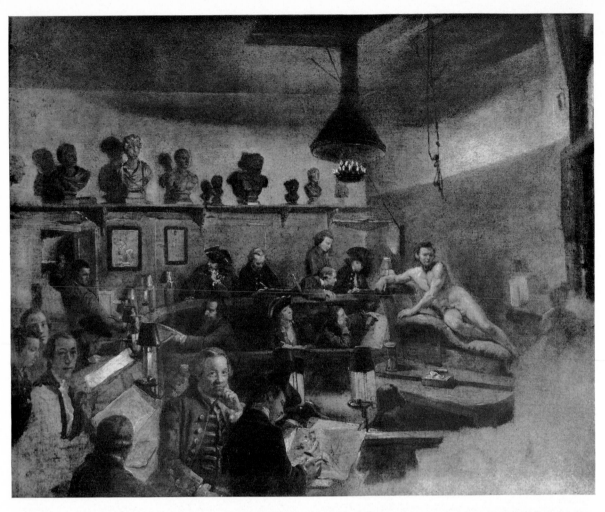

105 JOSEPH WRIGHT OF DERB
(1734–97): *An Academy by
Lamplight*. 1769. Canvas,
19 × 25½in. London, Roya
Academy of Arts

The effect of romantic
mystery in lamplight or
candlelight is heightened i
this painting by the way
strong relief gives an
illusory living quality to th
marble statue.

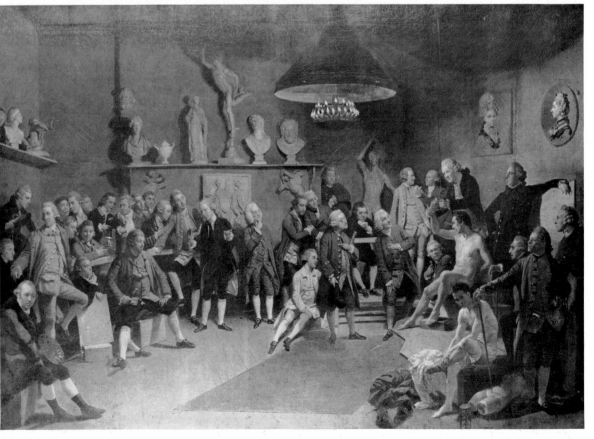

106 JOHANN ZOFFANY
(1733/4–1810): *The
Academicians of the Royal
Academy*. 1772. Canvas,
39¾ × 58in. Windsor Castl
Reproduced by gracious
permission of Her Majesty
The Queen

Zoffany includes portraits
of the following
Academicians: Zoffany
himself at left with palette
Benjamin West next to hi
Hayman with hands on
knees; Reynolds with ear
trumpet; and the Italian
landscape painter,
Francesco Zuccarelli, who
is the model.

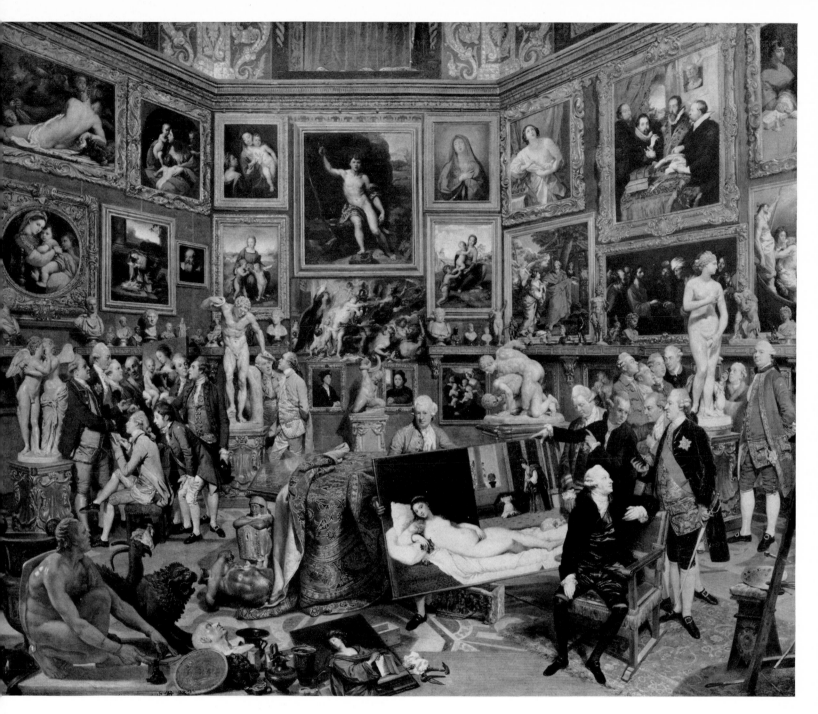

107 JOHANN ZOFFANY: *The Tribuna of the Uffizi*. 1780. Canvas, 48⅝ ×61in. Windsor
Castle. Reproduced by gracious permission of Her Majesty The Queen

The formerly simple conversation piece has gained complexity in Zoffany's *Tribuna*,
where the closely packed array of paintings and statuary is admired by a large and
important-looking assembly of connoisseurs. Titian's *Venus of Urbino*, taken down
from the wall, presumably for their inspection, is a central focus of the crowded scene.
The picture was probably bought from the artist by Queen Charlotte. See also detail
(Plate 109).

108 FRANC[IS]
WHEAT[LEY]
(1747–1[801])
Detail fr[om]
The Iris[h]
House of
Commons
(Plate 1[...])

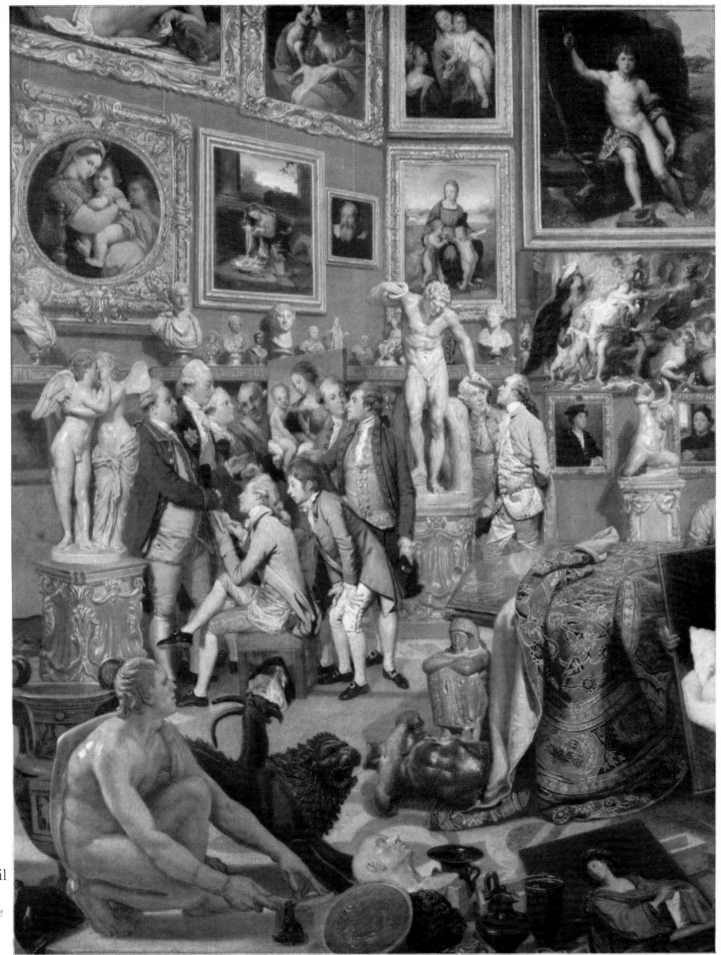

JOHANN
ZOFFANY
(1733/4–
1810): Detail
from *The
Tribuna of the
Uffizi*
(Plate 107)

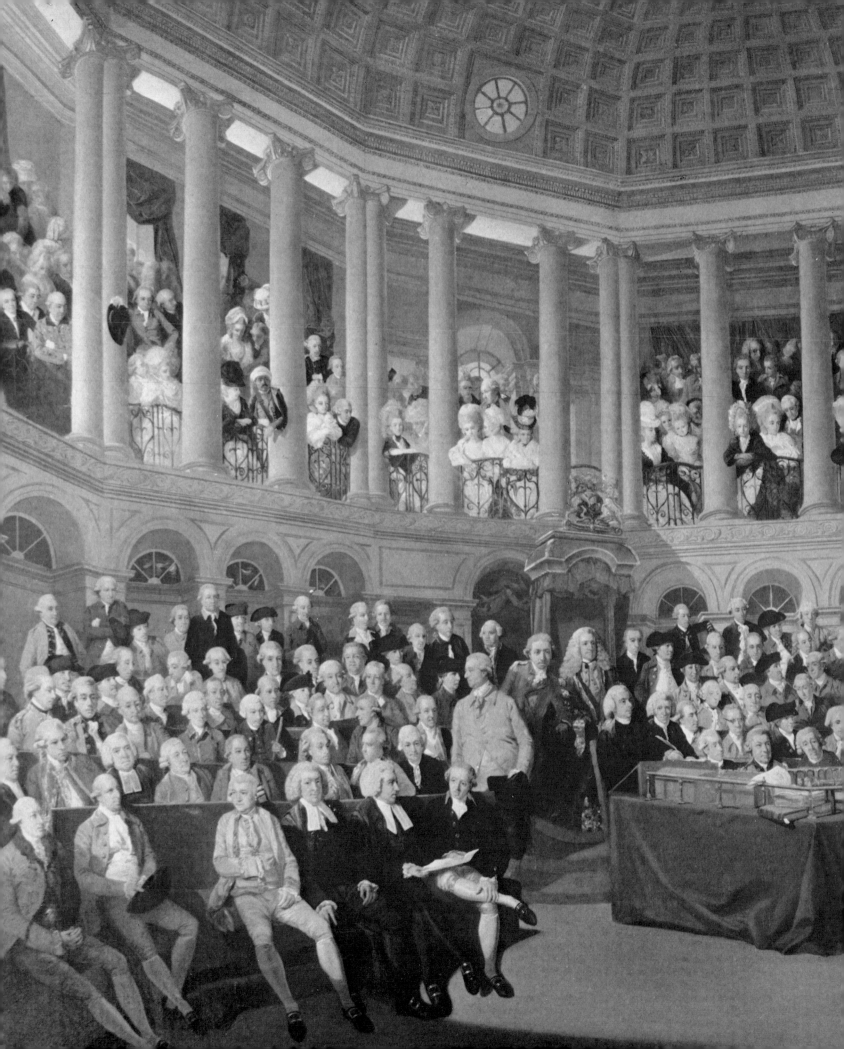

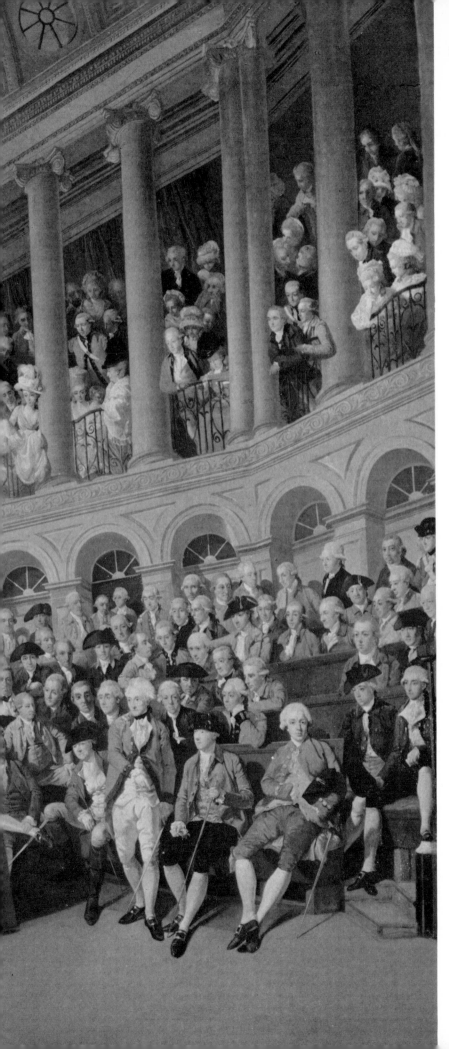

110 FRANCIS WHEATLEY (1747–1801): *The Irish House of Commons*. 1780. Canvas, 66 ×84in. Leeds City Art Galleries, Lotherton Hall

Born in London and a pupil of Richard Wilson, Wheatley fled to Dublin to escape his creditors in about 1779, and as the city was then a centre of fashion comparable with London and Bath, he obtained quite a number of important commissions. His masterpiece here reproduced depicts the scene when Henry Grattan spoke against Poynings Law and for the independence of the Irish Parliament. The vast work of group portraiture is brilliantly carried out. See also detail (Plate 108).

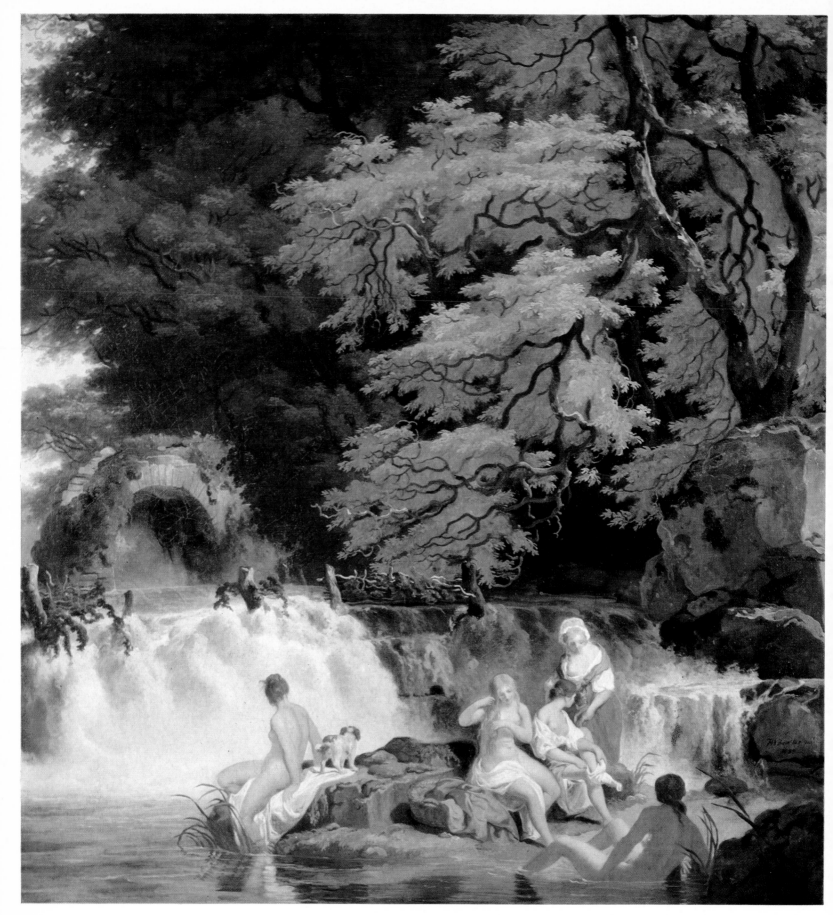

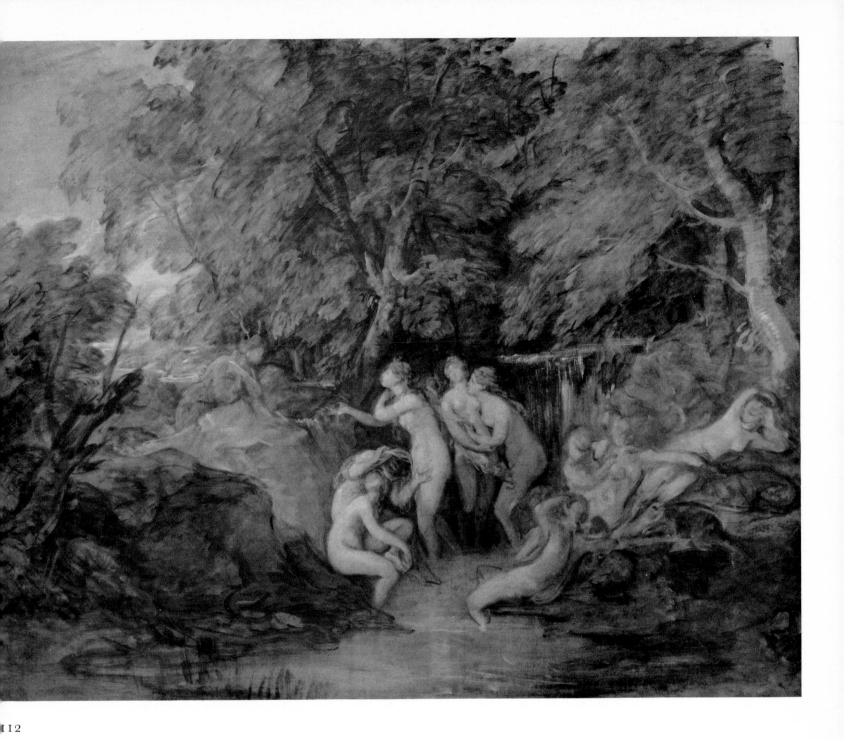

112

III FRANCIS WHEATLEY (1747–1801): *Nymphs Bathing, a View of the Salmon Leap at Leixlip.*
1783. Canvas, 26⅝ × 25½in. Collection of Mr and Mrs Paul Mellon

112 THOMAS GAINSBOROUGH (1727–88): *Diana and Actaeon.* Late 1780s. Canvas, 62¼ × 74in. Windsor
Castle. Reproduced by gracious permission of Her Majesty The Queen

The nude was not commonly a subject of the eighteenth-century painters in England. There was no
luxuriously self-indulgent court to command such decorative and voluptuous compositions as
Boucher and Fragonard produced in France. It was not until late in the century that there was an
imaginative reaction from the realism of portraiture, landscape and sporting scenes. In the case of
both Wheatley and Gainsborough, the nude was an exceptional subject for the good reason that
they were constantly preoccupied with other themes; the genre offered a poetic relaxation.

113 WILLIAM RADMORE BIGG (1755–1828): *The Charitable Lady*. 1787. Canvas, 29¾ × 35¾ in.
Philadelphia Museum of Art

The painting by Bigg shows how early there appeared the type of sentimental genre that is usually
dated much later. Bigg seems to have had a kindly nature that recommended him to Sir Joshua
Reynolds and gained him many other friends.

114 HENRY WALTON (1746–1813): *The Cherry Barrow*. 1779. Canvas, 29½ × 24½ in. Private Collection

Walton's painting is not only an attractive street scene but a sort of conversation piece inasmuch as
the young woman is said to have been a Miss Carr, friend of the artist, the boys his nephews and the
little girl his niece.

115 JOHN OPIE (1761–1807): *The Peasant's Family*. About 1783–5. Canvas, 59 ×71in. London, Tate Gallery

Opie was at first enthusiastically received in London as the 'boy genius' whom John Wolcot had discovered. For a while, as Opie himself said, he brought 'all the quality' to his London lodgings— 'nothing but Lords, Ladies, Dukes, Duchesses, etc. . .' But after this initial sensational success, the warmth of his reception quickly cooled. With the encouragement of a few loyal patrons, however, the young painter settled down to steady effort, and the pictures of rustic life he produced when still in his twenties are among his best. *The Peasant's Family* is a masterpiece of this phase.

116 THOMAS GAINSBOROUGH (1727–88): *A Cottage Girl with Dog and Pitcher*. 1785. Canvas, 68½ ×49in. Beit Collection

This lovely painting, with its rustic charm, is one of Gainsborough's finest 'fancy pictures'.

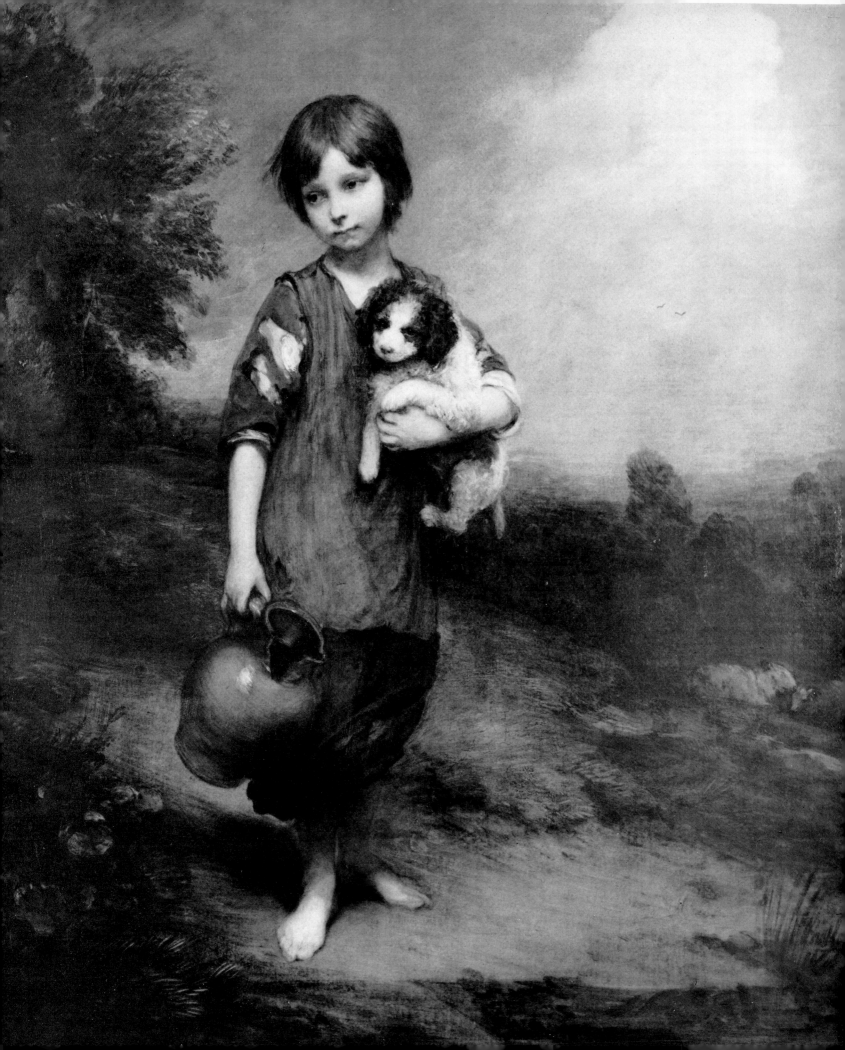

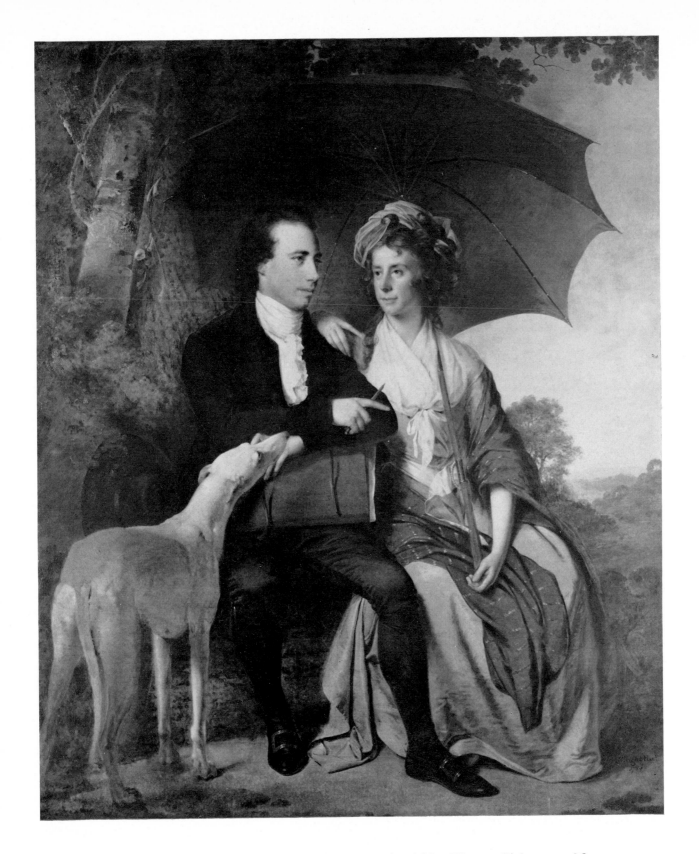

117 JOSEPH WRIGHT OF DERBY (1734–97): *The Reverend and Mrs Thomas Gisborne.* 1786.
Canvas, 73 ×60in. Collection of Mr and Mrs Paul Mellon

The style of Wright's portraiture in his later years was adapted to appeal to and
appropriately represent a serious-minded provincial society. Of this kind is the portrait
of his friends, the Reverend Thomas Gisborne, born at Derby in 1758, and his wife.
Gisborne was the author of such improving works as *An Inquiry into the Duties of Man.*

JOHN SINGLETON COPLEY (1738–1815): *The three youngest Daughters of George III.* 1785. Canvas, $104\frac{1}{2} \times 73\frac{1}{4}$in. Windsor Castle. Reproduced by gracious permission of Her Majesty The Queen

The freshness and charm of this painting show how far Copley had moved away from the early style that had mirrored the stiffness of Bostonian society. The Princesses frolicking with their dogs are Mary (1776–1857), Sophia (1777–1848) and Amelia (1783–1810). See also detail (Plate 138).

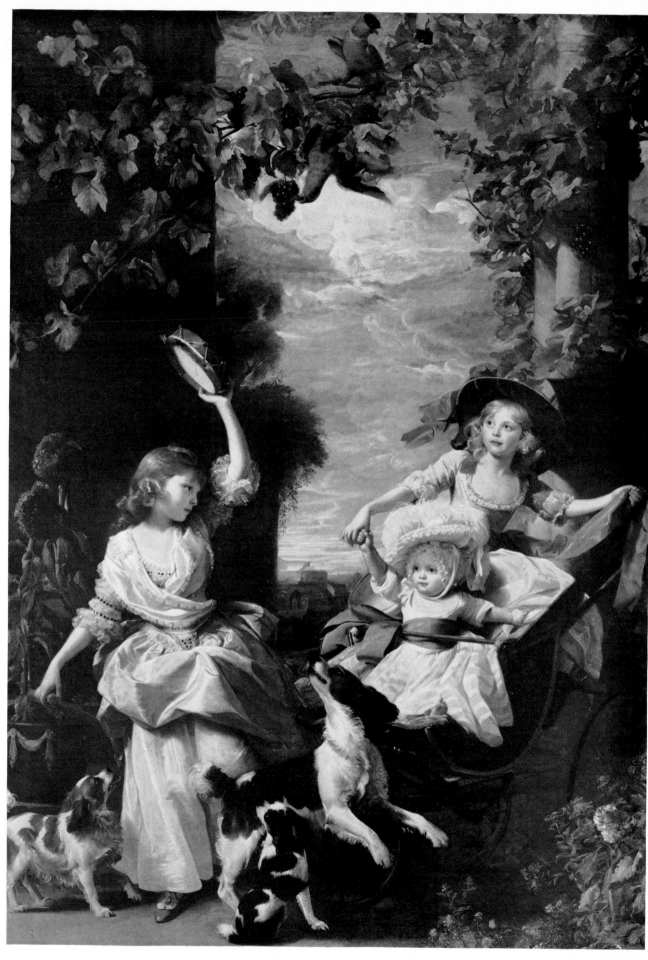

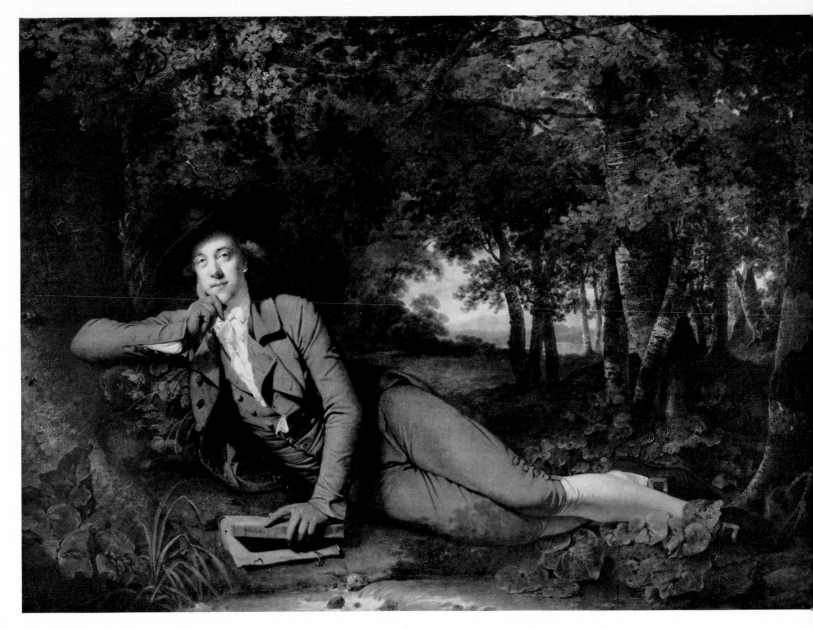

119 JOSEPH WRIGHT OF DERBY (1734–97): *Sir Brooke Boothby*. 1781. Canvas, 58¼ × 81¼in.
London, National Gallery

One of Wright's more unusual works, this portrait seems purposely to indicate the
way in which an *avant-garde* European concept found its response in provincial
England. Brooke Boothby (1744–1824), a member of the intellectual society of
Lichfield, brought together within the purview of his circle both science and poetry.
He was a friend of Rousseau, who gave him the manuscript of *Rousseau Jugé de
Jean-Jacques*; Boothby published it at Lichfield in 1780. This presumably is the
book Boothby holds in the portrait. The attitude is one of romantic contemplation,
such as the German painter Tischbein was later to convey in his portrait of Goethe
in the Roman Campagna.

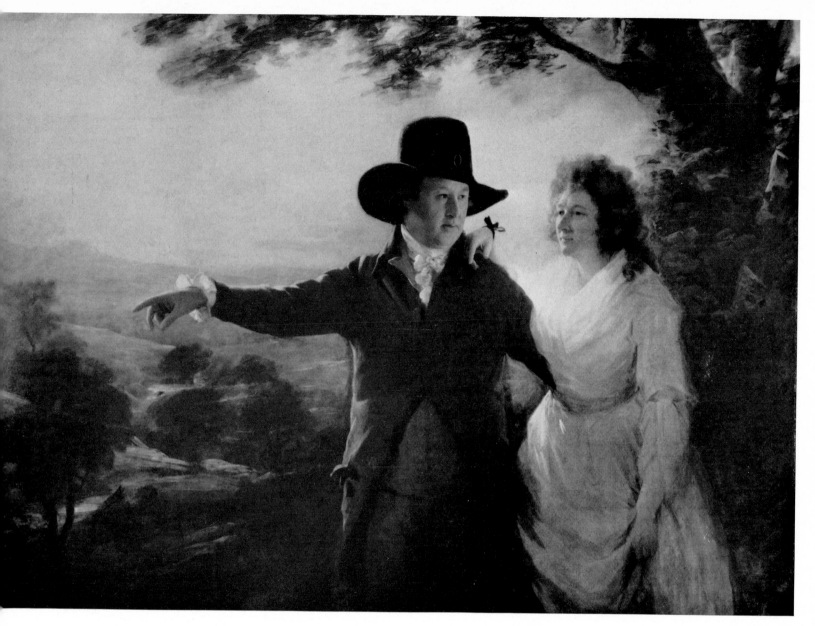

20 SIR HENRY RAEBURN (1756–1823): *Sir John and Lady Clerk*. About 1790. Canvas, 57 × 82in. Beit Collection

A landscape background suggestive of country life and the open air, as distinct from a grandiose setting, was a characteristic feature of much eighteenth-century portraiture. Raeburn places his middle-aged couple, the fifth Baronet of Penicuik and his wife, Rosemary Dacre, in the foreground of a spacious prospect that adds its suggestion of Scotland.

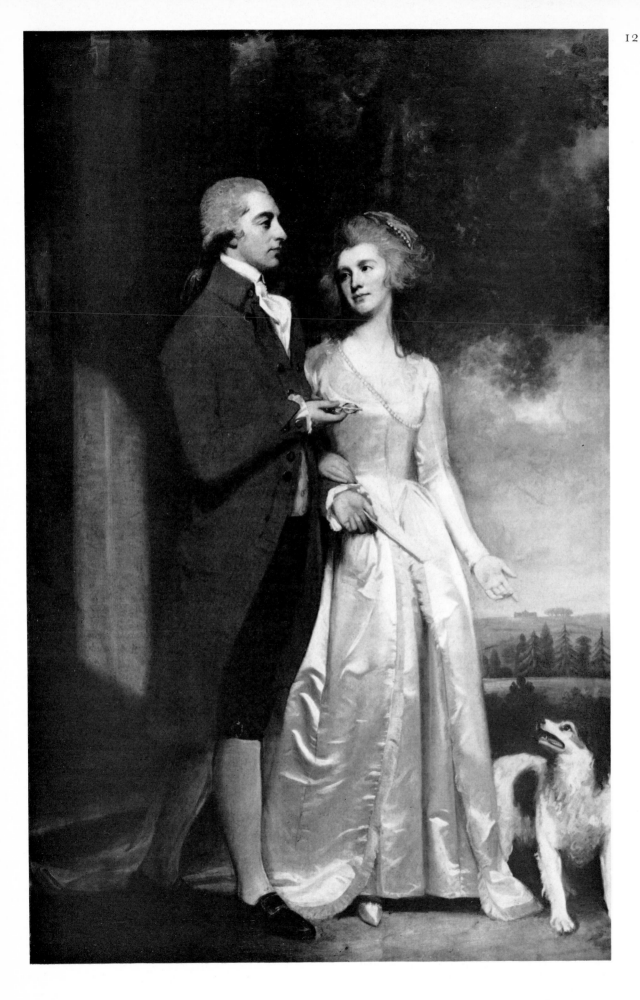

121 GEORGE ROMNEY (1734-1802): *Sir Christopher and Lady Sykes*. 1786. Canvas, 97×73in. Sledmere, Yorkshire, Collection of Sir Richard Sykes

Romney has made the baronet and his wife look stately and important, and they are near enough in attitude to the couple portrayed by Gainsborough in '*The Morning Walk*' to invite a comparison. They seem, however, to inhabit different worlds. Romney sees his subjects on a mater[?] plane, whereas Gainsborough's couple seem to stroll elegantly in a realm suffused with poetry.

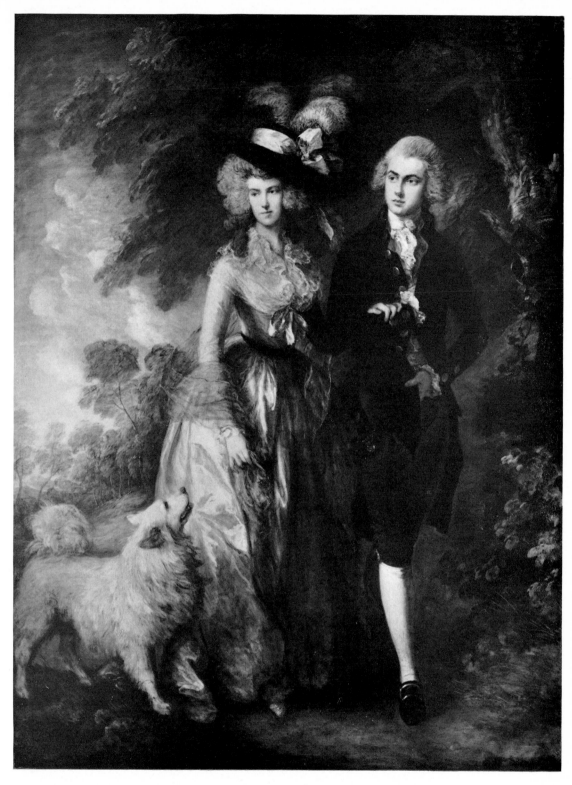

122 THOMAS GAINSBOROUGH (1727–88): *Mr and Mrs William Hallett* ('*The Morning Walk*'). 1785. Canvas, 93 ×70½in. London, National Gallery

Gainsborough here attains the zenith of his later style in the combination of freedom and elegance; the use of long-handled brushes creates a looseness of touch that was already a kind of impressionism. The extent of Gainsborough's development as an artist can be gauged by comparison with his earlier portrait of a newly married middle-class couple in a landscape: *Mr and Mrs Robert Andrews* (Plate 14).

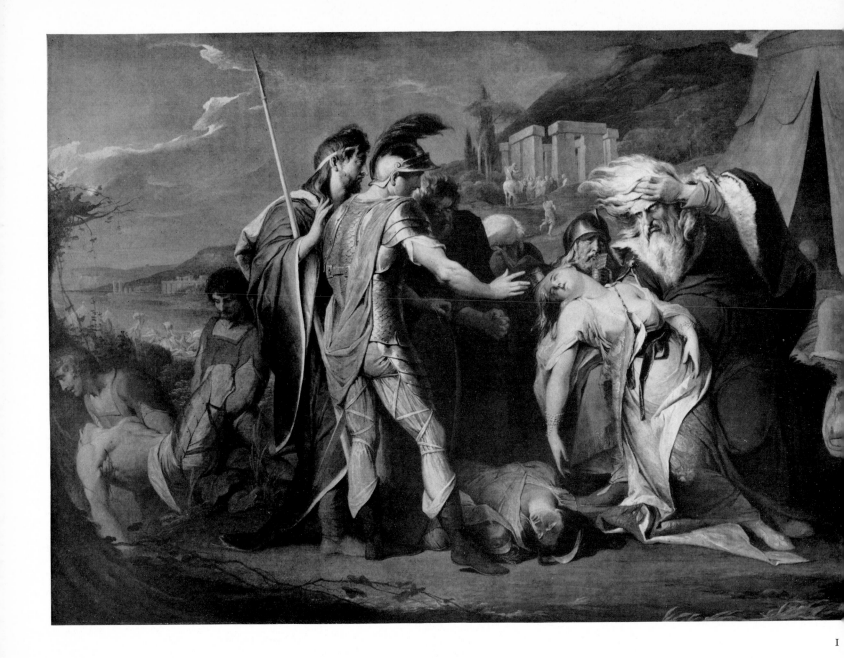

I

123 JAMES BARRY (1741–1806): *King Lear weeping over the Body of Cordelia*. 1786–8. Canvas, 106 × 144½in. London, Tate Gallery

124 HENRY FUSELI (1741–1825): *Thor battering the Serpent of Midgard in the Boat of Hymir*. 1792. Canvas, 51½ × 36in. London, Royal Academy of Arts

A scant regard for colour in any sensuous aspect and the impression of violent emotions conveyed by the exaggeration of form distinguish these works by Barry and Fuseli. *King Lear* had a special significance for an artist such as Barry, not only in the passions evoked, but in the tragic sublimity that could be set in a classic mould. Fuseli's imagination, though literary, was less intellectual in this visual sense, more concerned with the weirdness of legend or fancy. The source for Fuseli's painting was one of the poems collected by the Elder Edda, *Hymiskvida*. Thor, who had gone out fishing with Hymir, one of the sea giants of Norse mythology, caught the Serpent of Midgard, the huge snake that circled the world. When Hymir cut the line, the serpent sank back into the sea. If the subject is not immediately intelligible, Fuseli conveys to the eye a fine general impression of epic fury and exertion.

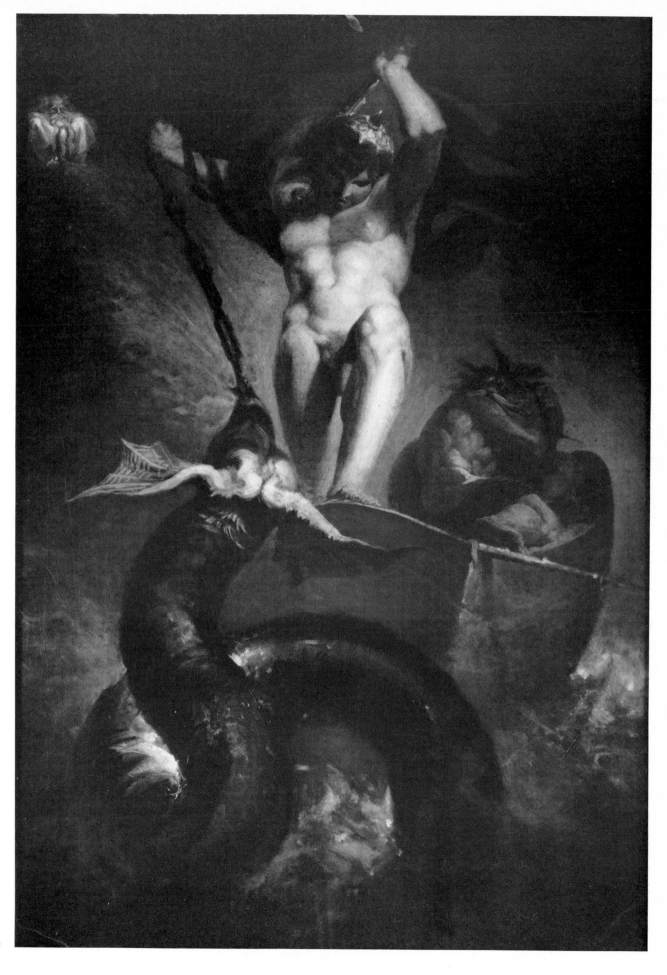

125 & 126 PHILIP JAMES DE LOUTHERBOURG (1740–1812): *The Shipwreck*. 1793. Canvas, 43½ ×63in. Southampton Art Gallery

The romantic feeling for storm and stress at the end of the eighteenth century is linked with the scene painter's sense of dramatic effect in de Loutherbourg's *Shipwreck*. There was some antecedent tradition in the work of Joseph Vernet, who caught in a storm at sea is reputed to have said 'What a sublime spectacle!' and who found connoisseurs in England as in France for his paintings of tempests and moonlight scenes. De Loutherbourg's rocky coast recalls a very similar ruggedness. *The Shipwreck*, the popular poem by William Falconer (1732–69) which went through three editions in his lifetime (before he himself perished at sea), may have contributed a literary inspiration. When the subject later became the tremendous vehicle of Turner's conception of the elements, a comparison with de Loutherbourg was not uncommon. Although de Loutherbourg obviously lacked Turner's unique genius, he was nevertheless a painter of imagination.

127 JOHN SINGLETON COPLEY (1738–1815): *The Siege and Relief of Gibraltar*. 1783–91.
Canvas, 214 ×297in. London, Guildhall

128 JOHN SINGLETON COPLEY: *Portraits of Colonels Hugo and Schleppengull*. Oil study for
The Siege and Relief of Gibraltar. Cambridge, Massachusetts, The Fogg Museum of Art

In all three of Copley's large historical canvases he painted actual portraits of the
participants in the scene. His thoroughness in this respect is instanced by the portrait
studies of Colonels Hugo and Schleppengull, which also illustrate a vivid and
spontaneous side of Copley's ability. The complete painting with its many portraits
was commissioned by Boydell in 1783 as the original for an engraving. This was to
commemorate the successful defence of Gibraltar by Lord Heathfield against the
combined French and Spanish forces between 1779 and 1783. Though the Spanish
had made earlier attacks on Gibraltar, this was the critical assault, which ended
with the confirmation of British occupancy by the Treaty of Versailles in 1783.

129 GEORGE STUBBS (1724–1806): *A green Monkey*. 1798. Canvas, $27\frac{1}{2} \times 22$in. Liverpool, Walker Art Gallery

No part of the animal world was alien to Stubbs, and he accepted the exotic creatures brought to England by the progress of exploration and discovery as being no less suitable as subjects for pictures than the familiar horses and dogs at home. His own scientific interests coincided with those of the surgeon-anatomists, William and John Hunter, who commissioned from him pictures of a number of wild animals. His green monkey is intensely alive and poised for movement.

130 HENRY FUSELI (1741–1825): *Titania, Bottom and the Fairies*. About 1793. Canvas, $66\frac{1}{2} \times 53\frac{1}{8}$in. Zürich, Kunsthaus

From his early years at Zürich, Fuseli had been a devoted literary admirer of Shakespeare and needed no persuasion to join in Boydell's scheme for a pictorial Shakespeare Gallery. In his paintings of *A Midsummer Night's Dream* he gave free rein to his imagination, inventing his own fairyland and defying all rules of proportion. What makes his images even stranger is the way macabre suggestions are combined with an air of daintiness in the dancing elves.

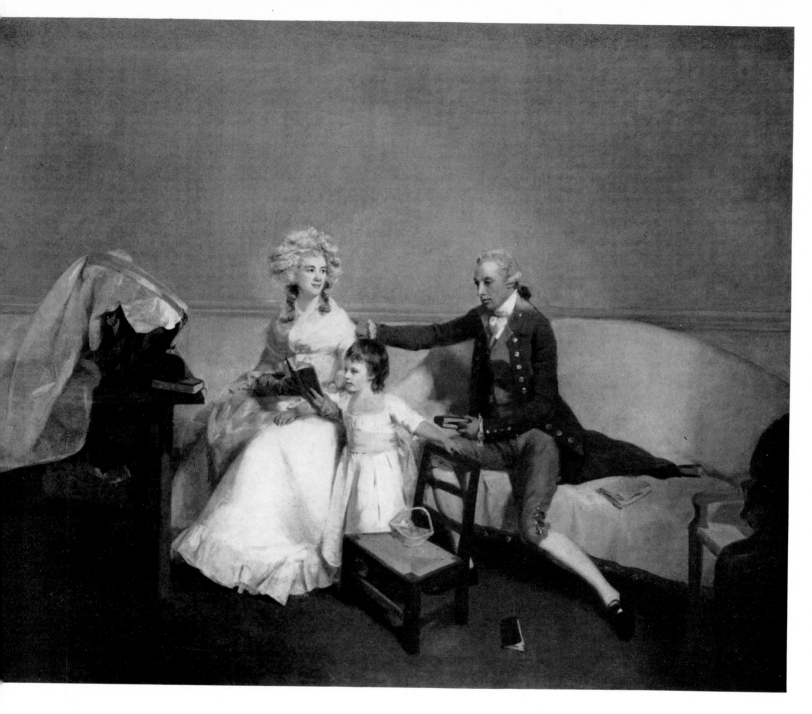

HENRY WALTON (1746–1813): *The Buxton Family*. 1786. Canvas, 29 ×36in. Norwich, Castle Museum

In this painting of Sir Robert and Lady Buxton and their daughter Anne, Walton seems to arrive at a happy point midway between the upper-class conversation piece of Zoffany, and the early Victorian insistence on a purely domestic atmosphere. There is an elegance in the composition as well as a casual intimacy.

GEORGE MORLAND (1763–1804): *The Fruits of Early Industry and Economy*. About 1785–90. Canvas, 30¼ ×25⅛in. Philadelphia Museum of Art

This is another example of the 'modern moral subject' that Hogarth had pioneered. As in Edward Penny's *The Virtuous comforted by Sympathy and Attention* (Plate 70), the advantages of an upright and sober life are plain for all to see.

133 GEORGE STUBBS (1724–1806): *The Prince of Wales's Phaeton*. 1793. Canvas, $40\frac{1}{4} \times 50\frac{1}{2}$ in.
Windsor Castle. Reproduced by gracious permission of Her Majesty The Queen

This was painted for George IV when he was Prince of Wales. The horses' blinkers
are decorated with his feathers. The man holding one of the horses is Samuel Thomas,
the Prince's state coachman, who was in the royal service for more than thirty years.
It is possible that the landscape in the distance is meant to represent Virginia Water.
The Spitz dog, called Fino, appears as the main subject in another picture by Stubbs
in the Royal Collection. Once again, Stubbs's liking for a frieze-like composition
is evident, superbly combined with naturalism.

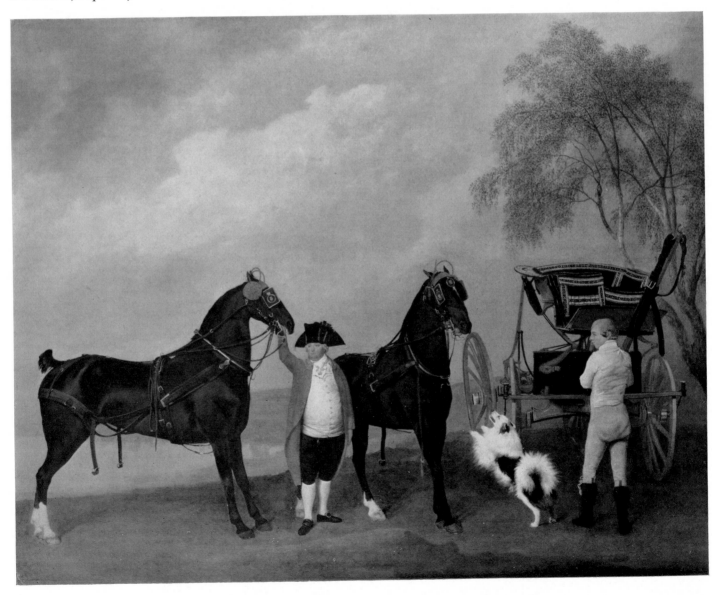

4 GEORGE STUBBS (1724–1806): *Soldiers of the Tenth Light Dragoons.* 1793. Canvas,
$40\frac{1}{4} \times 50\frac{3}{8}$in. Windsor Castle. Reproduced by gracious permission of Her Majesty
The Queen

Stubbs shows a mounted sergeant, with his sword 'at the carry'; a trumpeter;
a sergeant shouldering arms; and a private presenting arms (see details, Plates 136 and
145). The picture was presumably painted for George IV, who, as Prince of Wales,
was appointed Colonel Commandant of the Tenth Light Dragoons in 1793, and
who was always very fond of the regiment and its uniform. Both Plates 133 and 134
show that Stubbs had lost none of his skill in the 1790s.

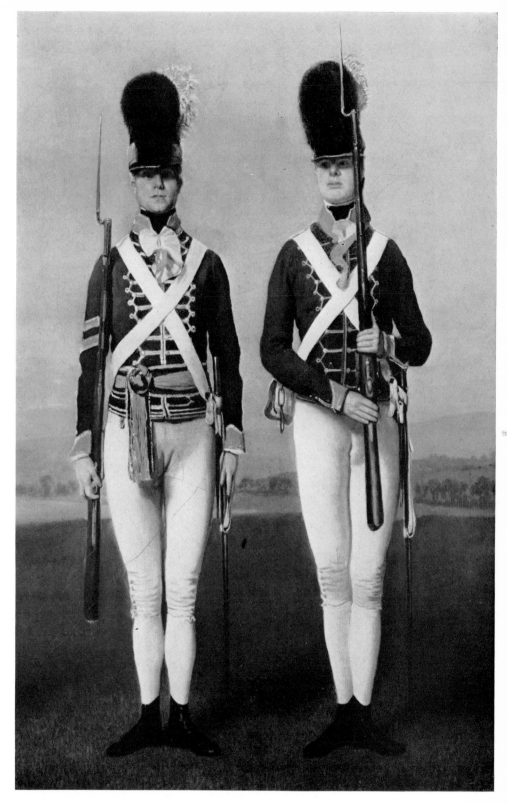

136 GEORGE STUBBS (1724–1806): *Sergeant and Private.*
Detail from *Soldiers of the Tenth Light Dragoons* (Plate 134)

137 SIR HENRY RAEBURN (1756–1823): *John Tait and his Grandson*. About 1793. Canvas, 49½ ×39¾in. Washington, D.C., National Gallery of Art, Andrew Mellon Collection

This is a fine example of Raeburn's elegant but robust style. Although he learned much from Reynolds's example, he was usually able to avoid Reynolds's tendency to rhapsody over childhood.

138 JOHN SINGLETON COPLEY (1738–1815): *The Princesses Sophia and Amelia*. Detail from Plate 118

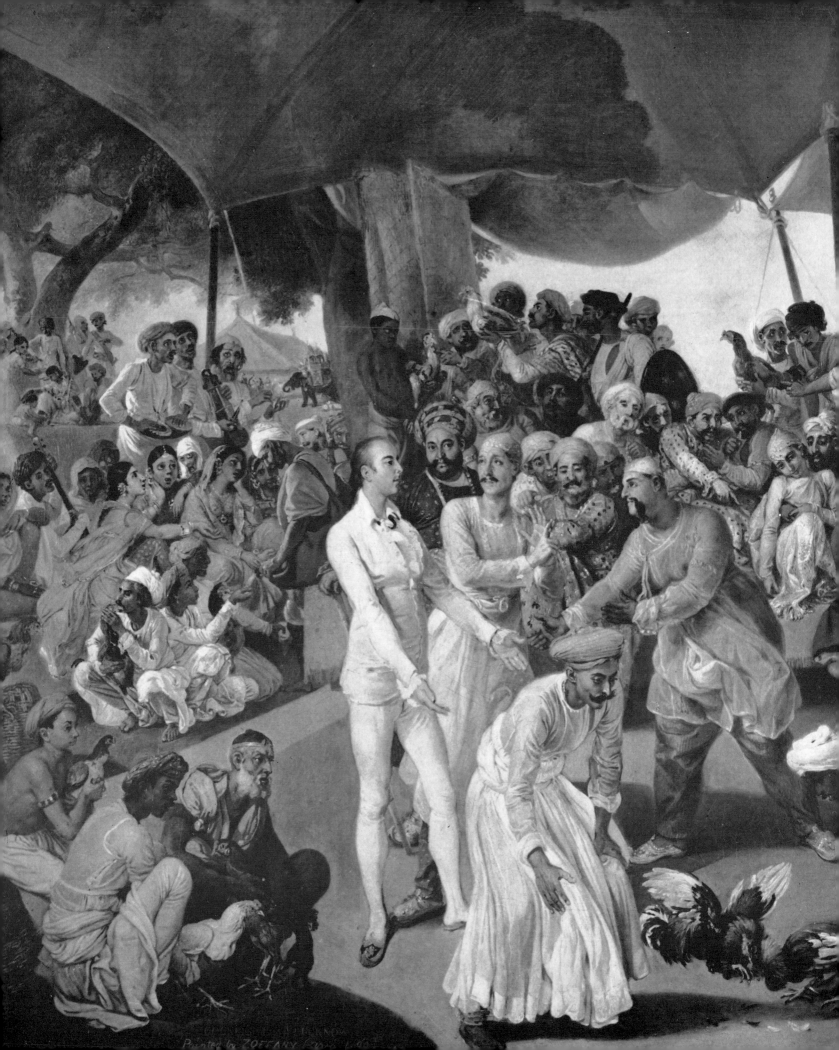

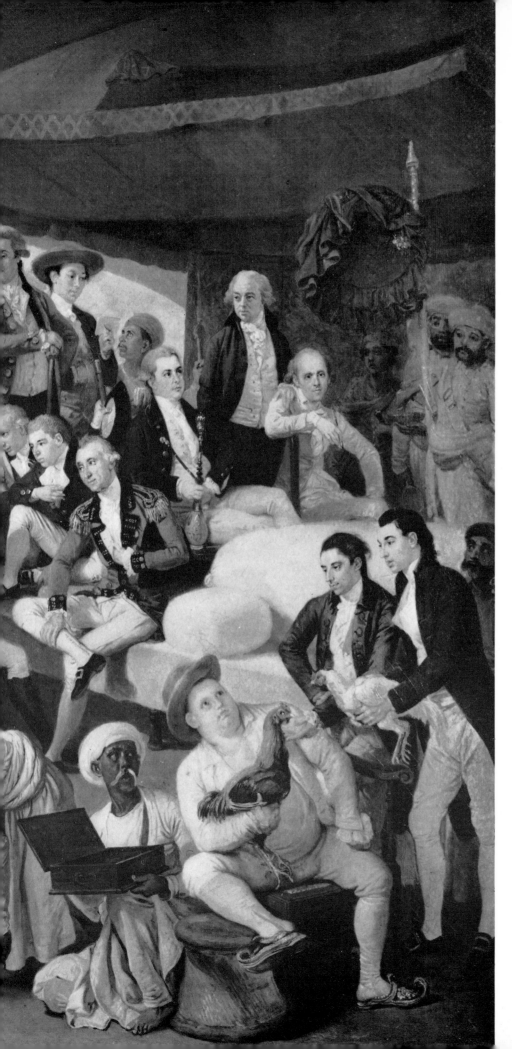

139 JOHANN ZOFFANY (1733/4–1810):
Colonel Mordaunt's Cock Fight at Lucknow.
1786. Canvas, 40 × 59in. Collection of
David Sutherland, Esq.

Generally speaking, the English painters
who went out to India, looking forward
to the prospect of munificent patronage,
were little influenced by Mughal art;
but Zoffany, if not altering his style
materially, shows the influence of his
Indian years in pictures which are
pageant-like in their crowds of figures
and heightened colour. Outstanding
works of this kind, engraved by Earlom,
were an Indian tiger hunt, and the
multitude at the cock fight organized
by Colonel Mordaunt and Nawab
Asaf-ud-daula, an event which had
some celebrity. Zoffany's ability to
handle a crowded composition is
exotically apparent in the *Cock Fight*.
See also detail (Plate 140).

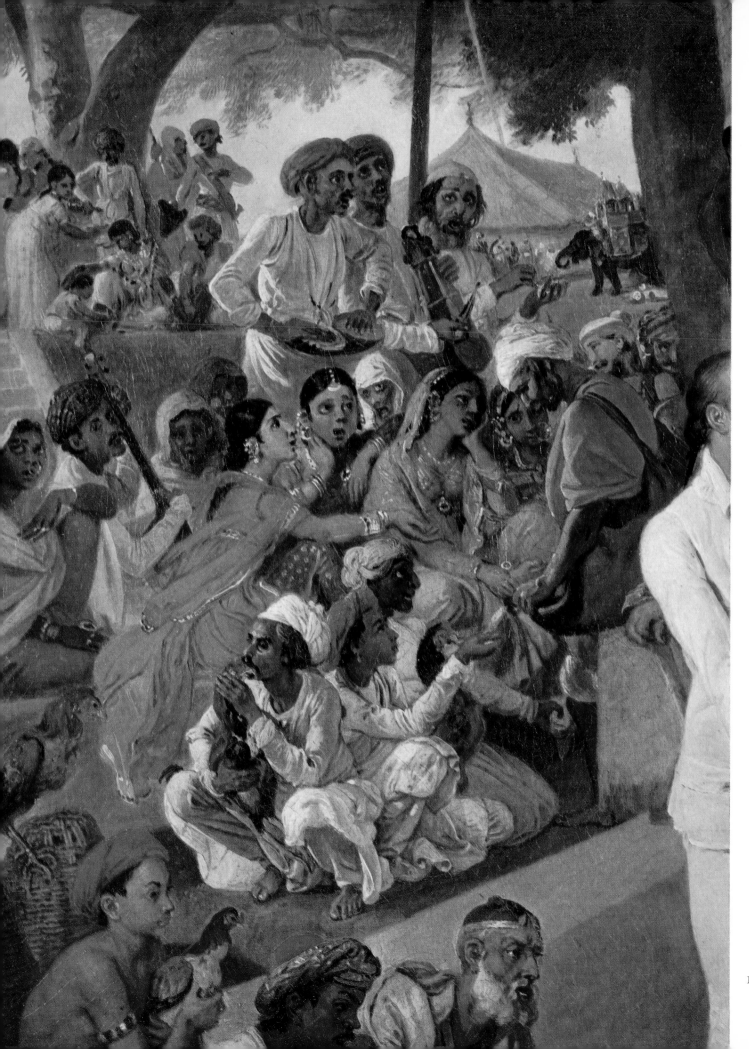

I

JOHANN ZOFFANY (1733/4–1810): Detail from *Colonel Mordaunt's Cock Fight at Lucknow* (Plate 139)

FRANCIS WHEATLEY (1747–1801): *Mr Howard offering Relief to Prisoners*. 1787. Canvas, 41 × 51 in. Private Collection

Wheatley's prison scene is an example of the portrayal of contemporary incident which was popular in the 1780s. It signalizes the great efforts made by John Howard (1726–90) to secure prison reforms.

142 SIR HENRY RAEBURN (1756–1823): *Sir Ronald and Robert Ferguson of Raith (The Archers)*. About 1787. Canvas, 39 ×48½in. Private Collection

Raeburn may be called self-taught in that he had no formal training in oil painting, but for one who began by painting miniatures he arrived at a remarkably bold style in maturity. Although influenced by the advice and example of Sir Joshua Reynolds, a separate destiny in Scottish painting is in part indicated by a breadth of treatment with a particular decisiveness of brushstroke, and also by an evident understanding of the character of his Scottish sitters. The portrait painter's delight appears in being diverted to such an abstract problem of design as the archer's bow, here a decorative supplement to portraiture. See also detail (Plate 144).

143 SIR THOMAS LAWRENCE (1769–1830): *Richard Payne Knight*. 1794. Canvas, 50 ×40⅛in. Manchester University, Whitworth Institute and Art Gallery

Lawrence, one of the greatest figures in British portraiture, here represents the connoisseur and antiquary Richard Payne Knight with strong characterization that made no concessions to the vanity of his sitter.

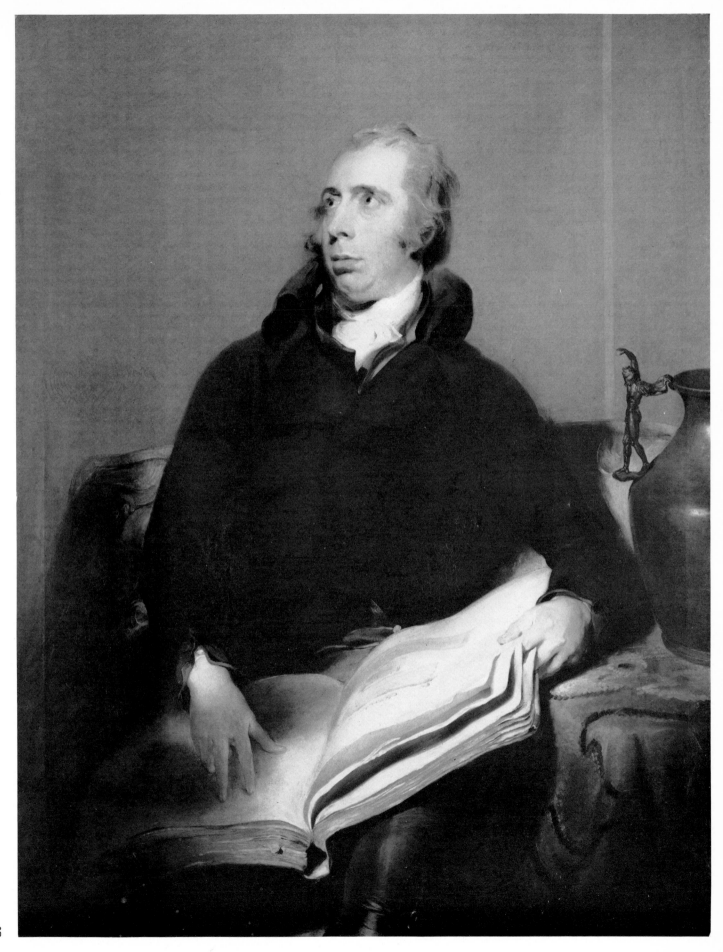

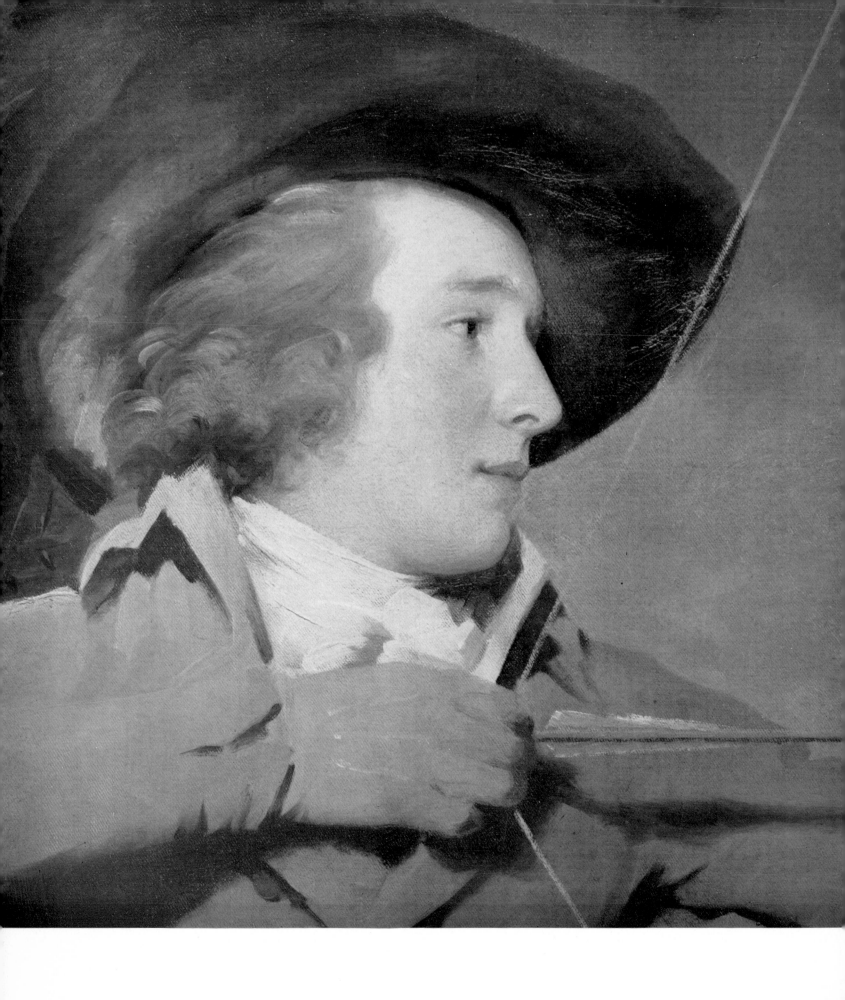

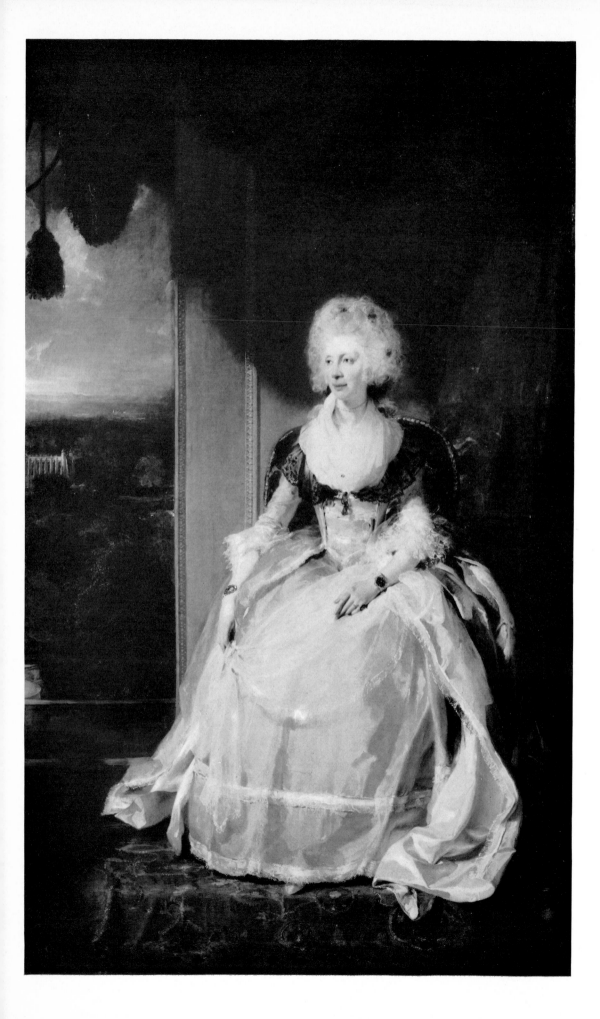

146 & 147
SIR THOMAS LAWRENCE
(1769–1830): *Queen Charlotte*.
1789–90. Canvas, $94\frac{1}{4} \times 58$in.
London, National Gallery

For a young man of twenty-one
to have gained a royal portrait
commission was exceptional, but
the brilliance of Lawrence's
precocious skill fully explains
the choice. He surpassed even
Zoffany's earlier likeness of the
Queen (Plate 42).

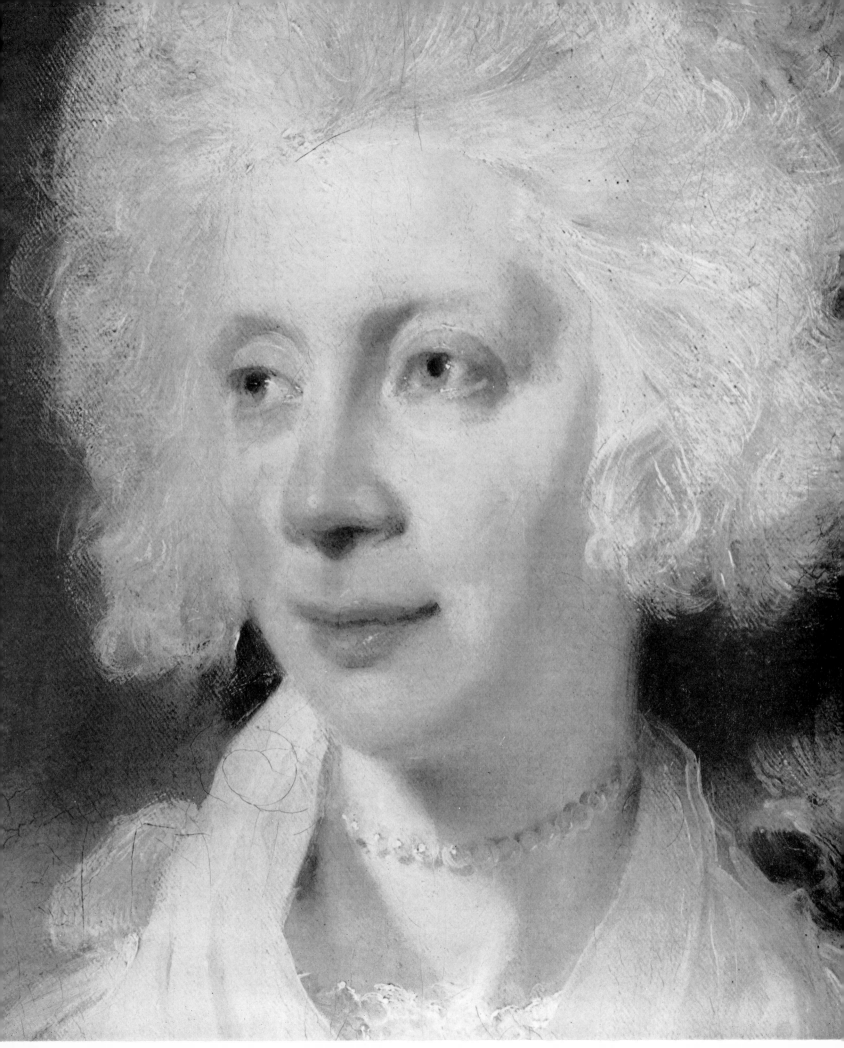

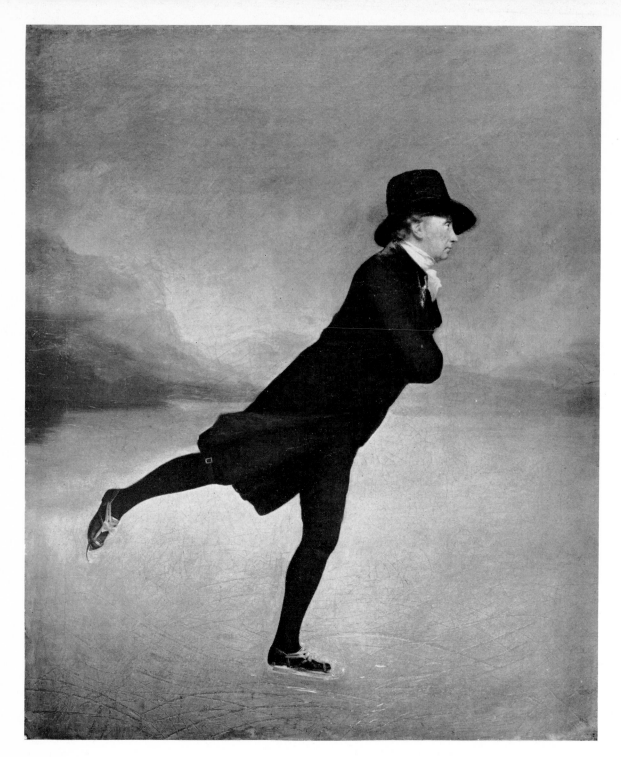

148 SIR HENRY RAEBURN (1756–1823): *The Reverend Robert Walker, D.D., skating on Duddingston Loch.* 1784. Canvas, 29 ×24in. Edinburgh, National Gallery of Scotland

By traditional account this picture was painted for Raeburn's own satisfaction, which seems to explain a representation of brisk movement unusual in his work, and the informality of the clergyman, obviously enjoying himself. Born in Ayrshire, the Reverend Robert Walker was minister of the Scots Church at Amsterdam for a period, and, evidently with a lively interest in sports, wrote an account of 'kolf' as practised in Holland. Raeburn presented this delightful picture, with its suggestion that the cloth did not preclude a hearty exercise of activity, to Mrs Walker after her husband's death.

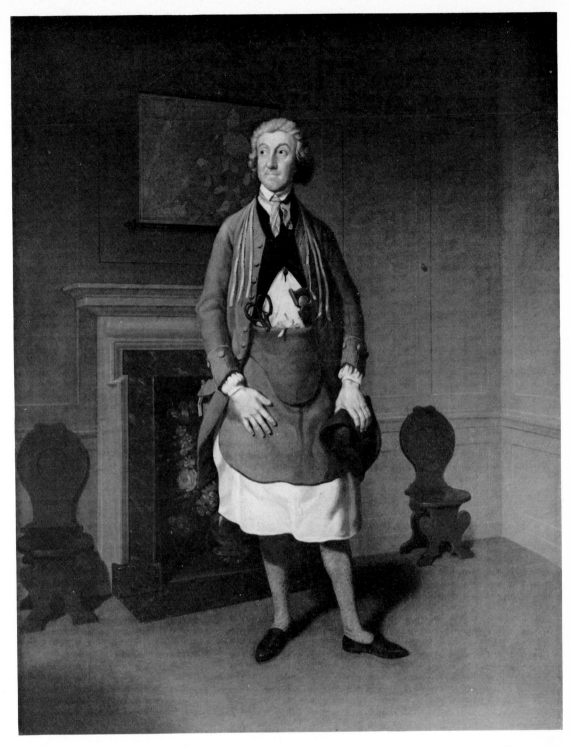

149 SAMUEL DE WILDE (1748–1832): *Richard Suett, the Actor, in Character*. 1797. Canvas, $29\frac{1}{8} \times 22\frac{7}{8}$ in. Oxford, Ashmolean Museum

In the representation of actors 'in character', the painters of the eighteenth century developed a genre comparable in subject though not in style with the *ukiyo-e* school of Japan. The genre was vigorously cultivated by Zoffany's pupil, Samuel de Wilde. He was a student of the Royal Academy in 1769 and subsequently painted many dramatic portraits and scenes of plays, finding, like Zoffany, his most congenial scenes in comedy. Richard Suett (1755–1805) is portrayed in the role of 'Dicky Gossip' in the musical farce *My Grandmother* by the artist and author, Prince Hoare.

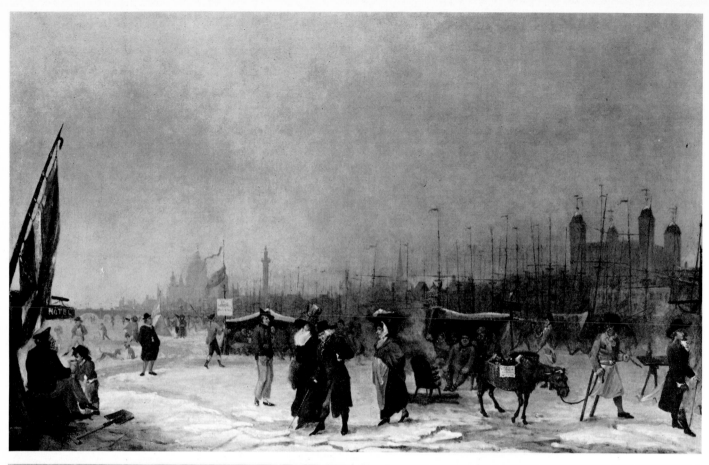

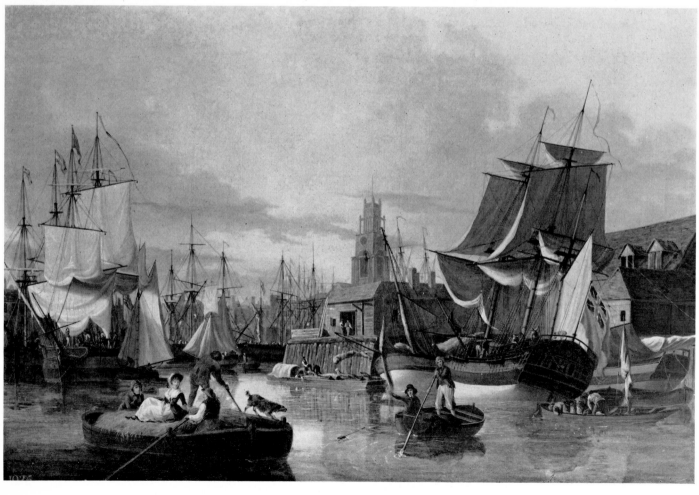

SAMUEL COLLINGS: *The Thames frozen over*. 1788/9. Canvas, 32 ×48in.
Collection of Mr and Mrs Paul Mellon

JOHN THOMAS SERRES (1759–1825): *The Thames near Limehouse*. 1790. Canvas, 42 ×60½in.
Kensington Palace. Reproduced by gracious permission of Her Majesty The Queen

GEORGE MORLAND (1763–1804): *Seashore—Fishermen hauling in a Boat*. 1791. London,
Victoria and Albert Museum

The Thames was never a more favourite subject of painters than in the eighteenth century. Samuel
Collings, better known as a satirical draughtsman and poet, recorded the icebound aspect of the
river opposite the Tower of London during the great frost of 1788–9. Collings himself, according to
tradition, is portrayed in the figure at the extreme right and also with a lady in the centre. John
Thomas Serres, a painter mainly of sea pieces, men-of-war and naval engagements, could also do
justice to the picturesqueness of Limehouse. Although George Morland is associated mainly with
inland rural scenes, his series of coast scenes are among his best productions.

153 JOSEPH WRIGHT OF DERBY (1734–97): *Landscape with a Rainbow—View near
Chesterfield*. About 1794–5. Canvas, 32 ×42in. Derby Museum and Art Gallery

Wright painted two landscapes with rainbows, one of which went to America and the
other, remaining in England, was acquired by Derby in 1913. It shows the same
scientific interest in natural phenomena, and especially of light, as his studies of
Vesuvius in eruption and firework display in Rome. The rainbow was a transient
effect to which artists had not previously given much attention—though it had a
place in Rubens's encyclopedic view of nature. The idea of landscape painting as a
form of natural science was no doubt in Wright's mind as it was later to be defined
by Constable. Both Constable and Turner were to ally science and poetry in
representing 'the grand ethereal bow' (so described in the quotation from Thomson that
accompanied Turner's *Buttermere Lake* in 1798). In this respect Wright may be looked
on as their herald.

54 JOSEPH MALLORD WILLIAM TURNER (1775–1851): *Moonlight: a Study at Millbank*.
About 1797. Panel, $11\frac{1}{2} \times 15\frac{1}{2}$in. London, Tate Gallery

Before the eighteenth century came to an end Turner was beginning to free himself
from the limits of topographical watercolour and prepare for that tremendous
development that was to extend far into the Victorian era. The study at Millbank was
one of his first oils, exhibited at the Royal Academy when he was twenty-two. The
small night river scene, after the style of Aert van der Neer, marks the
beginning of Turner's careful study of European landscape masters that preceded
the soaring flight of his individual genius.

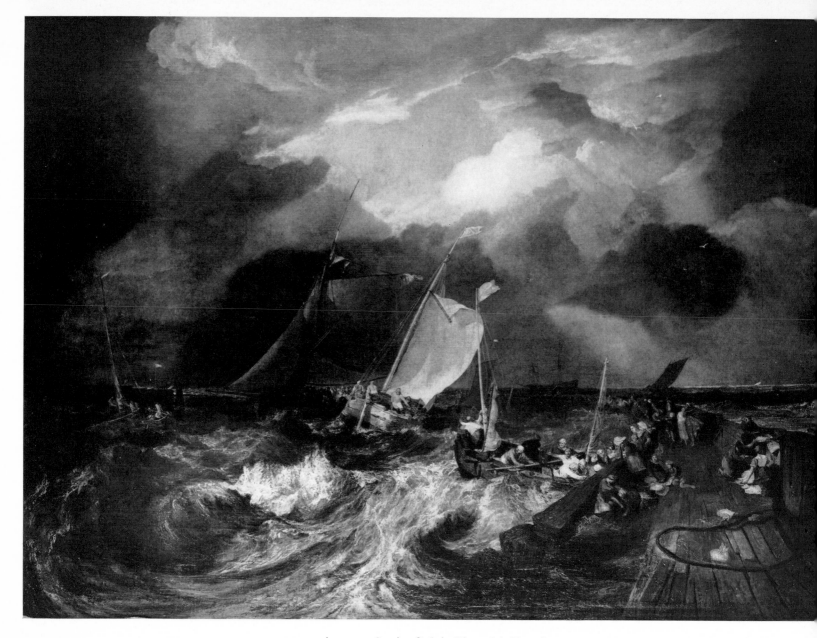

155 JOSEPH MALLORD WILLIAM TURNER (1775–1851): *Calais Pier with French Poissards* [sic] *preparing for Sea: an English Packet arriving.* 1803. Canvas, $67\frac{3}{4} \times 94\frac{1}{2}$ in. London, National Gallery

This is one of the most spectacular pictures painted by Turner in his youth, when he often attempted to emulate famous artists of the past. In this case the artist was Willem van de Velde, whose scenes of shipping, in calm and stormy seas, were very popular in the 18th and 19th centuries. Cuyp and Claude, two other much admired painters of the age, also inspired Turner. But although this identification of the past was a close one, Turner was too independent a spirit to be a mere imitator. The colour, the lively handling of the brush and the pictorial rhythm of *Calais Pier* belong to the early 19th century; the painting is as much a product of the romantic movement as it is a pastiche of an earlier age.

BARRY, *James*

Born in Cork, 11 October 1741, where his father was in the coastal shipping trade, Barry showed an early talent for drawing and was allowed to study under Robert West at Dublin. A painting of *St Patrick baptizing the heathen Ruler of Cashel* brought him to the notice of Edmund Burke, with whose assistance the young man was able to visit Italy in 1766. He came back in 1770, imbued with the ambition to paint in the classic 'grand style' and quickly attained academic honours, becoming Associate of the Royal Academy in 1772 and Royal Academician in 1773. In 1776 he applied himself to the subject then popular with a number of artists, *The Death of Wolfe*; but in contrast to Benjamin West, who gave the figures contemporary uniform and details of attire, Barry painted them in classical nudity. The ensuing criticism caused him to abstain thereafter from exhibiting at the Academy. Wishing to demonstrate—in refutation of the German apostle of classicism, Winckelmann—that Britain was capable of excelling in 'high art', he offered to paint for the Society of Arts the six works descriptive of human progress that still adorn the Society's premises in the Adelphi. For the seven years of labour he received £500 from the public exhibition of the paintings to which £200 was added by the Society. He himself engraved a set of prints after them and wrote accompanying descriptions. He became Professor of Painting at the Royal Academy in 1782, though his bad temper led him to insult the president when the latter remarked on the long delay of his inaugural lecture, and to engage in the differences with members that led to his expulsion from the Academy in 1799. Barry died in London on 21 February 1806.

BIGG, *William Radmore*

Biographical particulars are scanty concerning this artist. He was born in January 1755; was admitted as a student at the Royal Academy in 1778; was elected Associate in 1787 and full Academician in 1814. He was a friend of Reynolds and is said to have been generally popular. He exhibited at the Academy from 1780 to 1827, his work portraying in the words of William Sandby 'benevolence or the tender feelings either of parental affection or rustic society'. He died in Great Russell Street, Bloomsbury, on 6 February 1828.

BROOKING, *Charles*

The birthplace of this artist is not known and biographical facts are in general few. He died (as the Burial Register of St Martin in the Fields shows) in March 1759; and as he was supposed then to be thirty-six, this gives his birth date as 1723. The brief laudatory account by Edward Edwards (*Anecdotes of Paintings*, 1808) derived from the marine painter, Dominic Serres, described Brooking as 'bred in some department in the dockyard at Deptford', adding that he 'practised as a ship painter in which he certainly excelled all his countrymen'. Edwards's text goes on to remark that 'his merits were scarcely known' before he was laid low by a wasting disease. He painted marine subjects in the Dutch manner when he was seventeen. In the 1740s he painted the recent exploits of privateers (engraved by Boydell in 1753). In 1754 he was one of the painters who contributed works to the Foundling Hospital, a large picture of a flagship before the wind, with other ships, being painted by Brooking in eighteen days. The impression is given that he died in poverty in Castle Street, Leicester Square. He marks the emergence of an English style of marine painting freer than in the earlier generation of the Dutch influence shown, for example, by Isaac Sailmaker (1633–1721) and Peter Monamy. About one hundred existing pictures are distributed among museums and private collections.

CANALETTO (*Antonio Giovanni Canal*)

Born in Venice in 1697, Canaletto has a place in English art as a distinguished visitor. There were numerous English admirers of his views of Venice before he came to London. By 1726 the ex-theatrical impresario Owen MacSwiney, in the capacity of collectors' agent, was buying Canaletto's paintings for the Duke of Richmond. By 1730 Joseph Smith, later consul, had begun to buy the paintings and drawings now in the Royal Collection at Windsor. When the War of the Austrian Succession halted the Grand Tour in 1745, it was a reasonable step to renew acquaintance with English patrons on their own ground. Arriving in 1746, Canaletto painted in that year the two magnificent views from Richmond House in the Duke of Richmond and Gordon's Collection (Plate 25). Views of London seen through an arch of Westminster Bridge and of Westminster Bridge under construction

were painted for the Duke of Northumberland (1746–7), and of Badminton House and Park for the Duke of Beaufort in 1748. During a brief return to Venice in 1750, it is assumed he worked from drawings made in England, among the paintings being the two large views from the terrace of Somerset House now at Windsor Castle. Back in England in the following year he painted views of Northumberland House, Syon House and Alnwick Castle for the Duke of Northumberland (1752–3), *Whitehall from the Privy Garden* for the Duke of Montagu (1751) and his series of Warwick Castle for the Earl of Warwick (1751–2). Towards the end of his last stay, in 1754, he painted the fine *Old Walton Bridge* and *The Ranelagh Rotunda*, both for Thomas Hollis, as well as some of his architectural caprices. He left for Venice finally about 1756, and died there in 1768.

COLLINGS, *Samuel*

The dates of Collings's birth and death are unrecorded. He was better known to his contemporaries as a satirical draughtsman and poet than as a painter, contributing to *The Wits' Magazine* and *The Public Ledger*. But he also painted genre scenes and fanciful subjects and was an outside contributor to the Royal Academy in the 1780s. He first contributed *The Children in the Wood, a Sketch* in 1784, *The Chamber of Genius* and *The Triumph of Sensibility* in 1785 and 1786; and exhibited for the last time with *The Thames frozen over* (Plate 150) in 1789. He was a friend of Rowlandson, who etched some of his designs, for example, his satires on Boswell and Johnson's *Tour to the Hebrides* and Goethe's *Sorrows of Young Werther*.

COPLEY, *John Singleton*

Born in Boston, Massachusetts, 3 July 1738, Copley was the son of recent immigrants into the American colonies from Ireland, Richard and Mary Copley. His father's death and mother's subsequent marriage in 1748 to the English-trained engraver, Peter Pelham, provided a milieu in which art was of importance, as well as some education in technique from his mother's second husband. By 1755 he was a professional portrait painter in Boston, developing an incisive and veracious style of portraiture in which he was unrivalled. He married the daughter of a

Boston merchant in 1769; by then he had gained a reputation as a portrait painter that gave him enthusiastic welcome in New York in 1771. The wish for European experience as well as the dwindling of commissions in the disturbed state of the colonies in the 1770s caused him to move with his family to England, where his ability was quickly recognized. In 1779 he became a Royal Academician. He followed and excelled Benjamin West in historical paintings such as *The Death of Major Pierson* (Plates 76 and 77) and *The Death of Chatham* (1779–80; London, Tate Gallery, currently on loan to the National Portrait Gallery). *Brook Watson and the Shark* (Plate 69), shown at the Academy in 1778, is one of the early masterpieces of romanticism. More freedom of style appears in his portraits in England, the group of royal princesses painted for George III in 1785 being a splendid example (Plates 118 and 138). He died in London on 9 December 1815. His son, John Singleton Copley, became Lord Chancellor and Baron Lyndhurst.

DEVIS, *Arthur*

Born at Preston in Lancashire in 1711, Devis was the pupil of Pieter Tillemans, the Flemish-born painter of sporting subjects and conversation pieces in a context of outdoor sport. Devis painted some full-scale portraits but specialized mainly in small whole lengths and the domestic conversation pieces that added a delightful linear quality to precision of detail. He gave an excellent picture of upper middle-class life in the mid-century. He exhibited with the Society of Artists from 1761 and with the Free Society, 1762–80, becoming its president in 1768. Towards the end of his life he was employed on restoration work in the Hall of Greenwich Hospital, for which he received £1000. Devis died 24 July 1787. His brother, Antony Devis, was a landscape painter and drawing master.

FUSELI, *Henry (Johann Heinrich Füssli)*

Born in Zürich, 7 February 1741, Fuseli—as his name Füssli came to be finalized after his stay in Italy—was the son of a Swiss portrait painter and connoisseur. He had a liberal education from the Swiss savant, Bodmer. After a youthful revolt against authority, he emigrated to

England in 1764 and was encouraged by Reynolds to paint and study in Italy. The years he spent there, 1770–8, made for a form of mannerism derived from his admiration for Michelangelo, though his inspiration was mainly literary. The romantic love of fantasy and a psychological complexity gave an original character to his work. The *Nightmare* of 1782, a first pictorial representation of the sensation of a dream, made him famous. The dream state is still more vividly rendered in his strange boudoir pictures of women with exaggerated head-dresses. He made imaginative contributions to Boydell's Shakespeare Gallery, partly inspired by the tragedies, although Fuseli's northern idea of a fairyland appointed him the interpreter *par excellence* of Oberon's and Titania's Court (Plate 130). His art was related to William Blake's, but with less of the ideal quality of imagination than the sinister. He was elected Academician in 1790, and Professor of Painting in 1799. In his later years, as a witty and eccentric old man, he was pungently described by B. R. Haydon. Fuseli died 16 April 1825 at the age of 88.

GAINSBOROUGH, *Thomas*

Born in Sudbury, Suffolk, in May 1727, Gainsborough was the son of a manufacturer of woollen fabrics. As a boy of fourteen he went to London to study and was a pupil of the French engraver, Hubert Gravelot, at the academy in St Martin's Lane, where he presumably also became acquainted with Francis Hayman. He was married in London at nineteen to Margaret Burr (1728–98), illegitimate daughter of Henry, Duke of Beaufort, from whom she had an annuity. The young couple went to Sudbury, where Gainsborough worked as a painter of landscapes and open-air conversation pieces until 1752, and then to Ipswich from 1752 to 1759. His view of landscape was much influenced in this period by the work of the seventeenth-century Dutch painters, Ruisdael, Hobbema and Wynants, whose work he saw at the East Anglian houses he visited, Catton House especially. Some of these paintings he was commissioned to restore. Hayman's informal open-air portraiture in landscape setting gave him a lead he put to splendid use, and there are certain echoes of French pastoral that recall his time with Gravelot. But his own originality is beautifully seen in *Gainsborough's Forest* (Plates 32 and 33),

View of Dedham and *Mr and Mrs Robert Andrews* (Plate 14). His daughters—Mary, born 1748 and Margaret, born 1752—were portrayed in masterly works (Plates 34 and 75).

On the advice of his local patron, Philip Thicknesse, he moved to Bath in 1759, where his art entered into another and more urban phase. Busied in this centre of fashion with portrait commissions until 1764, he experienced new influences, especially that of Van Dyck, whose work he saw at Wilton and other great houses, and whose elegance of style he adapted. He still practised landscape painting, though as the setting for a Utopian peasantry and vehicle of generalized arrangements of light and shade, distinct from his early regional masterpieces.

In 1774 Gainsborough moved permanently to London. He was a foundation member of the Royal Academy in 1768 and was elected to the Council in 1774, the year in which he settled at Schomberg House, Pall Mall. He became the favourite painter of George III and Queen Charlotte—there are still 34 pictures by Gainsborough in the Royal Collection—and in 1781 was working at Windsor. It was in that year that he exhibited his full-length portraits of the King and Queen. His later output was very varied, including portraiture of great elegance in style; rural genre such as the popular *Cottage Girl with Pigs* (1782; bought by Sir Joshua Reynolds, and now at Castle Howard); landscape, at this time somewhat influenced by Rubens; and what he termed 'fancy pictures', imaginary figures or figure groups freely painted (Plate 116). His tendency to experiment is seen in his many landscape drawings executed in a mixture of media that might combine watercolour, chalk, pen and even oil. The romantic trend of the period, away from the settled lowlands to mountain scenery, took him on a sketching expedition to the Lake District in 1783. A temperamental man, Gainsborough quarrelled with the Royal Academy in 1784 over the hanging of his pictures and withdrew them to give his first private exhibition at Schomberg House. He was reconciled with Reynolds, with whom he had never been entirely in sympathy, during his last illness, and he died in London on 2 August 1788. In the number, variety and exquisite quality of his masterpieces, he was unique in his time; and his feeling for rhythm and colour often brings to mind the art of music to which he was also devoted.

GILLRAY, *James*

Born in London in 1756, Gillray was the second son of James Gillray, who had been in the army, lost an arm, and become an out-pensioner of Chelsea Hospital. Gillray was apprenticed to an engraver but ran away and joined a group of strolling players. Bored with this, he studied at the Royal Academy, where he gained a solid foundation in figure drawing. His genius led him to caricature, and he devoted all his energy to satire of politics and the morals of the day. He ruthlessly ridiculed the royal family, nobility and politicians, as well as attacking Napoleon and the French. He completed a few serious works, but it is as a skilful and witty caricaturist that he holds a foremost position in English graphic art. He led an intemperate life and in his last years was an imbecile. He died 1 June 1815 in St James's Street, London.

HAMILTON, *Gawen*

Born in the west of Scotland in 1698, Hamilton settled in London about 1730. He was one of the imitators of Hogarth in conversation pieces, and George Vertue considered him worthy in some respects of comparison with that master. As late as 1963, a conversation piece now attributed to him, *The Brothers Clarke with other Gentlemen taking Wine* (in the collection of Mr and Mrs Paul Mellon) was sold at Sotheby's as by Hogarth, though the style was different from Hogarth's and accorded with Hamilton's work—of which *A Club of Artists* (Plates 4 and 5) is a good example. He died in 1737. Gawen Hamilton is not to be confused with Gavin Hamilton (1723–98), the neoclassical history painter.

HAYMAN, *Francis*

Born in Exeter in 1708, Hayman is said to have been the pupil of an obscure portrait painter, Robert Brown. Going to London as a young man, he was employed as a scene painter by Fleetwood, the proprietor of the old Drury Lane Theatre, whose widow he was to marry after Fleetwood's death. By all accounts a convivial character, he had a wide circle of acquaintances, including Hogarth, Dr Johnson, Garrick and the actor Quin. Though not among the greatest masters of the age, he had a wide range of accomplishment. He painted both interior and open-air conversation pieces, influenced by Hogarth in directness of portraiture but also in elegance of style by Hubert Gravelot, with whom he was a teacher at the academy in St Martin's Lane. His portraits in landscape setting were clearly an influence on Gainsborough. Intimacy with the world of the theatre led him to paint some of the earliest pictures showing actors on stage 'in character'. He played an important part in the production of the ambitious scheme of decoration for Vauxhall Gardens organized by the manager, Jonathan Tyers, in the 1730s and 1740s; especially popular were his scenes from the Seven Years War. He exhibited many history paintings at the Society of Artists and Royal Academy. Few have been traced, but his *Finding of the Infant Moses* was presented in 1746 to, and preserved at, the Foundling Hospital. Hayman illustrated many works of literature, Richardson's *Pamela* and Hanmer's *Shakespeare* in collaboration with Gravelot, and other works independently. A founder member of the Royal Academy, he was its first librarian. He died at Dean Street, Soho, on 2 February 1776.

HIGHMORE, *Joseph*

Born in London, 13 June 1692, Highmore was the third son of Edward and Mary (Tull) Highmore, his father being a coal merchant in Thames Street. He was articled as clerk to an attorney in 1707, but his ambition was always to paint, and he studied for two years at the academy founded by Kneller in Great Queen Street. Beginning as a professional portrait painter in 1715, he gained clients from the City merchants who approved of his ability to convey likeness and character without ostentation. He married in 1716, and a move in 1723 to a house in Lincoln's Inn Fields marked his growing business and prosperity. His contribution to a folio of engravings relating to the Order of the Bath and its ceremonies obtained him a number of commissions from the Knights of the Order. Admiration for Rubens led him to visit the Netherlands in 1732. His series of twelve paintings in illustration of Samuel Richardson's *Pamela* (Plate 6) and small, full-length, single and group portraits of the same period and style, were a principal achievement of the 1740s. The successful novel *Pamela* had been illustrated

in 1742 by Francis Hayman and the French engraver Gravelot, and Highmore's picture series following a year later had an elegance somewhat recalling Gravelot's work. As a result of the paintings, Highmore became a close friend of Richardson, and not only painted illustrations for Richardson's other novels, but also portrayed the novelist (Plate 17). *Mr Oldham and his Guests* (Plate xxi), formerly attributed to Hogarth, is one of his best conversation pieces. Highmore retired as a painter in 1761 and left London to live with his family at Canterbury in 1762, his later years being occupied with written reflections on a variety of subjects. He died at Canterbury, 3 March 1780.

HODGES, *William*

Born in London in 1744, a blacksmith's son, Hodges went as a boy to Shipley's drawing school in the Strand and afterwards became studio assistant to Richard Wilson, acquiring something of his style. His early work included topographical views, and in 1772, at the suggestion of the second Viscount Palmerston, one of the Lords of the Admiralty, he was appointed draughtsman to Captain Cook's second expedition to the South Seas. His drawings were published with the narrative of the expedition and on his return after three years he painted views for the Admiralty of the Windward and Leeward Islands and New Zealand, where the *Resolution* had anchored. From 1778 to 1784 he worked in India with the protection and support of Warren Hastings. He became Royal Academician in 1787. In 1790 he travelled widely in Europe, his journeys extending to St Petersburg, of which city he exhibited a view in the Academy in 1793. He contributed to Boydell's Shakespeare Gallery scenes from *As You Like It* and *The Merchant of Venice* that gave scope for landscape treatment. His *Travels in India*, with a series of aquatint plates, was published in 1793 and dedicated to the East India Company. In 1795 he was ill-advised enough to invest the capital accruing from his work in India in establishing a bank at Dartmouth. Its failure may well have hastened his death on 6 March 1797.

HOGARTH, *William*

Born in London, 10 December 1697, Hogarth was the son of a poor schoolmaster from Westmorland who eked out a living by hackwork for publishers in the capital. The boy was apprenticed to the silverplate engraver, Ellis Gamble, thus gaining an introduction to the world of prints—satirical and illustrative—in which he made his first appearance as an original designer. His illustrations to Butler's *Hudibras*, 1726, gave him a certain reputation. There are no precise details of his studies at the academy founded by Kneller later supervised by Sir James Thornhill, but it may be assumed that he learned something from Thornhill's baroque style of decorative painting, for which he expressed admiration. His clandestine marriage in 1729 with Thornhill's daughter, Jane, caused him by his own account to take to the production of small conversation pieces for a living. Although not the first to practise the genre, he realized all its potentialities as a social study. Intermediate between his pictures of Georgian families in their daily aspect and his pictures of Georgian society in panorama, was his rendering of Gay's *Beggar's Opera* (1730), so popular as to require several versions, of which one is in the Tate Gallery in London. It was followed by the first of the great dramatic series *A Harlot's Progress* (1731), painted and engraved, though only the engravings now exist. They were popular and in this form Hogarth realized he could appeal to a wide public and be independent of the demands of an individual patron. The series that he himself thought of as dramas in several acts followed at irregular intervals: *A Rake's Progress*, 1735 (London, Sir John Soane's Museum); the *Marriage à la Mode*, 1745 (London, Tate Gallery); and *An Election*, 1755 (Sir John Soane's Museum; Plate viii). Apart from them, many individual pictures are stamped with his original genius. After 1735, when the act for which he agitated, protecting the designer's copyright, came into force, the prints from these pictures provided a secure income and made it possible for him to pursue varied ambitions. The wish to promote an English school of history painting seems to have prompted him to decorate the staircase of St Bartholomew's Hospital (of which he became a governor in 1734) with religious scenes. A sense of social responsibility made him the active supporter of Captain Coram's Foundling Hospital, for which again he painted a religious subject. He revived the academy in St Martin's Lane as a meeting place for artists, although he remained steadfastly against academic institutions. He produced numerous portraits admirably direct and unaffected, and a marvellous sketch in the

famous *Shrimp Girl* (Plate 45). In the 1740s he was at the height of his powers and productive energy, and his output included such a masterly conversation piece as *The Graham Children* (1742; London, Tate Gallery); the *Marriage à la Mode* series; *The March of the Guards towards Scotland* (1746; Plates 19, 20 and 135); and *Calais Gate* (1748–9; Plates 16 and 18).

In his mature style he seems to have profited by his two visits to France, probably from seeing works of Chardin and the rococo school, even though the visit of 1748 and his arrest as a spy increased his insular dislike of the foreigner as such. The line engravings of *Gin Lane* and *Beer Street* and the woodcuts of *The four Stages of Cruelty*, made by his own hand instead of by employed engravers, and without a preceding oil picture, were powerful comments on national vices, the *Stages of Cruelty* being made deliberately crude to grasp the attention of a brutal lower class. Hogarth's pugnacious character and constant assaults on false connoisseurship made him many enemies. The prints delighted the general public but the originals failed to appeal to the picture-buyer, as the two auctions he organized showed all too clearly. He retired in 1751 to his villa at Chiswick, devoting himself to his book, the *Analysis of Beauty* (1753). He was made Sergeant Painter to George III in 1757, but his best-known subsequent work, the *Sigismonda* (1759), painted in emulation of what was thought to be a Correggio (actually by Furini), caused an outburst of scorn and ridicule. Hogarth died on 26 October 1764. Though controversy and disappointment marred his last years, he had set a great example in his fearless independence and originality.

JONES, *Thomas*

Born in Pencarrig, Carmarthenshire, in 1742, of well-to-do parents, Jones was educated by tutors and in local schools and in 1759 matriculated at Jesus College, Oxford. Although it was his family's intention that he become a clergyman, he came down without a degree in 1761 and began his study of art in London at Shipley's drawing school and at the academy in St Martin's Lane. He became a pupil of Richard Wilson in 1763, referring to him later with profound respect, and was afterwards a member of the Incorporated Society of Artists. His early works were landscapes in oil and pastel, his friend J. H. Mortimer

sometimes adding figures for him. A romantic departure was his picture of *The Bard* in 1773, inspired by Gray's poem. He set off for Italy in 1776, spending two years mainly in Rome and Naples. A number of landscapes in oil and watercolour were in the English topographical tradition, but in his oil studies of buildings at Naples he made a distinctly original departure (Plate 87). He died a wealthy squire on the family estate in Wales in May 1803. For a long time neglected, he came into renewed notice in 1951 with the publication of his memoirs edited by Paul Oppé, which provide interesting detail of the English art colony in Italy. His considerable talent was confirmed by an exhibition of his work in 1970, in which appeared a number of recently discovered oil sketches of Wales, Rome and Naples.

KNAPTON, *George*

Born in London in 1698, Knapton was the son of a prosperous bookseller. He was the pupil of Jonathan Richardson and worked at first chiefly in crayons. He spent some years in Italy. He was an original member of of the Dilettanti Society in London (1740) and became its first portrait painter, painting portraits of 23 of its members. In 1765 he was appointed surveyor and keeper of the King's pictures. His largest work was of the widowed Princess of Wales and her family (1751; Hampton Court). He died in Kensington in December 1778.

KNELLER, *Sir Godfrey*

Originally Gottfried Kniller, of German origin, Godfrey Kneller was born in Lübeck on 8 August 1646, and trained as a painter at Amsterdam under Rembrandt's pupil, Ferdinand Bol. He went to Italy in 1672 and came to England two years later on what was intended to be a brief visit. It proved so successful that he stayed on, together with his elder brother John Zachary Kneller, also a painter, who died in 1702 and was buried in St Paul's, Covent Garden. Godfrey had the favour of successive sovereigns from Charles II to George I and, in all, he painted portraits of nine monarchs: Charles II, James II and his Queen, William and Mary, George I, Louis XIV, Peter the Great and the Emperor Charles VI. He was

made a knight of the Roman Empire, a doctor of Oxford University and a baronet in 1715. Some 6000 portraits were produced on factory lines with the cooperation of assistants, though his individual gifts appear undiluted in some pictures entirely his own, such as *The Chinese Convert* (Kensington Palace) and his portrait of Matthew Prior (Plate 3). Among his principal works are the series of *Beauties* (Hampton Court), the *Admirals* (Greenwich National Maritime Museum) and the Augustan *Kit Cat Club* (London, National Portrait Gallery). He was an eighteenth-century pioneer in the open academy that he founded in Great Queen Street, London, in 1711. He died in 1723.

LAMBERT, *George*

Born, it has been surmised, in Kent about 1700, Lambert is described by George Vertue in 1722 as a 'young hopefull Painter in Landskape aged 22', also as a pupil of 'Hassel' though 'much in imitation of Wotton'. Hassel, it is now assumed, was the portrait painter, Warner Hassels, active about 1680–1710, although little is known of him. Lambert has been described as a pupil of Wootton, but it may be simply that he followed Wootton in landscape style. Though he was the friend of Hogarth and the actor-manager Rich, details of Lambert's life are scanty. He lived in the Piazza, Covent Garden, and died there on 30 or 31 January 1765. The items in the sale of his effects suggested he had been fairly prosperous. Scene painting was one source of his income, first at Lincoln's Inn Fields Theatre and then with Rich from 1732 at the newly built Covent Garden Theatre. Scene painting equipped him to cope with the large-scale landscape backgrounds he added to Hogarth's *Good Samaritan* and *Pool of Bethesda* on the staircase of St Bartholomew's Hospital. An exceptional picture commission was to paint, in 1732, the land backgrounds to six pictures for the East India Company of their principal settlements (now in the Ministry of Commonwealth Relations) in collaboration with Samuel Scott, who painted the ships in the foreground. Lambert also painted decorative landscapes in a style deriving, as did Wootton's, from Gaspard Dughet and Nicolas Poussin, his 'classical' manner perhaps encouraging the Earl of Burlington to commission views of Chiswick Villa from him. His country-house views are

well exemplified by those of Westcombe House, Blackheath, 1732, and Copped Hall, Essex, 1746. Figures in his landscapes were sometimes put in for him by Hogarth, as in the *Ruins of Leybourne Castle* (Plate 23). In English landscape, Lambert marks the beginning of the transition from the ideal or conventional to the regional reality.

LAROON, *John Marcellus*

Born at Covent Garden, London, 2 April 1679, Laroon was the second son of Marcellus Laroon the Elder (1653–1702), a painter who had come to England from The Hague and was one of Kneller's assistants. The education of the young Marcellus comprised painting, dancing and music, and preceded a varied career. Before he was twenty he acted as page to titled travellers on the Grand Tour, going through Germany and the Tyrol to Venice and returning to London by way of France. He then became an actor and singer at Drury Lane, joined the footguards under Marlborough, fought at Oudenarde, was taken prisoner but was exchanged and returned to London to study painting again at Kneller's academy in 1712. He remained in the army, taking part in the action against the Jacobite rising of 1715, and retired on half-pay in 1732 with the rank of captain. He was a friend of Hogarth and imitated his free style of draughtsmanship, although he painted in a distinctive technique of his own devising. The type of conversation piece by which he is remembered—his renderings of fashionable gatherings, musical parties and outdoor scenes, without specific portraiture—shows some reminiscence of Watteau in thought but not in execution. He died at Oxford in June 1774.

LAWRENCE, *Sir Thomas*

Born in Bristol, 13 April 1769, Thomas Lawrence was a juvenile prodigy. His father, who had tried various occupations without success, became the landlord of the 'Black Bear' at Devizes in 1772 and it was there, before he was ten, that his youngest child astonished visitors by his pencilled likenesses as well as his poetic recitation. The family's removal to Oxford, Weymouth and Bath did not interrupt his progress and at Bath, by the time he was

seventeen, he could command three guineas for a crayon portrait. He moved to London in 1787 and with brief instruction at the Royal Academy schools, he quickly mastered the oil medium. At twenty he was not only fortunate in being commissioned to paint a full-length portrait of Queen Charlotte, but he carried it out with brilliant success (Plates 146 and 147). This work, exhibited at the Royal Academy in 1790, with his delightful full-length portrait of the actress, Miss Farren, later Countess of Derby (Plate XXIV), assured his popularity; sitters thronged to his London studio. He seemed the obviously predestined heir of Sir Joshua Reynolds, whom he succeeded in 1792 as King's Painter in Ordinary. He was elected Academician in 1794. Painting with great facility, sometimes having as many as five or six sitters in a day, he gave a unique picture of English society in the Regency and reign of George IV. He was knighted in 1815, and became president of the Royal Academy in 1820. After the victory over Napoleon he was commissioned by the Prince Regent to portray the allied sovereigns and dignitaries. Travelling for this purpose to Aix-la-Chapelle, Vienna and Rome, he was treated everywhere with great respect as a 'superior being and a wonder', the evidence of his exceptional ability being combined with the impression made by his distinguished presence and courtly manners. The portraits assembled in the Waterloo Chamber at Windsor Castle are a tremendous *tour de force* of large-scale painting as well as historical record. Portraiture remained his special gift, though he felt the temptation of the period to embark on immense and dramatic themes. The Miltonic Satan, alluring to the romantic age, inspired his *Satan summoning his Legions* (London, Royal Academy), but this was the failure of which Fuseli remarked, it was 'a damned thing but not the Devil'. There are, however, landscapes and landscape details (for example, the distant view of Eton in the background of *Queen Charlotte*) that show he was not a painter of faces only. As a painter of women and children he added an epilogue to the record of charm and good looks in the upper stratum of Georgian society that Gainsborough and Reynolds had made before him, though the restless glitter of his style, which intrigued Géricault and Delacroix, belonged to a changing epoch. Lawrence, as well as being eminent in painting, was one of the great connoisseurs, spending some £70,000 on a wonderful collection of old-master drawings; this collection was un-

fortunately dispersed after his death, though examples were acquired by the Ashmolean Museum and the British Museum. He died on 7 January 1830.

LOUTHERBOURG, *Philip James de*

Born in Strasbourg, 1 November 1740, de Loutherbourg was the son of a miniature painter of Polish extraction. He studied art in Paris under Francesco Casanova and Carle Vanloo and became a member of the Académie Royale in 1762. After travelling in Switzerland, Germany and Italy, he came to England in 1771 and worked for Garrick as a stage designer. His paintings were varied in subject and included battle pieces, religious subjects, landscapes and coastal scenes. He exhibited at the Royal Academy from 1772 to 1812 and was elected Royal Academician in 1781. About that time his inventive turn of mind was displayed in his *Eidophusikon or a Representation of Nature*, a species of diorama showing changes of light and weather conditions by means of illuminated gauze. It was an exhibition that fascinated Gainsborough and caused him to devise the similar spectacle preserved in the Victoria and Albert Museum. De Loutherbourg produced a number of etched and aquatinted prints after his own compositions. In later life he seems to have fallen a victim to the religious mania of Richard Brothers, and to have provoked disturbances by wild predictions and attempts at faith healing. He died at Chiswick on 11 March 1812.

MARLOW, *William*

Born in Southwark in 1740, Marlow became a pupil of Samuel Scott and was also a student at the academy in St Martin's Lane. He first exhibited with the Incorporated Society of Artists and travelled in France and Italy, 1765–8, producing a number of topographical watercolours during his stay in Italy, though he also painted in oils and exhibited at the Royal Academy from 1788 to 1807. He lived in Leicester Square on his return to London. He drew on his Italian experience in such works as the *Smugglers landing on a rocky Coast* (collection of Paul Mellon), and applied the Italian style of *capriccio* to English scenes (Plate 26). He also produced a number of views of English country houses and estates. He retired from professional practice in the 1780s but continued to paint. He died in Twickenham, 14 January 1813.

MARTINI, *Pietro Antonio*

Born in Trecasali, 9 July 1738, he studied under Benigno Bossi in Italy. Known mainly as a draughtsman and engraver, he worked for a number of years in Paris and came to England in 1787. He went back to Paris, and in 1792 returned to Parma, where he died on 2 November 1797.

MORLAND, *George*

Born in London, 26 June 1763, Morland was the son of the painter and picture dealer, Henry Robert Morland (died 1797). The boy was taught by his father, but though the latter was an able painter of domestic genre, he probably learned more from the Flemish and Dutch paintings that he helped to copy and restore. He studied at the Academy schools for a time, entering in 1784, but as soon as possible he escaped from family routine and led the casual and dissipated existence that has often been described. In 1785 he travelled to France and in the following year married Anne, the sister of the Ward brothers—William Ward the engraver and James Ward the painter; the latter married Maria Morland, George Morland's sister. Anne remained deeply attached to her husband through many trials. Refusing lucrative offers of patronage, he fell into the hands of unscrupulous dealers. For a time his prolific output kept him solvent, but the poor return for his pictures and his extravagant ways combined to accumulate debt. In 1789 he was able to pay off his debts by strenuous efforts, but his finances again deteriorated and he went to Leicestershire to escape his creditors. He changed London addresses often and in 1799 escaped to Yarmouth in the Isle of Wight. He was arrested on his return and sent to the King's Bench prison until 1802; the following year he was again imprisoned for debt. He died at a sponging-house on 29 October 1804. His wife survived him only three days and they were buried together in the St James's Chapel cemetery, Hampstead Road. In spite of his difficulties, his idyllic pictures of rural life were frequent exhibits at the Academy between 1778 and 1804, and the best of his work belongs to the last decade of the eighteenth century.

MORTIMER, *John Hamilton*

Born in Eastbourne in September 1741, of a prosperous middle-class family, Mortimer was from an early age ambitious to be a painter and was allowed to go to London when about seventeen to study under Hudson, his father paying a premium of one hundred guineas. Joseph Wright of Derby was a fellow pupil, and became a close friend. He also worked with Robert Edge Pine, a portrait painter who later emigrated to America. Between the ages of 19 and 23 Mortimer won all the prize competitions in drawing at the academy in St Martin's Lane and the Duke of Richmond's antique gallery, and in 1764 won the top prize of one hundred guineas offered by the Society of Arts for a history painting with his *St Paul preaching to the Britons*. From 1762 he exhibited at the Society of Artists regularly each year until he was elected an Associate of the Royal Academy in 1778. Until 1770 he was occupied with single portraits and conversation pieces that breathe all the polite reserve of eighteenth-century society. After that date he turned to historical and Biblical subjects, scenes with banditti in the fashion of the time (Plate 89), and subjects with a satanic element. The accounts of both Edward Edwards and Thomas Jones convey that his natural exuberance of character led him into wild excess, and indeed a self-portrait of the 1770s has the defiant air of the Byronic outlaw-hero. He died on 4 February 1779.

OPIE, *John*

Born in 1761 at St Agnes, a Cornish mining district on the Atlantic coast of the county, Opie was the youngest of five children of a carpenter. Although his father had strongly opposed his early interest in art, when he was fourteen the physician, writer and amateur painter, Dr John Wolcot ('Peter Pindar') began giving him lessons at Truro and started him off as an itinerant painter of faces in the region. After four years of this work in Cornwall and Devon, Opie showed such promise that Wolcot launched him in London as the self-taught genius he had discovered in the wilds. In 1782 Opie was presented to George III; had five pictures in the Academy; and was much praised as 'the Cornish wonder'. His brilliant success with the fashionable world lasted only a short time and Opie then buckled down to serious work. The rustic genre paintings of 1783–5, inspired by Gainsborough (for example, *The Peasant's Family*, Plate 115), and the portraits of this period show him at his best. Opie was elected Royal Academician in 1787. He then turned his attention to historical scenes

in the growing romantic taste of the time and to portraits of writers and artists. His wife, Mary Bunn, left him in 1795; they were divorced in the following year and in 1798 Opie married the authoress, Amelia Alderson, whose novels helped to give his work a flavour of literary anecdote—as in *The Fortune Teller* and *The Lovesick Maid* (1801). He was elected Professor of Painting at the Academy in 1805. His posthumously published *Lectures on Painting* (1809) influenced a younger generation, Constable included. Opie died in London on 9 April 1807.

PATCH, *Thomas*

Born in Exeter in 1725, a surgeon's son, Patch turned from the study of medicine to painting. He worked with Claude-Joseph Vernet in Rome but when he became unwelcome in the Papal State, his eccentric behaviour incurring the displeasure of the ecclesiastical authorities, he went to Florence, where he was befriended by Sir Horace Mann, British minister at the Florentine court. Patch settled in Florence and established a speciality of his own in the caricature conversation pieces which, in spite of their grotesque nature, were extremely popular with English visitors on the Grand Tour, the persons portrayed often drawing lots to decide who should own the painted group. Sir Horace Mann appears in one such caricature group preserved at the Royal Albert Memorial Museum, Exeter. The young Joshua Reynolds on his Italian tour tried his hand in this caricature vein and portrayed Patch in a caricature of *The School of Athens* (1751), but must have quickly decided that so unserious a form of art was not for him. In 1770 Patch engraved a series of *Twenty-eight Caricatures*. He also made landscape studies of the country around Florence and was a serious student of Florentine art. He made careful drawings of Masaccio's frescoes in the Church of the Carmine; etched on copper they were published in 26 plates in 1770, and were dedicated to Sir Horace Mann. Another set of etchings (1772), after the work of Fra Bartolommeo, was dedicated to Horace Walpole. Patch died in Florence on 30 April 1782.

PENNY, *Edward*

The son of a surgeon, Penny was born in Knutsford, Cheshire, 1 August 1714. He was a pupil of the portrait painter, Thomas Hudson, and later studied under Benefiale in Rome, where he specialized in small portrait heads. He also exhibited a number of historical paintings (adding his own version of *The Death of Wolfe* to that of Benjamin West) and sentimentally moralistic subjects that provided an English equivalent to works of similar purport by Jean-Baptiste Greuze in France. He was vice-president of the Incorporated Society of Artists and later, in 1768, was one of the founder members of the Royal Academy, contributing a painting of the Smithy Scene from *King John* to the first exhibition. He was the first Professor of Painting at the Academy, an office he held until 1783. He died in Chiswick on 15 November 1791.

PETERS, *Matthew William*

Born on the Isle of Wight in 1742, Peters studied art under Robert West, master of the National Academy of Design in Dublin, in which capital city Peters's father was employed in the Custom House. The boy's promise of ability caused a group of connoisseurs to finance his journey to Italy, where he remained until 1766 studying and making copies of old masters. On his return he painted portraits and such subjects as the scenes from *The Merry Wives of Windsor* and *Much Ado about Nothing*, which he contributed to Boydell's Shakespeare Gallery. His paintings of young people had much charm, though moralists cast a critical eye on his *Woman in Bed* (Plate 93), of which he painted several versions. In portraiture he followed the style of Reynolds. The charm of his work made it popular in engravings by Bartolozzi and J. R. Smith. Peters was elected Associate of the Royal Academy in 1771 and full Academician in 1777, but he later gave up painting as a professional occupation. It is said he was led to this act of renunciation on finding Richard Wilson, for all his genius, unable to buy canvas and colours and at the point of starvation. Peters entered Exeter College, Oxford, took the degree of LL.B., and as the Reverend Matthew William Peters was Chaplain to the Prince of Wales and from 1784 to 1788 Hon. Chaplain to the Royal Academy. He resigned membership from the Royal Academy in 1790 although occasionally exhibiting works of a pious character. He died in Kent in April 1814.

RAEBURN, *Sir Henry*

Born in Stockbridge, near Edinburgh, 4 March 1756, he was the second son of Robert Raeburn and Ann Elder. Both parents died when he was a child, his elder brother succeeding to the family business, a yarn-boiling mill. Henry was educated at Heriot's Hospital and at fifteen became apprenticed to a goldsmith and jeweller in Edinburgh. Early efforts in painting were miniatures, by which he was recommended to David Martin (1737–98), a pupil of Allan Ramsay and a portrait painter and engraver, who after working in London settled in Edinburgh in 1775. Martin gave him technical hints but Raeburn probably found his best education in the collections of oil paintings to which he obtained access. The year 1779 has been given as the date of his marriage to Ann Edgar, a widow of some fortune. Soon after this he came to London with an introduction to Sir Joshua Reynolds, who advised him to study in Italy. Raeburn spent two years there and is said to have profited more by the advice of Byers, a dealer in pictures and antiques, than by acquaintance with artists in Rome. On his return to Edinburgh in 1787 he at once took a leading place as portrait painter. The broad style of oil painting he developed, in which no trace of the miniature remained, was well suited to convey the virile Scots character. He excelled in male rather than female portraiture, his sitters including the luminaries of literature and law in the golden age of Edinburgh's intellectual eminence, as well as many of the Highland chieftains. He was elected Royal Academician in 1815 but was dissuaded from moving to London by Lawrence, who pointed out the superior advantages he enjoyed in the northern capital. Raeburn was knighted by George IV when the King visited Edinburgh in 1822, and was appointed His Majesty's Limner for Scotland. He died 8 July 1823.

RAMSAY, *Allan*

Born in Edinburgh, 13 October 1713, Ramsay was the eldest son of the poet and bookseller of the same name. He was educated at the Royal High School and at sixteen launched as a student of art, with his father's encouragement. He attended the shortlived Academy of St Luke in Edinburgh and then went to London, where he was a pupil of the Swedish painter, Hans Hysing. He returned to Edinburgh, where he gained some small

portrait commissions, but his career began in earnest with his stay in Italy in 1736–8. He studied under Francesco Imperiale in Rome and Francesco Solimena in Naples and was also influenced by the polished portraiture of Pompeo Batoni. His acquirement of baroque elegance served him well when he set up as portrait painter in London on his return from Italy in 1738. In 1739 he married Anne Bayne, daughter of the professor of municipal law at Edinburgh University, and the informal charm of his portrait of her was an early indication of the celebrity he was to have in the mid-century as a painter of women. Having numerous commissions, he made use of the drapery painter Joseph Van Haeken (died 1749) for details other than the sitter's head. The return of the young Joshua Reynolds to London after his studies in Italy in 1753 promised Ramsay a formidable rival and caused him to take stock of his own abilities and their direction. Influenced at this stage by the grace and delicacy of contemporary French portraiture, he cultivated these qualities (in contrast with Reynolds's weightier manner) in portraits such as that of his second wife, which is generally regarded as his masterpiece (Plate 41). Anne, his first wife, had died in 1743 and he eloped in 1752 with Margaret Lindsay, whose parents had opposed the match. Her portrait was painted about 1755, in the period of his second visit to Italy, 1754–7. He spent much time in Rome with the architect Robert Adam, but in studying the Italian masters he now looked for the delicate qualities he could readily absorb and develop. The style he developed met with great success on his return to London. The interest of the Earl of Bute brought him to the notice of the Prince of Wales, who after his accession as George III appointed him in 1761 Painter in Ordinary in preference to Reynolds. The years 1754–66 were the period of his greatest achievements in full-length portraits, notably his *Lord Mountstewart* (1759) and *Lady Mary Coke* (1762), and smaller works such as his *Elizabeth Montagu* (1762). The demands made on him as court painter and the requirement of endless copies of his royal portraits seem to account for his waning interest in painting after 1766. He delegated more and more to assistants and turned to literary pursuits, these including such an unlikely work from a painter as *The Constitution of England*. He was a respected member of the Johnsonian circle and in 1778 the Doctor could remark: 'I love Ramsay. You will not find a man in whose conversation there is more instruction,

more information and more elegance than in Ramsay's'. Yet, having virtually given up painting by the time the Royal Academy was founded in 1768, and never exhibiting there, he was almost forgotten when he died, at Dover, 10 August 1784. Modern reappraisal has again placed him in the front rank.

REYNOLDS, *Sir Joshua*

Born at Plympton, Devon, 16 July 1723, Joshua Reynolds was, like Hogarth, the son of a schoolmaster, the Reverend Samuel Reynolds, rector of Plympton St Mary and master of the Plympton grammar school. An early leaning towards art was encouraged by reading the *Theory of Painting* by the portrait painter and writer on art, Jonathan Richardson (1665–1745). Between 1740 and 1743 Reynolds was the pupil in London of another Devonian, the portrait painter Thomas Hudson (1701–79), and from 1744 to 1749 he painted portraits on his own both in London and Devonshire. A decisive turning-point in his career was the three years' stay in Italy, made possible by his early patron, the Commodore (later Admiral) Keppel, who took him to the Mediterranean on board *H.M.S. Centurion* in 1749. In Italy he painted portraits of visitors and some caricature groups in the style of Thomas Patch; but it was the study of Renaissance art in Rome, Florence, Bologna and Venice that impressed him with the grandeur of the European tradition and provided a basis for his own learned style of portrait composition, as well as for the system of aesthetic judgement he was later to expound in his *Discourses* to the students of the Royal Academy, 1769–90.

Returning to England in 1752 he settled in London in the following year and was soon the most eminent and sought-after of portrait painters. In 1760 he moved to the house in Leicester Fields that he occupied until his death. He remained a bachelor, and his younger sister, Frances (Fanny) Reynolds (1729–1807), kept house for him. His circle of acquaintance comprised all that was brilliant in contemporary society. He favoured the company of men of letters and in 1764 founded the Literary Club. The friend of Johnson, Goldsmith, Burke, Sheridan and Garrick, he painted a series of literary portraits that are among his best, though only a part of the unrivalled gallery in which all the greatness and graciousness of the

age is mirrored. When the Royal Academy was founded in 1768 he became the first president by unanimous vote. The fifteen *Discourses* that were his annual and self-imposed task form a classic work of art appraisal. His own work, however, is outstanding in its sense of humanity rather than conformity to his canon of the 'grand style', owing much to Rembrandt as well as Titian, and little if anything to Michelangelo. Reynolds was knighted in 1769 and made Hon. D.C.L. of Oxford in 1773, marked by his masterpiece of self-portraiture (Plate 111), in which he appears in academic dress. A journey to the Netherlands in 1781 produced a loosening of style inspired by Rubens's example. In these later years he applied himself to such imaginative subjects as those for Boydell's Shakespeare Gallery (for example, *Puck*, exhibited at the Academy in 1789). Designs for stained glass in New College Chapel, Oxford, also occupied him in the 1780s but show the limitations of the painter of oil pictures in decorative design.

In spite of deafness, attributed to a chill caught in the Vatican while studying its works of art, Reynolds with his ear trumpet was at no disadvantage in society—as Goldsmith conveys in the poetic sketch of his *Retaliation*. Reynolds's sight became affected in 1789 and he died in London, 23 February 1792. Revered as the founder of the English School he was buried in the crypt of St Paul's Cathedral. He left a substantial fortune of some £80,000 to his niece, Miss Pearson, later Lady Alchiquin, and the sale of his art collection produced £17,000.

ROMNEY, *George*

Born at Dalton-in-Furness, Lancashire, 26 December 1734, Romney was the son of a builder and cabinetmaker by whom he was instructed in woodcarving. When he was twenty-one he was apprenticed for four years to a travelling portrait painter, Christopher Steele, who worked for a while in Paris under Jean-Baptiste Van Loo. In 1756 Romney married and thereafter ended his apprenticeship and worked on his own as a portrait painter in Kendal, Lancaster and York, somewhat after the style of Arthur Devis. In 1762 he departed for London, leaving his wife behind but providing her subsequently with means enough to live on. In the capital he rapidly gained favour, though a mutual antipathy seems to have declared itself

between him and Sir Joshua Reynolds. He became a member of the Society of Artists but was not one of the founders of the Royal Academy in 1768 nor did he ever exhibit there. In 1773 he travelled to Italy, where he was impressed and influenced by classical sculpture in Rome and by Correggio at Parma. On his return in 1775 he settled in Cavendish Square and there rose to the height of his fame and success; opinion was divided as to whether he or Sir Joshua was foremost in portraiture. At this time he became acquainted with the poet William Hayley, later Romney's biographer, who seems to have contributed to the impressionable painter's turning away from the realism of his portraiture to such fanciful works as *Serena in the Boat of Apathy* (Serena being the heroine of Hayley's poem, 'Triumphs of Temper'). The beauty of Emma Hart, later Lady Hamilton, whom Romney met in 1782, also filled him with ambition to paint ideal compositions, in which she was to be the principal figure. The romantic spirit of the later eighteenth century and the enterprises of Boydell and Fuseli impelled him to subjects from Shakespeare and Milton. He moved in 1797 to the studio house at Hampstead that he himself had designed, but he was by then broken in health and in 1799 returned to Kendal and his long-suffering wife. He died in Kendal on 15 November 1802.

SCOTT, *Samuel*

Born in London, probably in 1702, Scott is said to have first taken up painting as an amusement but acquired professional status as a marine painter. He followed the tradition of Willem van de Velde the Younger in paintings of warships and naval engagements; fourteen of these paintings are in the National Maritime Museum, Greenwich. He collaborated with George Lambert in six pictures for the East India Company of their principal settlements, Scott's part being to depict the foreground shipping in front of the various ports and forts. From about 1735 he turned from the open sea to the Thames and painted the almost rural picturesque reaches of the river in its east London aspects. He painted many of the subjects that claimed the interest of Canaletto when the Venetian master came to London in 1746, and Scott may have been incited by Canaletto's example to devote himself to river views centred at Westminster. Like Canaletto he painted a number of views of the Westminster Bridge

before its completion in 1750 (Plate 29). He exhibited at the Society of Artists, 1762–5, and retired to Bath, where he died on 12 October 1772.

SERRES, *John Thomas*

Born in 1759, the eldest son of the marine painter Dominic Serres, John Serres followed in his father's profession. For a number of years he was a drawing master at a marine school in Chelsea and in 1780 started exhibiting at the Royal Academy. He went to Italy in 1790 via Paris, Lyons and Marseilles, but came home after a year to marry Olive Wilmot. In 1793 he succeeded his father as marine painter to George III and was also appointed marine draughtsman to the Admiralty, for whom he frequently made sketches of enemy harbours. He contributed regularly to Royal Academy exhibitions, mainly shipping and marine subjects. He was ruined by the extravagance and claims of his wife, from whom he separated in 1804. As a result of her debts, Serres was thrown into prison, and he died, broken in spirit and health, on 28 December 1825.

SEYMOUR, *James*

Born in London in 1702, he was the son of a banker and amateur artist. He gained a reputation with his pictures of hunting subjects and racehorses, many of which were engraved by Thomas Burford and Richard Houston. His sketches of horses show great skill, and though he was denied excellence as a painter by Vertue and Walpole, his reputation has grown in this century. *A Kill at Ashdown Park* (Plate XVIII) is a principal work. He died 30 June 1752.

STUBBS, *George*

Born in Liverpool, 25 August 1724, one of the seven children of John Stubbs, a currier, George Stubbs started to draw when he was eight years old. At the age of fifteen he became apprenticed to an artist, Hamlet Winstanley, who was copying the Earl of Derby's pictures at Knowsley Hall. This apprenticeship came to an abrupt end and until he was twenty Stubbs studied at Liverpool on his own. He then worked as a portrait painter, mainly at York, while pursuing the study of human and animal

anatomy, eventually being able to lecture on these subjects to the medical students at York Hospital. He left York in 1753 and after a short stay in Hull took a ship for Italy. Little transpires of his visit to Rome, but it is probable that an antique sculpture of a lion attacking a horse, seen at Rome, inspired his many later versions of the subject, rather than an actual incident in Morocco on the way back, as his biographer Ozias Humphry related. In 1758 he rented a farmhouse in Horkstow, Lincolnshire, and there carried on the work of dissection that had its eventual result in the text and plates of *The Anatomy of the Horse*, published in 1766. In 1759 he moved to London where he established himself permanently. He promptly gained commissions for pictures of hunting and racing from such noble patrons as the third Duke of Richmond, the second Marquess of Rockingham and the first Earl Grosvenor; *The Grosvenor Hunt* of 1762 (Plates xix, 1, 51 and 52) is a fine example. As such patrons required specific sporting subjects, Stubbs was nearest to being a sporting artist in this decade, producing one of the masterpieces of the genre in his picture of *Gimcrack* (1765; Plates 62, 38 and 63), which he painted for Viscount Bolingbroke. He began a new and mature phase of the genre, clearly distinguished from the earlier period of John Wootton and James Seymour, in which Sawrey Gilpin and Ben Marshall were Stubbs's followers.

Stubbs had the mark of greatness in a universal outlook which precluded any narrow specialization. He was great not only as an animal painter but in his rendering of human character and landscape and in his understanding of the abstract constituents of pictorial composition. All these qualities are combined in his *Cheetah with two Indians*, painted for Sir George Pigot about 1765 (Plates 47 and 64). His work comprised portraits; open-air conversation pieces, often with equestrian figures; pictures of animals of many kinds (the series of mares and foals are masterly variations on a theme without reference to sport); and a number of farming subjects. The miniaturist Richard Cosway (1740–1821) interested him in enamel painting, and Josiah Wedgwood aided him by the experimental production of the large china plaques he needed to serve as a ground. In return Stubbs in 1780 painted portraits of the Wedgwood family, spending some months at Etruria for the purpose. In November 1780 he was elected an Associate of the Royal Academy but his enamel method seemed heretical to the conservative oil painters. Dispute caused him to refuse to deposit a diploma work and to decline full membership.

In the 1780s he applied himself to making prints of wild-animal and farming subjects (perhaps to disclaim the reputation of specialist in horse portraiture). With characteristic originality he used a mixed method of his own, in which mezzotint, stipple and line engraving and etching provide much subtlety of tone. In the 1790s he was much employed by the Prince of Wales for pictures of his horses, and *The Prince of Wales's Phaeton*, 1793 (Plate 133), is an outstanding work of his later years. In 1795 he devoted himself to an illustrated *magnum opus*, his *Comparative Anatomical Exposition of the Human Body with that of a Tiger and a Common Fowl*, incomplete at the time of his death. He died on 10 July 1806 in Portman Square, London.

TURNER, *Joseph Mallord William*

Born 23 April 1775 at 21 Maiden Lane, London, in the house and shop where his father, William Turner, carried on business as a hairdresser, the boy who was to be one of the greatest landscape painters began to draw at an early age, beginning with copies of engravings. After a modicum of general education at Brentford, where he stayed for a while with his uncle, Joseph Mallord William Marshall, he began four years' study at the Royal Academy schools in 1789. He also had lessons at some time during this period from the architectural draughtsman, Thomas Malton. His first exhibit at the Academy in 1790 was a watercolour of Lambeth Palace. He was then fifteen, and was quick to take advantage of the vogue for picturesque topography, his sketchbooks bearing witness to the amount of ground he covered in his search for topographical material. Between 1791 and 1801 he made extensive tours of Wales and the West Country, the Midland counties, the Lake District, Yorkshire and Scotland, as well as the southern counties and the Isle of Wight. By 1799 he was able to state that he had then 'sixty drawings bespoke by different persons'. He had attained the topographical mastery that appears in his drawings of Salisbury Cathedral and of Oxford for the Oxford Almanacks. The winter evenings spent at Dr Monro's house in the Adelphi between about 1794 and 1797 had contributed to this accomplishment. In company with

Thomas Girtin (1775–1802), in whom he found an inspiring co-worker, he had gained a broader outlook from copying or completing watercolours by J. R. Cozens (1752–99) in Dr Monro's collection. But his ambitions were not confined to watercolour, though it was an art he practised alternately with oil painting throughout his career. His first Academy picture that was certainly in oil was the *Moonlight: a Study at Millbank*, exhibited in 1797. In the years following, oils and watercolours were exhibits in more or less equal balance. No doubt his taking to oils facilitated his election as Associate in 1799 and as full Academician in 1802.

A reminder that this was the period of the Napoleonic Wars is given by his first historical painting, the *Battle of the Nile*, exhibited in 1799. The signing of the Treaty of Amiens and the reopening of Europe to English travellers mark a new stage of Turner's career; eighteenth-century topography was put behind him. He was prompt in crossing the Channel for the first time in 1802, and the 400 drawings in his sketchbooks testify to his excited discovery of France and Switzerland. *Calais Pier*, which he painted in 1803 (Plate 155), was a brilliant sea piece that heralded many major works up to 1820 that were produced in rivalry with, or admiring comment on, masterpieces of the past. But from 1819, when he first visited Italy, light and colour gained a new meaning that led to the poetic visions of his later years: for example, his *Rain, Steam and Speed* (1844; London, National Gallery) and *Snowstorm at Sea* (1842; London, Tate Gallery). In these and other abstractions of light and atmosphere he seems detached from both the eighteenth and nineteenth centuries in a unique independence. Turner died in Chelsea, 19 December 1851, having bequeathed a collection of his works of some 300 paintings and more than 19,000 drawings to the British nation. According to his wish, he was buried near Reynolds in St Paul's Cathedral, London.

WALTON, *Henry*

Born at Dickleburgh, Norfolk, in 1746, Walton was a pupil of Zoffany, developing the style of popular genre represented by *A pretty Maid buying a Love Song* (1778; Plate 73) and *The Cherry Barrow* (1779; Plate 114). He exhibited at the Society of Artists, 1771–6, and at the Royal Academy, 1777–9. The attraction of his work came freshly to view when included in the 'First Hundred

Years of the Royal Academy' exhibition at the Royal Academy in 1951–2. Walton died in London in 1813.

WEST, *Benjamin*

Born 10 October 1738 in Springfield, Pennsylvania, of a Quaker family, West began to paint when he was eight years old. Before he was twenty he was working in Philadelphia as a sign and portrait painter, and subsequently in New York. Engravings after European portraits had provided some instruction but he felt the need to study in Europe. With the aid of a New York patron he was enabled to go to Italy in 1759, was well received in Rome and elsewhere, and assimilated the ideas of the neoclassic school. The welcome he received on his arrival in London in 1763 led him to settle there. He was employed by George III from 1768 to 1802, was a founder member of the Royal Academy and succeeded Reynolds as its president in 1792. West's subjects were various, including classical, religious, medieval and later historical themes. He was exceptional among artists in England as a successful practitioner of history painting on a large scale. At sixty-five he painted his huge *Christ healing the Sick*, which attracted vast crowds when exhibited in London and was bought by the British Institution for 3000 guineas. A replica was sent to Philadelphia to assist in raising funds for a Quaker hospital, the purpose for which the first version was painted. A great many American artists in London owed him gratitude for help and advice, including Gilbert Stuart, Washington Allston, J. S. Copley, C. R. Leslie, Samuel Morse, John Trumbull and others. Matthew Pratt, in his *American School* (1765; New York, Metropolitan Museum of Art), depicted West's painting room with visitors and pupils. West's most famous picture was *The Death of Wolfe* (1770; Plate 68); no other painter handled this theme as effectively or as convincingly, though several artists attempted it. West died 11 March 1820 in London and was buried with great ceremony in St Paul's Cathedral.

WHEATLEY, *Francis*

Born in London in 1747, the son of a tailor, Wheatley went to Shipley's drawing school in the Strand; he obtained several premiums from the Society of Arts and was a student of the Royal Academy in 1769. He was

influenced first by Hayman and Gravelot and later by John Mortimer, whom he assisted in decorating the ceiling of Lord Melbourne's Hertfordshire mansion, Brocket Hall, in 1771. He was also employed on the Vauxhall decorations. Rural scenes in oil and watercolour and small full-length portraits were his speciality. Edward Edwards (*Anecdotes of Painters*, 1808) refers with strong reproof to Wheatley's leaving for Ireland in the company of a Mrs Gresse, but whatever the details of this episode, it is evident that he had success as a painter in fashionable Dublin. His masterpiece in that period of his career was his painting of the Irish House of Commons; it has portraits of all the members and a throng of spectators, and shows Grattan moving the repeal of Poyning's Act (Plates 108 and 110). On his return to London Wheatley painted a picture of the Gordon Riots of 1780, and although this was destroyed in a fire, the engraving from it shows the dramatic quality of which he was capable. But the later trend of his work, influenced by the popularity of Jean-Baptiste Greuze, was towards the exploitation of charm, as in his *Cries of London*, engraved in 1795. He painted twelve pictures, mainly from Shakespeare's comedies, for Boydell's Shakespeare Gallery. Wheatley was elected Royal Academician in 1791. He died 28 June 1801 in London.

WILDE, *Samuel de*

Born in 1748, de Wilde became a student of the Royal Academy in 1769. He followed Zoffany in theatrical conversation pieces and portraits of actors 'in character'. He specialized in humorous scenes and personalities, and the many paintings by him preserved at the Garrick Club form a vivid record of the comedies and farces popular in his time as well as the actors and actresses who took part in them. He worked in both oil and watercolour, exhibiting with the Incorporated Society of Artists from 1776 and at the Royal Academy from 1778 to 1821. His last work was exhibited in the year of his death. He died on 19 January 1832 and was buried in the ground of Whitefield's Tabernacle, in the Tottenham Court Road.

WILSON, *Richard*

Born at Penegoes, Montgomeryshire, 1 August 1714, Wilson was given a classical education by his father, a clergyman at Penegoes. In 1729 he was sent to London to study art under Thomas Wright, a portrait painter in Covent Garden (a different Thomas Wright from Wilson's first biographer in 1824). Wilson practised as a portrait painter in London until 1750 with considerable success, his sitters including the Prince of Wales, afterwards George III, and his brother the Duke of Kent (portraits now in the National Portrait Gallery in London) and Flora Macdonald (National Gallery of Scotland). In 1750 he went to Italy, remaining there until 1756. He was encouraged to devote himself to landscape by Francesco Zuccarelli, whom he met in Venice, and Claude-Joseph Vernet, an acquaintance in Rome. In addition, his chalk drawings of buildings and views in the environs of Rome were well received by English visitors on the Grand Tour, as many as twenty-five being commissioned about 1753 by William Legge, second Earl of Dartmouth. He made landscape his theme when he returned to England in 1756, his *Niobe* (Plate 53) being shown at the first exhibition of the Society of Artists in 1760. He exhibited regularly at these exhibitions until 1768, when the Royal Academy was founded. Wilson was nominated a founder member and exhibited at the Academy until 1780. He had few commissions, however, and was reduced to spartan poverty until the post of librarian of the Academy, which had fallen vacant on the death of Francis Hayman in 1776, gave him some measure of relief. In 1781 he was able to retire to his native Wales, living at Colomendy Hall, near Llanberis, Denbighshire, until his death on 12 May 1782. It must be concluded that his best work was too original in style to find popularity in his own time; it was appreciated by a following generation of painters, however, Constable describing him as one 'appointed to show the world what exists in Nature but which was not known until his time'.

WOOTTON, *John*

Born about 1682, Wootton studied under John Wyck and first became known at Newmarket, where he portrayed the favourite horses of his time. He became distinguished as a painter of horses and dogs and hunting scenes, his works fetching large prices. As one of the most popular artists of his day, his works, usually on a large scale, decorate many of the great country houses. There are also some in the Royal Collection. Wootton, with failing

eyesight, sold his collection in 1761 and died in Cavendish Square, London, probably in 1764.

WRIGHT, *Joseph*

Born 3 September 1734 in Derby, Wright (known as 'of Derby') was the son of an attorney in that city, where the greater part of his life was spent. He went to London in 1751 and studied portrait painting with Thomas Hudson; John Mortimer was a fellow pupil and friend. Though Wright returned to Derby, he sent pictures to the London exhibitions of the Society of Artists in the 1760s, the effects of candlelight and lamplight in which he specialized being much admired. If recalling the practice of Honthorst and other seventeenth-century painters of artificially lit scenes, such works as *A Philosopher giving a Lecture on the Orrery* (about 1763–5), *Experiment with the Air Pump* (1768; Plates 57, 60 and 61) and also *An Academy by Lamplight* (about 1769; Plate 105) all displayed a mixture of the romantic and scientific that was of his own time and country. He made the conventional journey to Italy in 1773–5, his scientific interest in natural phenomena being further shown in paintings of Vesuvius in eruption. On his return to England he lived for two years at Bath, hoping to gain a fashionable clientele as Gainsborough had done a short while before; but his stay was a fiasco from this point of view and he went home to Derby once more, remaining for the rest of his days among the industrialists and scientific philosophers of the region. His later work included portraits, such as that of Sir Richard Arkwright (whose cotton mill in the Derwent valley he also painted), and landscapes to which he applied his scientific interest, as in the *Landscape with Rainbow* (about 1795; Plate 153). There is a trace of romantic neoclassicism in *The Corinthian Maid* (1782–4), in which he depicted the daughter of the Corinthian potter who, according to legend, drew her lover's outline from his shadow so accurately that her father took an impression in clay and turned it into a pottery figure; this painting was appropriately bought by the great potter, Josiah Wedgwood. Wright was elected Associate of the Royal Academy in 1781 but renounced the connection after a quarrel. He died at Derby, 29 August 1797. He has been described as the first painter to express the spirit of the Industrial Revolution.

ZOFFANY, *Johann*

Born in Frankfurt, probably in either 1733 or 1734' Zoffany came of a Czech family, although his father, an architect, had settled in Germany. He was a pupil of Martin Speer at Ratisbon and also studied in Rome. Zoffany came to England about 1758 and for some time met with little encouragement. He is supposed to have been first employed as a drapery painter by the minor portrait painter Benjamin Wilson, but was later helped by Sir Joshua Reynolds and David Garrick. In 1762 he exhibited the picture of a stage scene, the first of many in which the celebrated dramatic performers of the time— Garrick, Foote, Weston and others—were portrayed in their favourite parts, and with their characteristic expressions and gestures faithfully rendered. Engravings of works of this kind were very popular. He also gave a fresh impetus and fashionable vogue to the conversation piece by the wealth of detail in his portrait groups, his style commending itself to the royal family, for whom he painted many works. Extensions of the conversation piece were such remarkable pictures as *The Academicians of the Royal Academy* (Plate 106) and *The Tribuna of the Uffizi* (Plates 107 and 109); the latter was painted during Zoffany's stay in Florence (1772–6) and both were painted for George III. Zoffany was one of the original members of the Royal Academy (an added nomination in 1769) and exhibited there from 1770 to 1800, though he worked in India from 1783 to 1789 painting both individual portraits and the crowded compositions for which he had a special facility (Plates 139 and 140). Before setting out for India he painted the portrait of Gainsborough (London, National Portrait Gallery), considered his best likeness by Gainsborough family tradition. Zoffany died at Kew on 11 November 1810.

Acknowledgements

The author gratefully acknowledges the collaboration of Keith Roberts in the choice of the illustrations.

Plates x, xvii, xxv, 40, 42, 85, 94, 96, 106, 107, 109, 112, 118, 133, 134, 136, 138, 145 and 151 are reproduced by gracious permission of Her Majesty The Queen.

Grateful acknowledgement is made to the following for permission to reproduce pictures in their collections:

The Lords Commissioners of the Admiralty, London (67); Ashmolean Museum, Oxford (87, 149); Barber Institute of Fine Arts, Birmingham (56); Birmingham Museum and Art Gallery (58, 59); Brighton Museum and Art Gallery (66); Burnley Corporation, Towneley Hall and Art Gallery and Museum (xii); Carnegie Institute Museum of Art, Pittsburgh (54); Castle Museum, Norwich (132); The Trustees of the Chatsworth Settlement, Derbyshire (xi); Thomas Coram Foundation for Children, London (11, 13, 19, 20, 135); Derby Museum and Art Gallery (153); Detroit Institute of Arts (89); The Syndics of the Fitzwilliam Museum, Cambridge (6); The Fogg Museum of Art, Cambridge, Massachusetts (128); Guildhall, London (127); Henry E. Huntington Library and Art Gallery, San Marino, California (74, 100, 101); The Greater London Council of Trustees of the Iveagh Bequest, Kenwood, London (ii, 43); Kunsthaus, Zürich (130); The Leeds City Art Galleries, Gascoigne Collection, Lotherton Hall (108, 110); Manchester City Art Gallery (47); The Metropolitan Museum of Art, New York (xxiv: Bequest of Edward S. Harkness, 1940; 98: Fletcher Fund, 1945); Ministry of Public Buildings and Works, London (23); The Trustees of the National Gallery, London (ix, 14, 32, 33, 34, 45, 102, 119, 122, 146, 147, 155); National Gallery of Canada, Ottawa (xv, 68, 83, 84); National Gallery of Ireland, Dublin (104); National Gallery of Scotland, Edinburgh (41, 148); National Gallery of Art, Washington, D.C. (69; 137: Andrew Mellon Collection); National Maritime Museum, London (24); The Trustees of the National Portrait Gallery, London (vii, 1, 2, 4, 5, 12, 17, 21, 22, 99); Philadelphia Museum of Art (113; 131: photograph by A. J. Wyatt, staff photographer); Royal Academy of Arts, London (iii, iv, 105, 124); Royal Society of Arts, London (103); The Trustees of Sir John Soane's Museum, London (viii); Society of Dilettanti, London (v, vi); Southampton Art Gallery (125, 126); The Trustees of the Tate Gallery, London (xviii, xxi, 8, 9, 16, 18, 26, 27, 28, 29, 30, 31, 57, 60, 61, 76, 77, 90, 115, 123, 154); The Masters and Fellows of Trinity College, Cambridge (3); Victoria and Albert Museum, London (15, 152); Wadsworth Atheneum, Hartford, Connecticut (79, 80); Walker Art Gallery, Liverpool (39, 55, 81, 82, 129); The Trustees of the Wallace Collection, London (44); Whitworth Art Gallery, University of Manchester (143, on loan from Her Majesty's Treasury).

The publishers are also grateful to all the private owners, both those listed and those who wish to remain anonymous, and family trustees who have given permission to reproduce their works.